PRE-RAPHAELITES
AT HOME

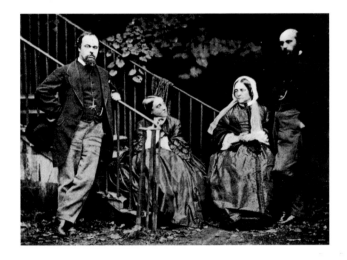

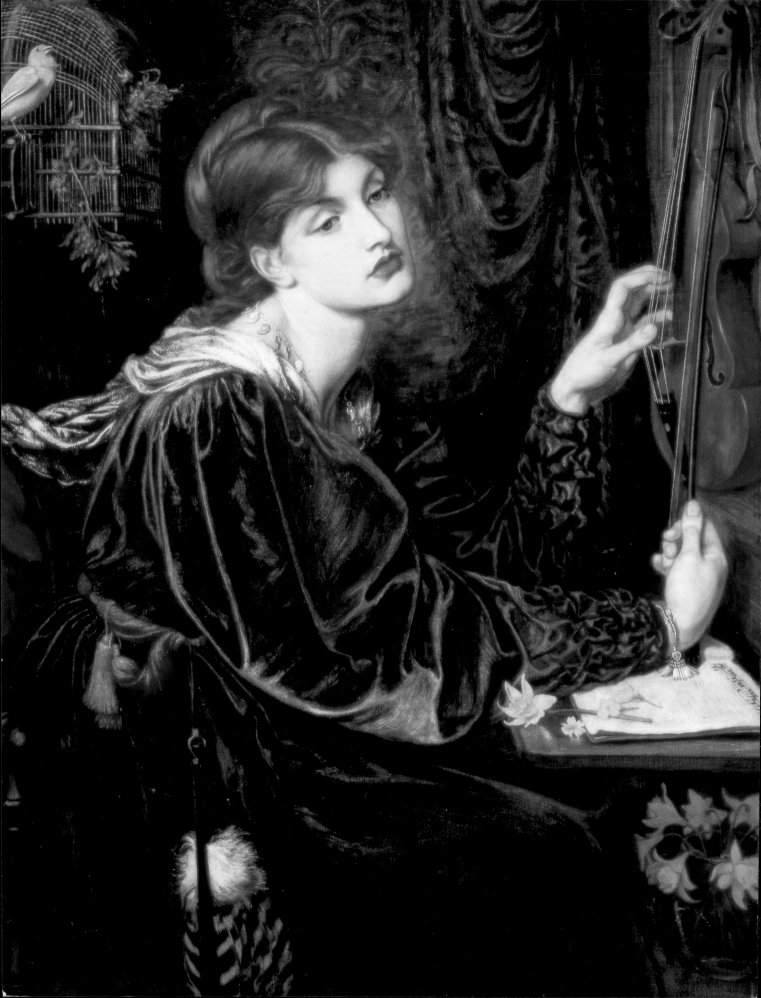

PRE-RAPHAELITES
AT HOME

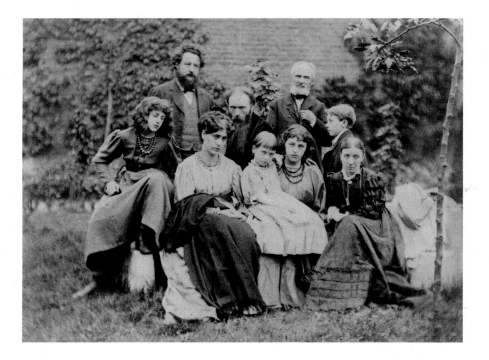

PAMELA TODD

WATSON-GUPTILL PUBLICATIONS / NEW YORK

Text © 2001 by Pamela Todd
Design and layout © Pavilion Books, Ltd.

First published in the United States in 2001
by Watson-Guptill Publications,
a division of BPI Communications, Inc.,
770 Broadway, New York, NY 10003
www.watsonguptill.com

Designed by David Fordham
Picture research by Mary-Jane Gibson
Text set in 9-pt Centaur MT

Library of Congress Control Number: 2001091045

ISBN 0-8230-4285-5

First published in Great Britain in 2001
by Pavilion Books Limited
London House, Great Eastern Wharf
Parkgate Road, London SW11 4NQ
www.pavilionbooks.co.uk

Printed in Italy

First printing, 2001

1 2 3 4 5 6 7 8 / 08 07 06 05 04 03 02 01

PAGE 1: *Gabriel, Christina, their mother, and William Michael Rossetti pose on the steps of Tudor House.*

PAGE 2: ***VERONICA VERONESE*** *by Dante Gabriel Rossetti. One of a number of paintings Gabriel made of women playing musical instruments for the Liverpool shipping millionaire F. R. Leyland.*

PAGE 3: *The Morris and Burne-Jones families pose together for this group portrait. The gentleman standing on the right is Edward Burne-Jones's father.*

CONTENTS

CHRONOLOGY

1848

Semisecret Pre-Raphaelite Brotherhood first formed in Millais's studio in Gower Street. The seven members are John Everett Millais, Dante Gabriel Rossetti, William Holman Hunt, F. G. Stephens, William Michael Rossetti, James Collinson, and Thomas Woolner. Euphemia (Effie) Chalmers Gray marries John Ruskin.

1849

First Pre-Raphaelite paintings—Millais's *Lorenzo and Isabella* and Hunt's *Rienzi*—hung in the Royal Academy in May 1849, both bearing the initials PRB.

1850

Lizzie Siddal spotted by Walter Deverell working in the back room of a milliner's shop in Cranbourne Alley. Dante Gabriel Rossetti and Deverell share a studio at 17 Red Lion Square.

1851

John Ruskin champions the Pre-Raphaelite Brotherhood and Effie meets Millais.

1852

Millais's *Ophelia* causes a sensation at the Royal Academy Exhibition. Rossetti moves out of the family home in November to rooms in Chatham Place near Blackfriars Bridge.

1852

Woolner emigrates (temporarily) to Australia. Hunt's first visit to the the Middle East.

1853

Millais accompanies the Ruskins on a Highland holiday. William Morris and Edward Burne-Jones together at Exeter College, Oxford.

1854

Effie and Ruskin separate and are divorced. Deverell dies tragically of Bright's disease.

1855

Ruskin offers Lizzie Siddal an annual stipend of £150. Millais and Effie Ruskin marry. Rossetti introduces Lizzie to his mother and sister Christina at Albany Street. Burne-Jones introduced to Rossetti at the Working Men's College in Great Ormond Street.

1856

Burne-Jones engaged to fifteen-year-old Georgiana Macdonald. Morris buys Arthur Hughes's *April Love*. Rossetti embarks on flirtation with Hunt's protégée Annie Miller, left in F. G. Stephens's charge while Hunt away in the Middle East.

1857

Rossetti secures commission to decorate new Debating Hall of the Oxford Union building with Arthurian murals. Jane Burden spotted by Rossetti and Burne-Jones at theater in Oxford. Rossetti meets Fanny Cornforth in Royal Surrey Gardens. Lizzie Siddal studying art in Sheffield.

1858

Morris marries Jane Burden. Unofficial engagement between Lizzie Siddal and Rossetti is broken off. Burne-Jones convalesces at Little Holland House after a serious illness and, in Georgiana's absence, embarks on an *amitié amoureuse* with Sophia Dalrymple.

1860

Rossetti marries Lizzie Siddal. Burne-Jones marries Georgiana Macdonald. Janey and William Morris move into Red House, Bexleyheath.

1861

Jane Alice Morris (Jenny) born. Morris founds the firm of Morris, Marshall, Faulkner & Co. Ford Madox Brown, Philip Webb, Burne-Jones and Rossetti also partners. Burne-Jones's first child, Philip, born. Rossetti's first child, a daughter, stillborn.

1862

The International Exhibition at South Kensington provides a platform for the first public showing of work of the Firm. Lizzie Rossetti dies after a laudanum overdose in Chatham Place. Rossetti leases Tudor House, 16 Cheyne Walk, Chelsea. Mary (May) Morris born.

1863–5

Fanny Cornforth an almost permanent fixture at Tudor House.

1864

Georgiana Burne-Jones contracts scarlet fever and her second son,

Christopher, born prematurely, dies. Algernon Swinburne is asked, "with all possible apology," to leave Cheyne Walk.

1865

Morris regretfully abandons Red House for Queen Square. Burne-Jones moves to 41 Kensington Square, Kensington. Rossetti accosts Alexa Wilding in the Strand and persuades her to pose for him.

1867

Janey Morris begins to pose again for Rossetti and their relationship deepens. Burne-Jones's affair with Mary Zambaco begins. Burne-Jones moves to the Grange, Fulham.

1869

Janey and William Morris visit German spa resort of Bad Ems. Exhumation of Lizzie Rossetti's grave in Highgate Cemetery.

1871

Rossetti and Morris jointly lease Kelmscott Manor, Oxfordshire. Morris's first voyage to Iceland.

1872

Rossetti suffers mental breakdown, provoked by savage criticism of his poems and morals. Madox Brown accompanies him to Scotland for rest cure. Janey Morris moves into Horrington House, Turnham Green, with her daughters, and Morris joins them in February 1873.

1873

Rossetti at Kelmscott with Janey Morris.

1874

William Michael Rossetti marries Madox Brown's daughter, Lucy.

1875

Morris's controversial restructuring of the Firm cuts out Rossetti and Madox Brown. Morris renews lease on Kelmscott Manor alone.

1877

Burne-Jones's affiliation to the newly opened Grosvenor Gallery catapults him to new heights of fame. Burne-Jones buys Prospect House, Rottingdean, and renames it North End House.

1878

Janey and William Morris move to Kelmscott House, Hammersmith.

1879

Morris invites more than ninety guests to watch the annual Oxford v. Cambridge Boat Race on the Thames from Kelmscott House—this becomes an annual event. Morris converts the coach house at Kelmscott House into a lecture room for the Hammersmith Socialists.

1880

The Morris family and friends make the first of two trips by boat along the Thames from Kelmscott House, Hammersmith, to Kelmscott Manor, Oxfordshire.

1882

Rossetti dies on Easter Sunday at Birchington-on-Sea.

1885

Burne-Jones elected an Associate of the Royal Academy. Millais accepts a baronetcy.

1886

Millais's picture *Bubbles* at the center of a controversy.

1888

Margaret Burne-Jones marries John Mackail in the church at Rottingdean.

1891

Morris sets up the Kelmscott Press in a rented cottage at 16 Upper Mall.

1894

Burne-Jones accepts a baronetcy.

1896

Millais elected President of the Royal Academy on death of Lord Leighton. Morris dies shortly after returning from a final trip to Norway. Millais dies.

1898

Burne-Jones dies.

1910

Hunt dies.

FIGURES IN THE PRE-RAPHAELITE LANDSCAPE

ALLINGHAM, William (1824–1889) Poet, writer, and friend of the Pre-Raphaelites.

ALMA-TADEMA, Lawrence (1836–1912) Dutch-born painter of classically inspired paintings hugely popular with Victorian audiences. His London houses were famous for his well-attended "At Homes" and extravagant parties.

ANGELI, Helen Madox Rossetti Daughter of William Michael Rossetti and Lucy Madox Brown, she wrote a defense of her uncle Dante Gabriel Rossetti.

BALDWIN, Louisa, née Macdonald (1845–1925) Sister of Georgiana Burne-Jones. She married Alfred Baldwin and their son Stanley was Conservative prime minister in the 1920s and 1930s.

BENSON, W. A. S. Architect introduced to Edward Burne-Jones by his sister, who modeled for the painter. He designed the garden studio at the Grange (Edward Burne-Jones's Fulham house), made improvements to the house and the studio lighting, and made up Arthurian props for the painter's pictures. In 1889 he expanded the family's holiday cottage, North End House, on the Green at Rottingdean, Sussex.

BLUNT, Wilfrid Scawen (1840–1922) Poet and political maverick who had an affair with Janey Morris in 1883.

BODICHON, Barbara Leigh Smith Progressive thinker, suffragist, and painter to whom the founding and rise of Girton College is mainly due. She became friendly with Lizzie and Gabriel Rossetti, who stayed in the house, Scalands Gate, that she had built for herself in 1853 on her father's estate in Robertsbridge. Rossetti described her as having "plenty of fair hair, fat, and tin [money], and readiness to climb a mountain in breeches or to ford a river without them."

BOYD, Alice Owner of Penkill Castle, Ayrshire, who was William Bell Scott's companion from 1859 until his death in 1890.

BROWN, Ford Madox (1821–1893) Although never formally a member of the Pre-Raphaelite Brotherhood (PRB), he was an important mentor, teacher, and loyal supporter. He married his cousin Elizabeth Bromley in 1841, and their first child, Lucy, was born in 1843. When Elizabeth died abroad on 5 June 1846 her body was brought back to England for burial in Highgate Cemetery beneath a gravestone of Brown's design. He made a second marriage in the spring of 1853 to Emma Matilda Hill, his model and mistress, when their daughter Catherine Emily was two years old. Their son Oliver (Nolly) died tragically young. Unfailingly kind and courteous, he was dogged in his early years by poverty and anxiety and he never gained the recognition he deserved. He was a founding member of the Firm, although he fell out with Morris over the restructuring of the business. For years he toiled over a series of important murals depicting local history in Manchester Town Hall for the paltry sum of £300 a year, suffering a stroke that affected his painting arm, but going on to finish the series using his left hand.

BROWN, Lucy Madox (b.1843) Daughter of Ford Madox Brown and his first wife, Elizabeth. When her mother died abroad in 1846 Lucy was placed in the care of Helen Bromley, her maternal aunt, but she joined Ford and his second wife Emma after their marriage. In 1856 she went to board with the Rossetti family and was instructed by Gabriel's sister Maria, a teacher and governess (later a nun) for a fee of £40 a year. She became engaged to William Michael Rossetti in 1873, marrying him the following year. She had begun to paint, but the arrival of six children (including twins) in five years put an end to her painting career.

BURDEN, Elizabeth (b.1842) Known as Bessy, she was Janey Morris's sister and lived with the family, becoming a skilled embroiderer and helping with the Firm's accounts. She went on to become an instructor at the Royal School of Needlework and adviser to schools in the London area.

BURNE-JONES, Edward (1833–1898) Born plain Edward Jones in Birmingham, the only son of a widowed picture framer and gilder, he added the Burne (a family name) later at Rossetti's suggestion. Part of the second wave of Pre-Raphaelitism, he went on to become one of the most important painters of his age. He accepted a baronetcy in 1894.

BURNE-JONES, Georgiana, née Macdonald (1840–1920) Fifth of eleven children born to Birmingham Methodist minister George

Macdonald and his wife, Hannah. Three of her sisters made important marriages and two were mothers of major twentieth-century figures—Rudyard Kipling and Stanley Baldwin. She put her ambitions for her own woodcut illustrations second to caring for her husband and two children, a son, Philip (born 1861) and a daughter, Margaret (born 1866). She weathered her husband's whimsical flirtations and emerged as a public figure of some stature, sitting as a parish councillor and serving on the Board of Trustees of the South London Art Gallery.

BURNE-JONES, Margaret (1866–1954) Daughter of Georgiana and Edward Burne-Jones, she married William Morris's first biographer, J. W. Mackail, and had two children, Angela and Denis.

CAINE, Hall Supplanted Henry Treffry Dunn as Rossetti's secretary and lived with him at Cheyne Walk and Birchington for the last two years of his life.

CAMERON, Julia Margaret (1815–1879) Pioneer photographer and sister of Sara Prinsep, she began taking photographs in 1863 after she was given a camera by her daughter.

COLLINSON, James (1825–1881) A founder member of the PRB, he painted at least three significant Pre-Raphaelite pictures before he resigned in 1850. After his engagement to Christina Rossetti ended, he joined a seminary.

COMBE, Thomas Oxford-based friend and, with his wife, patron of the early Pre-Raphaelites. He purchased *The Light of the World* by William Holman Hunt in 1853 and oversaw its installation in Keble College Chapel, Oxford.

CORNFORTH, Fanny Sussex blacksmith's daughter and blonde "stunner" who sat for Rossetti (whose mistress she became), Burne-Jones, George Boyce, and J. R. Spencer Stanhope. A professional prostitute, she was maintained by Rossetti in a house in Chelsea and remained on good terms with him until his death. She married Timothy Hughes, a mechanical engineer, who died in 1872. A fine-looking woman who later ran to fat, she was known affectionately as "Dear Elephant" by Rossetti.

CORONIO, Aglaia, née Ionides (1834–1906) Daughter of a wealthy Greek family of Pre-Raphaelite patrons and recipient of personal letters from William Morris.

DALRYMPLE, Sophia (1829–1911) One of the famous Pattle sisters and object of Edward Burne-Jones's affection. Married John Warrender Dalrymple (later the seventh baronet) in 1847. Lived at Little Holland House during much of the 1850s and 1860s while her husband continued his career with the Bengal civil service.

DE MORGAN, William (1839–1917) British artist, potter, and novelist, introduced to the Pre-Raphaelite circle via the Royal Academy Schools. He abandoned his artistic ambitions in favor of a career in decorative design. He produced stained glass and tiles for Morris & Co. from the basement of his home in Fitzroy Square until 1881, when he transferred his business to Merton Abbey to be near the Firm's new workshops. He married fellow artist Evelyn Pickering in 1885.

DEVERELL, Walter Howell (1827–1854) Fellow student of Rossetti and Holman Hunt at the Royal Academy, he became an assistant master at the Government School of Design but died tragically young, probably of Bright's disease, in the rooms at 17 Red Lion Square that Burne-Jones and Morris would later occupy. He was the first painter to use Elizabeth Eleanor Siddal as a model (for Viola in *Twelfth Night*).

DIXON, Richard Watson (1833–1900) Schoolfriend of Burne-Jones and member of Oxford "Set," he officiated at the marriage of William and Jane Morris in Oxford. He became canon of Carlisle Cathedral.

DU MAURIER, George (1834–1896) *Punch* artist, friendly with the Burne-Joneses until he fell out with Edward over his caricatures of Rossetti and Swinburne.

DUNN, Henry Treffry (1838–1897) Rossetti's art assistant at 16 Cheyne Walk and painter of the portrait of Rossetti now in the Uffizi Gallery in Florence, also one of Rossetti and Theodore Watts-Dunton in the National Portrait Gallery in London.

EGG, Augustus Leopold (1816–1863) Hunt's friend and patron, a typical Victorian romantic genre painter.

FAULKNER, Charles (1834–1892) A Birmingham friend of Burne-Jones. Introduced to Morris at Oxford, he became a highly original mathematician and founding member of Morris, Marshall, Faulkner & Co. He followed Morris in his espousal of socialism and led the Oxford branch of the Socialist League.

FILDES, Luke (1843–1927) A successful Victorian artist with a studio-house in Kensington, he moved from the searching realism of his early work to the lucrative genre of society portraiture.

FRITH, William Powell (1819–1909) With Richard Redgrave and Luke Fildes, he was among the most important artists working in the genre of Victorian narrative painting.

HILL, Emma Matilda (d.1890) Daughter of a bricklayer, she became a model and mistress to Ford Madox Brown, bearing him a daughter, Catherine Emily, in 1850, and, (after their marriage, conducted in conditions of some secrecy, in 1853) a son, Oliver (Nolly). Uneducated and simple in her tastes, Emma stoically endured the poverty of their early life together. She is the model for the wife in his painting *The Last of England.*

HOWARD, George (1843–1911) Ninth Earl of Carlisle, Liberal MP, and, with his wife Rosalind (1845–1921), a friend to Morris and Burne-Jones and patron of the Firm. Philip Webb designed the Howards' London residence at 1 Palace Green, which was decorated by Morris & Co.

HOWELL, Charles Augustus (1840–1900) Art agent and adventurer who worked as a secretary to Ruskin from 1865 until his dismissal in 1870. He ingratiated himself with Rossetti by a present of Madeira wine, acted as go-between for Janey and Rossetti, and played a central part in the exhumation of Lizzie Siddal's coffin.

HOWITT, William and Mary Quakers who, with their daughters Anna Mary and Margaret (a painter and a translator respectively), were part of the circle of intellectuals, politicians, writers, and artists interested in radical politics and progressive causes. The family invited Rossetti to use the cottage studio in their garden in Highgate West Hill.

HUNT, William Holman (1827–1910) Son of a warehouse manager in the City of London and founding member of the Pre-Raphaelite Brotherhood. He groomed his model Annie Miller for marriage but eventually, in 1865, wed Fanny Waugh, daughter of a wealthy pharmacist. Fanny died in Italy six weeks after giving birth to their son, Cyril, and ten years later Hunt married her sister Edith when she was thirty-one and he was fifty. The marriage had to take place abroad, as such a union was illegal at the time in England. He traveled extensively in the Middle East and, though

he suffered periods of appalling poverty, was able, at the height of his career, to command £10,000 for a single picture.

HUGHES, Arthur (1832–1915) Three years younger than Millais, he was an important Pre-Raphaelite follower who produced his best work during the 1850s and early 1860s. Extremely retiring, gentle, and well liked, he married Tryphena Foord and had five children. The family lived in Bowling Green House, a small low-lying white house at the foot of the south side of the Putney Bridge across the Thames.

KIPLING, Rudyard (1865–1936) Poet and writer, spent much time as a boy with his aunt Georgiana Burne-Jones and her family at the Grange, Fulham, and in North End House, Rottingdean.

LEIGHTON, Frederic, Lord (1830–1896) Painter and Royal Academician who became president of the Royal Academy in 1878. Cosmopolitan, eloquent, and handsome, he lived in Rome, Florence, Paris, and Berlin before having a sumptuous house built for himself in Holland Park, which became the center of an artistic circle.

LUSHINGTON, Vernon (1832–1912) As a young man he introduced Burne-Jones to Rossetti. He settled down after three adventurous years of travel to a life at the Bar, eventually becoming a judge and pillar of the establishment. He lived with his wife and daughters at 36 Kensington Square.

MACKAIL, J. W. (1859–1945) William Morris's first biographer and later Professor of Poetry at Oxford, he married Margaret Burne-Jones in 1888.

MARSHALL, Peter Paul (1830–1900) Scottish engineer and amateur painter who first suggested the idea of the Firm to William Morris. A founding member, he did little work in the early years and left, with compensation, in the restructuring of 1875.

MILLAIS Euphemia, née Gray (1828–1897) Known as Effie, she was pretty and vivacious. Her first marriage to John Ruskin was annulled in 1854, but her second, to John Everett Millais, lasted forty-one years and they had eight children. Effie suffered social ostracism as the result of the scandal over the annulment and was not able to accompany her daughters to debutante balls. Queen Victoria eventually agreed to Millais's deathbed wish that she be received at Court. Effie survived her husband by a little over a year, dying at the age of seventy. She is buried in the graveyard of Kinnoull, on the banks of the Tay.

MILLAIS, John Everett (1829–1896) One of the seven founding members of the Pre-Raphaelite Brotherhood, he won a silver medal for drawing at the Royal Academy Schools at the precociously early age of eleven. Nicknamed "The Child," he was frequently sent on errands to fetch pies and stout for his older colleagues. Less well educated than Rossetti, he nevertheless had the security of parents with independent means. He was made an Associate of the Royal Academy in 1853 and became a Royal Academician ten years later, eventually succeeding Lord Leighton as president in 1896. In 1885 he was created a baronet, although Queen Victoria would still not receive his wife, believing that "he had seduced his future wife while painting her." He died of throat cancer in August 1896 and was buried in the crypt of St. Paul's Cathedral, next to the artist J. M. W. Turner. William Holman Hunt was a pallbearer.

MILLER, Annie She grew up in a slumyard behind Holman Hunt's studio in Chelsea. He had her luxuriant hair deloused and left her in the charge of the Pre-Raphaelite Brotherhood as an occasional model while he was away in the Middle East. F. G. Stephens was meant to oversee the arrangements for her to be schooled as a lady and prospective wife. Rossetti's dalliance with her was the cause of a rift between the two painters and Hunt never married Annie, who went on to make an advantageous match with Major Thomson, cousin of Lord Ranelagh.

MORRIS, Janey, née Burden (1840–1914) Daughter of a groom at the stables in Holywell, Oxford, she was a statuesque and astonishing beauty who captivated the hearts of Rossetti and Morris, whom she married in 1858. Despite a reputation for fragility and ill health, she lived to a ripe old age, securing Kelmscott Manor for her children before her death.

MORRIS, Jane Alice (1861–1935) Elder daughter of Janey and William Morris, from childhood she suffered from epilepsy and spent much of her life as a recluse.

MORRIS, May (1862–1938) Younger daughter of Janey and William Morris, who taught her how to draw and paint. Extremely active in all her father's interests, she designed textiles and wallpapers for the Firm and became an accomplished embroideress, managing the embroidery workshop at Merton Abbey from 1886. She was a participant in Morris's political activities and a founding member of the Women's Guild of Arts in 1907. After her father's death, she edited his writings in twenty-four volumes. Her "mystic betrothal"

to George Bernard Shaw did not result in marriage, and, although she was briefly married to Henry Halliday Sparling, she finally found love and devoted companionship with Mary Lobb, who had worked at Kelmscott during the First World War.

MORRIS, William (1834–1896) Eldest son and third child of William Morris and Emma Shelton. Born at Elm House, Walthamstow, he attended Marlborough College, where he acquired a love of landscape and medieval architecture, and Exeter College, Oxford, where he acquired a lifelong friend in Edward Burne-Jones. He abandoned plans to enter the Church in favor of architecture then, on meeting Rossetti, architecture for art. He married Jane Burden in 1858. Founder of the Firm and the Kelmscott Press, he turned in later life to politics but continued to write poems, weave tapestries, design wallpapers, and also to fish at his beloved Kelmscott.

NICOLSON, Mary Housekeeper to Edward Burne-Jones and William Morris in Red Lion Square. Known as Red Lion Mary, she was a cheerful and relatively cultivated woman whom Morris taught to embroider and who worked for him until her marriage.

NORTON, Charles Eliot (1827–1908) American scholar and friend of John Ruskin and William Morris.

PRICE, Cormell (1836–1910) Known as "Crom," a Birmingham schoolfriend of Edward Burne-Jones, member of the Oxford "set'"and loyal friend of Morris, he went on to found the United Services College, a boarding school for children whose parents were serving in the colonies and that Rudyard Kipling, a former pupil, immortalized in *Stalky & Co.*

PRINSEP, Sara One of the famous "Pattle sisters," (Julia Margaret Cameron, Sophia Dalrymple, and Virginia Woolf's grandmother Maria Jackson were among the others) whose family fortune came from trade in India, she married Thoby Prinsep, of the Indian civil service, and leased Little Holland House from Lord Holland in 1851 until 1875 when the house was demolished.

PRINSEP, Valentine (1838–1904) Youngest son of Sara and Thoby Prinsep, a painter and friend of Rossetti, who needed little persuasion to contribute to the Oxford Union scheme. At the age of twenty-one he toured Italy with Edward Burne-Jones prior to attending the Atelier Gleyre in Paris. He commissioned Philip

Webb to build a substantial house for him on an acre of "Holland land" when it was sold in 1864 and it still stands beside Lord Leighton's House at 1 Holland Park Road.

ROBERTSON, W. G. An Eton-educated young follower of Burne-Jones in his later years at the Grange, he went on to become a costume designer and friend of Sarah Bernhardt, Oscar Wilde, and Mrs. Patrick Campbell.

ROSSETTI, Christina (1830–1894) Dante Gabriel Rossetti's younger sister and poet.

ROSSETTI, Dante Gabriel (1828–1882) Son of an Italian political exile living in London, he showed early artistic promise and attended Sass's Drawing Academy and the Royal Academy Schools but found lessons tedious and spent much of his time reading and writing poetry. A founding member of the Pre-Raphaelite Brotherhood, he rarely exhibited in public, preferring to sell his work to private patrons. He married Elizabeth Siddal in 1860, was a founding member of Morris, Marshall, Faulkner & Co. in 1861, and began an intimate relationship with Janey Morris in 1869. After a breakdown in 1872 and an increasing dependence on alcohol and drugs, his physical and emotional health suffered. He died after a stroke on Easter Sunday 1882 in a large rambling bungalow near the cliff face at Birchington-on-Sea. He is buried in the churchyard there.

ROSSETTI, Maria (1827–1876) Dante Gabriel Rossetti's older sister, she became an Anglican nun.

ROSSETTI William Michael (1829–1919) Dante Gabriel Rossetti's brother and, although not artistic, a founding member of the Pre-Raphaelite Brotherhood. He worked at Somerset House for the Inland Revenue and, through his work as art critic for *The Spectator*, ensured the movement's popular success, while shaping a mythologized version of Pre-Raphaelitism through his many published accounts of it and the personalities concerned. He participated in the production of the PRB's short-lived magazine, *The Germ*. He married Ford Madox Brown's daughter "Lucy the Lovely" in 1874.

RUSKIN, John (1819–1900) Only child of doting and wealthy parents, Ruskin was a precociously brilliant writer and thinker and early champion of the Pre-Raphaelite Brotherhood. His *Modern Painters*, which preached the doctrine of "fidelity to nature," had a profound influence on the PRB. He married Euphemia (Effie) Gray

in 1848 but during a holiday in Scotland she fell in love with Millais and the marriage was annulled, causing considerable scandal. He suffered his first mental breakdown in 1878 and died in 1900 at Brantwood in the Lake District.

SAMBOURNE, Edward Linley (1844–1910) *Punch* artist and friend of Leighton whose tall, stuccoed house in Stafford Terrace is now open to the public.

SANDYS, Frederick (1829–1904) Norwich artist and friend of Dante Gabriel Rossetti, he married Georgina Creed in 1853 but went on to have a long liaison with a gypsy woman and later eloped with a seventeen-year-old actress named Mary Jones, who bore him nine children.

SCHEU, Andreas (1844–1927) Austrian furniture designer and founder, with William Morris, of the Socialist League.

SCOTT, William Bell (1811–1890) Poet and friend of William and Dante Gabriel Rossetti, he contributed to *The Germ* and dedicated his published *Poems* to his friends Rossetti, Morris, and Swinburne. In 1870 became a neighbor of Rossetti in Cheyne Walk.

SIDDAL, Elizabeth Eleanor (1829–1862) Third of seven children born to Elizabeth Eleanor Evans and her husband, Charles Siddall, a Sheffield-born cutler who ran an ironmongery business in Southwark, London, she worked, like her sisters, as a dressmaker and milliner. She was famously spotted by Walter Deverell in "a bonnet shop" and became the muse of the new movement, the archetypal heroine of Pre-Raphaelite romanticism. Under Rossetti's tutelage she began to paint and was offered an annual stipend of £150 by Ruskin, who was keen to shape her art, which owed much to Rossetti's idealized medievalism. In 1860, after a period of separation during which she concentrated on her painting and exhibited alongside Ford Madox Brown, she married Rossetti. The next year she gave birth to a stillborn child, a girl. The trauma tipped her into madness, she became addicted to laudanum, and, in February 1862, she died from an overdose of drugs. Rossetti, distraught and consumed with guilt, placed his poems in her coffin before it was buried in Highgate Cemetery, only to have it exhumed in 1869 to retrieve the manuscript.

SOLOMON, Simeon (1840–1905) Jewish painter much influenced as a young student at the Royal Academy by the Pre-Raphaelites and Swinburne, whose poems he illustrated. His

successful career as an artist was ruined in 1873 when he was sentenced to an eighteen-month imprisonment for homosexual offences. He died in a London workhouse.

SPARTALI, Marie (1844–1927) Daughter of Michael Spartali, the Greek consul-general in London, she was one of a trio of lovely young cousins immortalized in Pre-Raphaelite painting and the photographs of Julia Margaret Cameron. W. G. Robertson called her "Mrs. Morris for Beginners" because of her long neck and tumbling dark hair. She studied painting under the guidance of Ford Madox Brown and became a close friend of his daughter Lucy. A lively, likable woman, she married the American journalist and war correspondent William Stillman in April 1871 and moved with him to Greece and then Italy, where Janey Morris was a frequent visitor. She exhibited in England and America and died in March 1927 a few days short of her eighty-fourth birthday. Both her daughter Effie and her stepdaughter Lisa became artists.

STEPHENS, Frederick George (1828–1907) One of the original seven members of the Pre-Raphaelite Brotherhood, he quickly recognized that he was less talented than the others and abandoned painting in 1850 in favor of writing. He married a young and barely literate woman called Clara and named his son Holman (always known as Holly) after his godfather William Holman Hunt, who sent a check for £13 to celebrate the birth. He became a respected art critic on *The Athenaeum* and chronicler of the Pre-Raphaelite movement. William Michael Rossetti called him "the kindliest and most persistent of friends," and Ford Madox Brown used him as a model for the face of Christ in *Christ Washing Peter's Feet* (now in the National Gallery, London).

STREET, George Edmund (1824–1881) Architect dedicated to the Gothic Revival and to whom William Morris was briefly apprenticed in 1856.

SWINBURNE, Algernon Charles (1837–1909) Poet and friend of Burne-Jones and Rossetti, whom he met at Oxford when he was an undergraduate at Balliol and Rossetti was decorating the walls of the Debating Society Hall in the new Oxford Union. For a short, but disastrous, time he formed part of the household at Cheyne Walk, but had to be asked to leave "with all possible apology."

WALLIS, Henry (1830–1916) Painter on the fringe of the Pre-Raphaelites responsible for *The Stonebreaker* and *The Death of Chatterton*

(for which he used George Meredith as the model, only to elope with Meredith's wife two years later in an episode that curiously parallels the triangle of Millais and the Ruskins). Meredith charts the course of the affair in his sonnet sequence *Modern Love*.

WATTS-DUNTON, Theodore (1832–1914) Solicitor friend of Rossetti who acted for him, Ford Madox Brown, and Peter Marshall in their 1875 counterclaim against William Morris when he sought to restructure the Firm.

WEBB, Philip Speakman (1831–1915) Oxford-born architect who started out as an assistant to G. E. Street, in whose office he first met William Morris. Morris commissioned him to design and build Red House at Upton in Kent. He also designed much of the furniture for Morris & Co. and Standen near East Grinstead, which is now maintained, largely untouched and intact, by the National Trust. He was a cofounder, with Morris, of the Society for the Protection of Ancient Buildings.

WILDING, Alexa Former dressmaker turned model, who sat a good deal for Rossetti, both in London and at Kelmscott Manor.

WOOLNER, Thomas (1825–1892) Suffolk-born son of a letter sorter for the Royal Mail, he was a sculptor and founding member of the PRB, whose emigration to Australia in 1852, following the rejection of his designs for the Wordsworth Memorial, prompted Ford Madox Brown's painting *The Last of England*. He returned two years later and became an accomplished, if conventional, portrait sculptor and Royal Academician. He married William Holman Hunt's sister-in-law Alice Waugh in 1864 and built up so successful a practice that when he died his fortune was estimated at £64,000, including a fine house in London and an estate in the country.

ZAMBACO, Mary Born Mary Cassavetti in Athens in 1843, she was cousin of Aglaia Ionides and Marie Spartali, known collectively as the Three Graces, and inherited a fortune on her father's death when she was only seventeen. Strikingly lovely with glorious red hair and "almost phosphorescent white skin," she married Demetrius Zambaco, doctor to the Greek community in Paris, but the marriage failed and she returned to her mother's house in Kensington with her two children. A sculptress and medalist of considerable talent, she modeled for Burne-Jones, who fell tempestuously in love with her. Their affair threatened but did not destroy his marriage and he continued to paint her repeatedly in the late 1860s and 1870s.

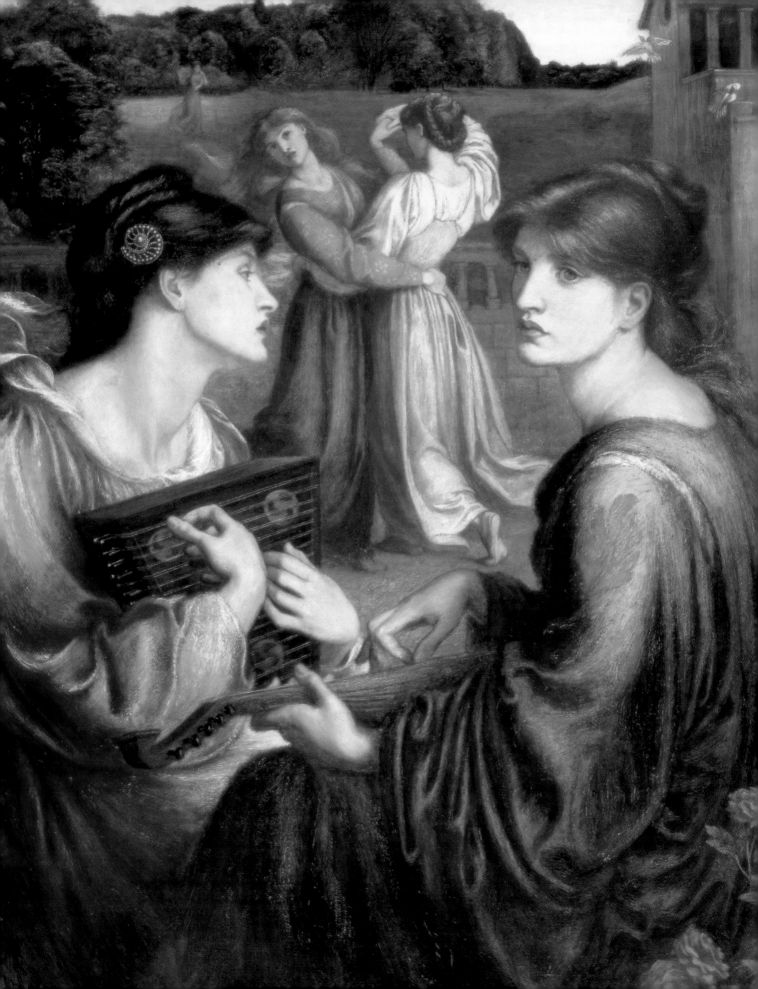

Chapter 1

THE PRE-RAPHAELITES *at* HOME

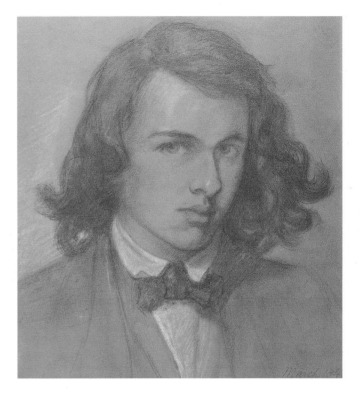

"A picture is a painted poem and those who deny it have simply no poetry in their nature."

DANTE GABRIEL ROSSETTI

MANY LEGENDS SURROUND the figure of Dante Gabriel Rossetti, who shimmers on the Pre-Raphaelite horizon, a romantic figure, amorous, intense, extravagant and reclusive, generous and difficult. He wrote voluptuous poetry and famously exhumed the body of his wife in order to retrieve the manuscript of his unpublished poems, which he then reworked and published along with a new sonnet sequence inspired by his latest love for the wife of one of his best friends. Born to an Italian father, he worshiped Dante but never visited Italy. He painted beautiful pictures of beautiful women for private patrons, mostly male members of an emerging class of *nouveaux riches* Northern textile merchants. These solitary and sensuous female figures, often in the soulful guise of doomed classical heroines, have become the prevailing icons of Pre-Raphaelite art. Friends—and he had many—spoke of the "glamour of his tongue" but others found him lazy, impatient, and mercurial. He started paintings but failed to finish them. He chafed against the drudgery of the exercises set by his teacher Ford Madox Brown and soon abandoned them, and he lacked the necessary concentration and staying power to continue working alongside his friend William Holman Hunt. And yet, by common consent, there was a quality of genius in his work and in his life.

His homes were extraordinary. He came from a family of intellectuals who lived first in Charlotte Street (now Hallam Street), London, before moving to Albany Street, a middle-class section of Regent's Park. Edward Lear, the naturalist Francis

ABOVE: *SELF PORTRAIT* by *Dante Gabriel Rossetti, aged nineteen.*

OPPOSITE: *THE BOWER MEADOW* by *Dante Gabriel Rossetti. Alexa Wilding and Marie Spartali posed for this musical composition, which sold to a dealer for £735.*

"We were all really like brothers, continually together and confiding to one another all experience bearing on questions of art and literature and many affecting us as individuals. We dropped using the term "Esquire" on letters and substituted "P.R.B." . . . There were monthly meetings, at the houses and studios of the various members in succession; occasionally a moonlight walk or a night on the Thames. Beyond this, very few days can have passed when two or more P.R.B.s did not gather together for one purpose or another . . . Those were the days of youth, and each man in the company, even if he did not project great things of his own, revelled in poetry or sunned himself in art."

(WILLIAM MICHAEL ROSSETTI, *SOME REMINISCENCES*)

ABOVE: *A CARICATURE OF CHRISTINA ROSSETTI by her brother Dante Gabriel Rossetti, showing her having a tantrum after reading a review of her poetry in* The Times.

Trevelyan Buckland, and Henry Mayhew, who co-founded *Punch* in 1841, were neighbors. His father, a professor of Italian and well-known commentator on Dante, attracted a circle of Italian scholars and allowed his four children, whom he nicknamed "the calms and the storms" to "rollick around the room." His brother William Michael (one of the "calms" along with his older sister Maria) wrote that "the household was of narrow means . . . I suppose the years were few in which Rossetti (senior) made more than an annual £300, and it must generally have been less." The family existed on "a careful, but not stingy economy" overseen by Mrs. Rossetti "an assiduous housewife from day to day and from year to year . . . infallibly upright, with no indebtedness." All the children were talented. The poetry of his younger sister, Christina, is now more widely read than his own, although Gabriel was the more acclaimed poet in their time. Maria wrote a book on Dante and later became a nun. His brother William Michael helped to bring the Pre-Raphaelite Brotherhood to prominence through his work as an art critic, and certainly shaped a view of the Pre-Raphaelites that endured long after the initial grouping of 1848 and the second formation of 1857, when a new, younger set of disciples clustered once again around the charismatic figure of his brother Gabriel.

Gabriel was twenty and at the center of a fiery group of young artists, outside the Victorian mainstream, when the semisecret Pre-Raphaelite Brotherhood was first formed in John Everett Millais's studio in Gower Street. At that time Gabriel was sharing a studio with William Holman Hunt in nearby Cleveland Street. This corner of London, just south of Fitzroy Square, has long been colonized by artists. In 1848 it was rapidly sliding down in the world. Rag-and-bottle shops, penny barbers, and pawnbrokers lined the street. Yet a studio represented a major achievement to the grimly determined Hunt, whose early artistic ambitions had been thwarted by poverty and opposition from his father, a warehouse manager in the City of London. Their situations were very different. Gabriel's father was indulgent and proud of his son's obvious talent, Hunt's scorned his efforts and had found him a position as a clerk at the age of twelve. According to Hunt's biographer, even as a child if he could

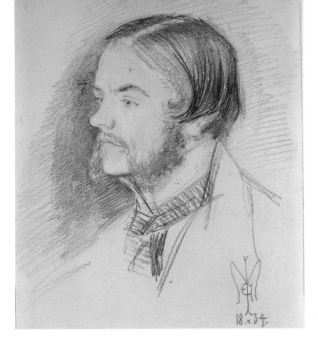

LEFT: **WILLIAM HOLMAN HUNT** *by John Everett Millais. Millais made this portrait of his friend just before Hunt left for the Holy Land.*

not get his hands on a brush he would make one out of a piece of firewood and hair cut from his own head. Denied an artistic training as a boy, he took himself off to the British Museum to study independently and eked out a meager living for himself by painting portraits. At twenty-one his first big picture, *The Eve of St Agnes*, sold for £70 and he used the money to rent the somewhat gaunt and depressing studio in Cleveland Street. The doorway was shabby and the staircase dimly lit and musty smelling. F. G. Stephens, one of the founding members of the Brotherhood, recalled how the fuss and clatter of a boys' school frequently rose up the fusty stairwell. In these unpromising surroundings Rossetti painted his first "Pre-Raphaelite" pictures, signing them only with the initials PRB as had been agreed.

Like all the best secret societies, its members totaled seven, a number with magical associations. The three core founder members were Gabriel, Hunt, and the precociously brilliant John Everett Millais, whose doting parents had brought their gifted son to London in 1838 from their home in the Channel Islands at the tender age of nine. Once installed in Adam Street, midway between the British Museum and the Royal Academy, which was then housed in a Trafalgar Square yet to boast Nelson's Column, erected five years later in 1843, Mrs. Millais wasted no time in making an appointment to see Sir Martin Archer Shee, president of the Royal Academy. Indeed, she presented her letter of introduction from Millais's painting master, Mr Bissel, the very next morning. Shee is famously supposed to have told Mrs. Millais that her blue-eyed, curly-haired son would be "better employed sweeping chimneys" (the unhappy fate of many nine-year-old boys in London at the time), but changed his mind after looking through the boy's portfolio and watching in amazement as he copied a nearby statue.[1] Millais was in. He became the youngest probationary student at the Royal Academy, won a silver medal for drawing before he was twelve, was named an Associate in 1853, and became a Royal Academician ten years later, eventually becoming president of the Royal Academy and a baronet. But in 1848 he was more rebel than academician. Startlingly attractive—William Michael Rossetti described him as "a beautiful youth . . . with a face nearer to being

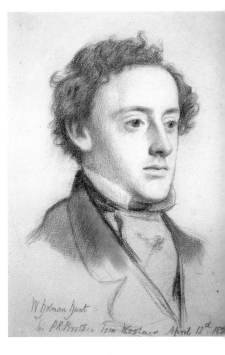

ABOVE: **PORTRAIT OF JOHN EVERETT MILLAIS** *by William Holman Hunt. This is one of the portraits the PRB made of each other on 12 April 1853 to send to Thomas Woolner in Australia. Photographs prove that it was a particularly good likeness of Millais.*

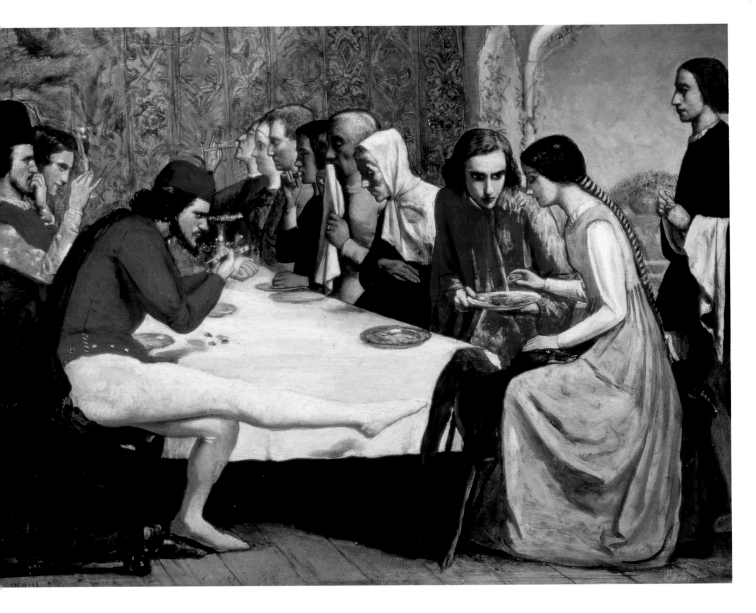

angelic than any other male visage I have seen"— he was just nineteen when he painted *Lorenzo and Isabella*, which was hung in the Royal Academy in May 1849 along with Hunt's *Rienzi*, both bearing the initials PRB.[2] Hunt called it the most wonderful painting that any youth under twenty years of age ever painted; it sold to three Bond Street tailors for £150 and a suit of clothes.

Gabriel's brother William Michael was the fourth member. Another invited to join was James Collinson, a somewhat dumpy young man from Nottingham, who was unhappily in love with Gabriel's sister Christina. He painted three significant Pre-Raphaelite paintings before succumbing to a melancholy obsession with religion that led to him resigning from the Brotherhood and entering a seminary. Thomas Woolner, the son of a Suffolk letter sorter for the Royal Mail, was primarily a sculptor whose (temporary) emigration to Australia in 1852 prompted Madox Brown's evocative painting *The Last of England*. He remained a member of the

ABOVE: ***LORENZO AND ISABELLA*** *by John Everett Millais. In this painting, inspired by Keats's poem of the same name, William Michael Rossetti posed as the doomed Lorenzo sharing a prophetic blood orange with the demure Isabella (Millais's sister-in-law, Mary Hodgkinson) while the scheming brothers (Fred Stephens in the black hat with Walter Deverell to his left) look grimly on.*

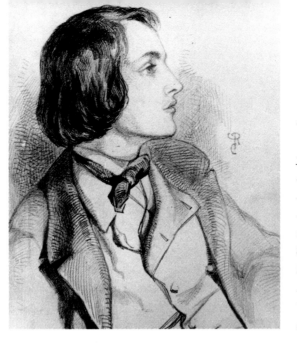

LEFT: A flattering pencil portrait of William Michael Rossetti when young by his brother Dante Gabriel Rossetti. The only non-artist in the PRB, William's salary from the Inland Revenue together with the £50 a year he was paid by The Spectator *as their art critic made him "almost a capitalist" among the PRBs. "Millais alone," he wrote, "made more than I did, most of the others much less or hardly anything."*

Brotherhood and on his return to England two years later established himself as an accomplished, if somewhat conventional, portrait sculptor, eventually being made a Royal Academician and leaving a fortune of £64,000. Finally there was F. G. Stephens, who quickly recognized that he was out of his league and gave up painting altogether in 1850 in favor of writing. Known as Fred, he had grown up in a busy street in Lambeth and his father was, according to William, some kind of official in the Tower of London. Cherished as "the kindliest and most persistent of friends," he married a young wife, Clara, who was barely literate, and went on to become a highly respected art critic on *The Athenaeum* as well as one of the chief chroniclers of the movement.

BELOW: TOUCHING UP MORNING AT THE ROYAL ACADEMY 1851 by John Everett Millais. Dante Gabriel Rossetti is shown on the right in earnest conversation with Ford Madox Brown.

The Brotherhood's aims, as defined by William Michael, were to have genuine ideas to express; to study nature attentively, so as to know how to express them; to sympathize with what is direct and serious and heartfelt in previous art, to the exclusion of what is conventional and self-parading and learned by rote; and most indispensable of all, to produce thoroughly good pictures and statues. The name Pre-Raphaelite was chosen to convey their admiration for the early Italian painters of the period before Raphael. The honesty and simplicity of these Christian artists was what they wanted to emulate in their own art. Using pure colors over a white ground, they sought to paint noble and uplifting works that "turned the minds of men to good reflections." They subscribed fervently to the Ruskinian ethos that a good picture was one that conveyed a large number of ideas; theirs was a didactic moralistic art. The Pre-Raphaelites were conscious of the social evils of their age and painted several pictures on controversial subjects, particularly the position of women in Victorian society. It was also highly romantic art, many of their paintings dealing with romantic or tragic love or inspired by romantic poetry and medieval and literary themes. And it was deliberately revolutionary, for the Brotherhood rejected the prevailing artistic establishment with its conventional techniques and orthodoxies upheld by the Royal Academy. Paradoxically both modern and medieval, romantic yet seeking

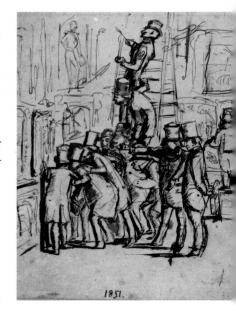

DANTE GABRIEL ROSSETTI TO THE PRB, 25 OCTOBER 1849,

FROM BRUGES WHERE HE WAS TRAVELLING WITH WILLIAM HOLMAN HUNT

"We have bought an extraordinary self-concocting coffee-pot for state-occasions of the P.R.B. . . ."

(*LETTERS OF DANTE GABRIEL ROSSETTI*)

scientific realism, the movement had an explosive impact on English nineteenth-century art and its influence endures still.

The collective personality that the group developed was very much an extension of Rossetti's: boisterous yet touchingly romantic, fun-loving yet deeply idealistic. There were monthly meetings at the houses and studios of the seven members in succession, when the intense conversations on art and literature would carry on out into the street as the friends walked home together. Occasionally they would go out rowing on the Thames at night. Hardly a day passed when two or more did not gather together: "for every P.R.B. to drink a cup of tea or coffee, or a glass or two of beer in the company of other P.R.B.s . . . was a heart relished luxury" according to William Michael. They began using the initials PRB on their letters in place of Esquire. Hunt introduced the group to Keats and Tennyson, whose works he was said to know by heart. Legends of this kind relating to Hunt's formidable powers of concentration or retention abound. His eyesight, for example, was said to be so accurately penetrating that he could see the moons of Jupiter with his naked eye and he sat up all night to finish Ruskin's *Modern Painters* in one avid reading. We tend to remember him now as a rather forbidding full-bearded figure but for Gabriel, in those early years, he was "jollier than ever with a laugh which answers one's own like a grotto full of echoes." William Michael recorded: "We thoroughly admired him for his powers in art, his strenuous efforts, his vigorous personality, his gifts of mind and character, his warm and helpful friendship . . . In conversation he was sagacious, anecdotal, and, within certain limits, well informed, with a full gusto for the humorous side of things."[3]

He was, however, too driven, too demanding for the feckless Gabriel, who, in December 1850, moved across to Red Lion Square to work in a shared studio with another young friend and fellow student at the Royal Academy, Walter Deverell, who rented rooms on the first floor of No. 17 for £1 a week. (These were the very same rooms that Edward Burne-Jones and William Morris would occupy six years later.) William Michael Rossetti, who had been charged with keeping a journal of

the Pre-Raphaelite Brotherhood, recorded on 7 December 1850 the landlord's stipulation "that the models are to be kept under some gentlemanly restraint, as some artists sacrifice the dignity of art to the baseness of passion."[4] No doubt the handsome Walter and his friends appeared impossibly bohemian to the landlord. Their late hours, unrestrained friendliness, occasional naivete, sexual tolerance, and sheer pleasure in each other's company can hardly have made them ideal tenants.

Female beauty was central to their art, friendship to their lives. One of the first tests of their friendship came in the spring of 1850 when Walter, shopping with his mother, spotted a red-haired young woman working in the back room of a milliner's shop in Cranbourne Alley just off Leicester Square. Walter was looking for a model to pose as Viola, dressed as Cesario, the page, in his large and ambitious depiction of Act II, Scene IV of Shakespeare's *Twelfth Night*. According to Hunt, Walter raced round to his Chelsea studio, bursting with a breathless description of Elizabeth

BELOW: TWELFTH NIGHT, ACT II, SCENE IV by Walter Howell Deverell. Here Lizzie Siddal (on the left) as Viola, dressed as Cesario the page, gazes up in rapt attention at Orsino (Deverell), while Rossetti dressed as Feste the fool sings "Come away, come away, death." Walter called Lizzie "a miraculous creature."

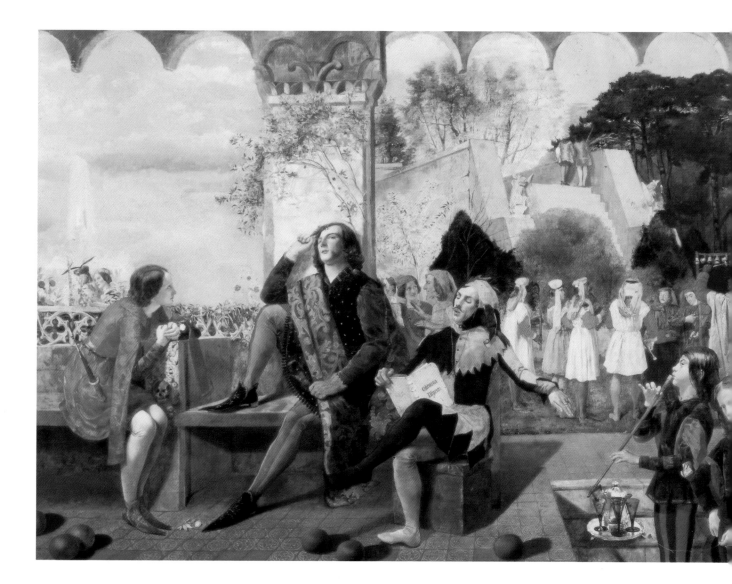

Eleanor Siddal. She was, he told Hunt and Gabriel, "like a queen, magnificently tall, with a lovely figure, a stately neck, and a face of the most delicate and finished modeling." But her most striking feature was her hair "like dazzling copper," which "shimmers with lustre as she waves it down."[5]

Since Miss Siddal, although clearly from the lower classes, was a demure and modest young woman, Walter's mother was charged with the delicate business of securing her consent to model. In the painting Lizzie is dressed as a boy and gazes up attentively at the dashing but distracted Count Orsino (Walter) while Feste the fool (Rossetti) in a jester cap and bells declaims from an open book. A not unconvincing case has been made that Lizzie was drawn first to the undeniably attractive Walter—said to be so good looking that young women, passing by, would hurriedly dash down side streets in order to come upon him a second time—and that her attachment to Gabriel came later.[6] What we do know is that she was soon drawn into the circle of young painters and sat for Hunt (*Valentine Rescuing Sylvia*) as well as Millais, for whom she posed as Ophelia in an "old and dirty" antique dress, "all flowered over in silvery embroidery," lying in a tin bath full of water heated by a system of oil lamps burning underneath. Unfortunately the lamps burnt out and Lizzie lay on, uncomplaining in the freezing water, while Millais completed his picture. The resulting cold put her out of commission and her father wrote threatening to sue Millais if he did not pay for the doctor's bills, which, eventually, he did.

The Pre-Raphaelite painters adored her and called her "the Sid." But Gabriel became increasingly possessive about her and his move in May 1851 away from Walter's Red Lion Square studio to share one with Madox Brown is interpreted by one commentator as a strategy to remove Lizzie "from the constant company of one of the most remarkably handsome young men in London."[7] According to an account by his niece, Helen Rossetti Angeli, Lizzie and Gabriel were, by the beginning of 1852 an affianced couple, although it is unlikely that Rossetti's mother regarded them as such since she had never been introduced to Miss Siddal—indeed, she did not even know that Lizzie existed. When her son moved out of the family home in November 1852 to rooms near Blackfriars Bridge at Chatham Place, she had no idea that he was often to be found there in the unchaperoned company of a lovely young woman with large greenish-blue eyes in a pale face framed with a mass of coppery-golden hair. Neither is there any record of Gabriel meeting Lizzie's parents at her home, above her father's ironmongery, just off the Old Kent Road.

Gabriel threw a party in Chatham Place the week after he moved in but after that visitors were few, and they were discouraged. William was supposed to be his co-tenant but Gabriel made it plain that he was *de trop*, writing: "I have Lizzie coming, and do not of course wish for anyone else."[8] He retreated with Lizzie into a private world where they could be together and work together, for Gabriel had begun to encourage Lizzie's natural talent for drawing and to stimulate her enthusiasm for writing poetry.

Without Gabriel the Brotherhood fragmented. Millais's career had been given a considerable boost by the influential critic John Ruskin, who had invited the young

*OPPOSITE: **THE LAST OF ENGLAND** by Ford Madox Brown. This painting was inspired by Woolner's emigration to Australia and is something of a family affair, for Ford painted himself as the careworn man and Emma Matilda Hill, whom he married in conditions of some secrecy during the painting of the picture, as the woman clutching her child's tiny hand. Their daughter, Catherine, appears to the left of the picture eating an apple.*

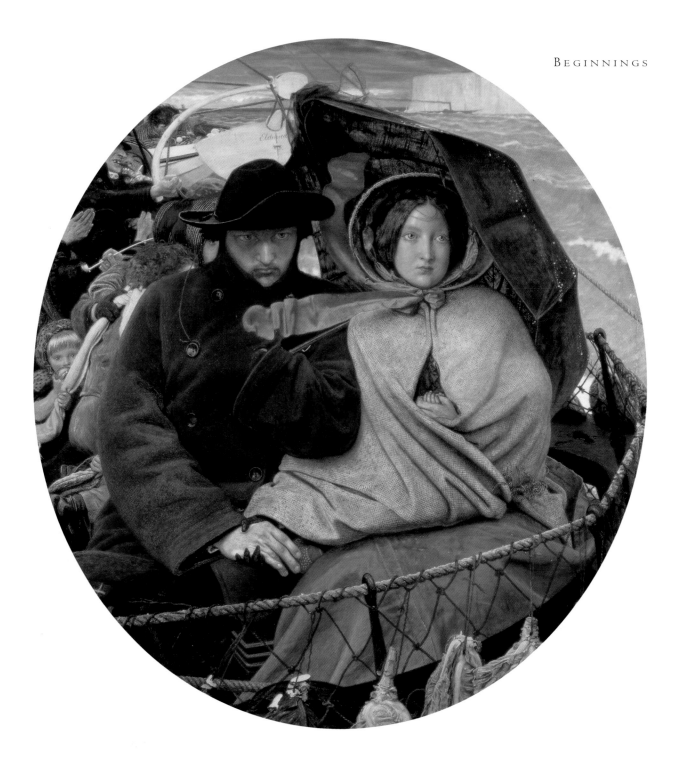

painter to accompany him and his effervescent wife on a trip to Scotland. Thomas Woolner was off to Australia and William Holman Hunt was preparing for his first visit to the Holy Land. Millais accompanied Hunt to the station and pressed a signet ring on him, a token of their friendship that Hunt wore to the end of his life. Their parting was emotional and recorded later by Hunt: "What a leave taking it was with him in my heart when the train started! Did other men have such a sacred friendship as that we have formed?"

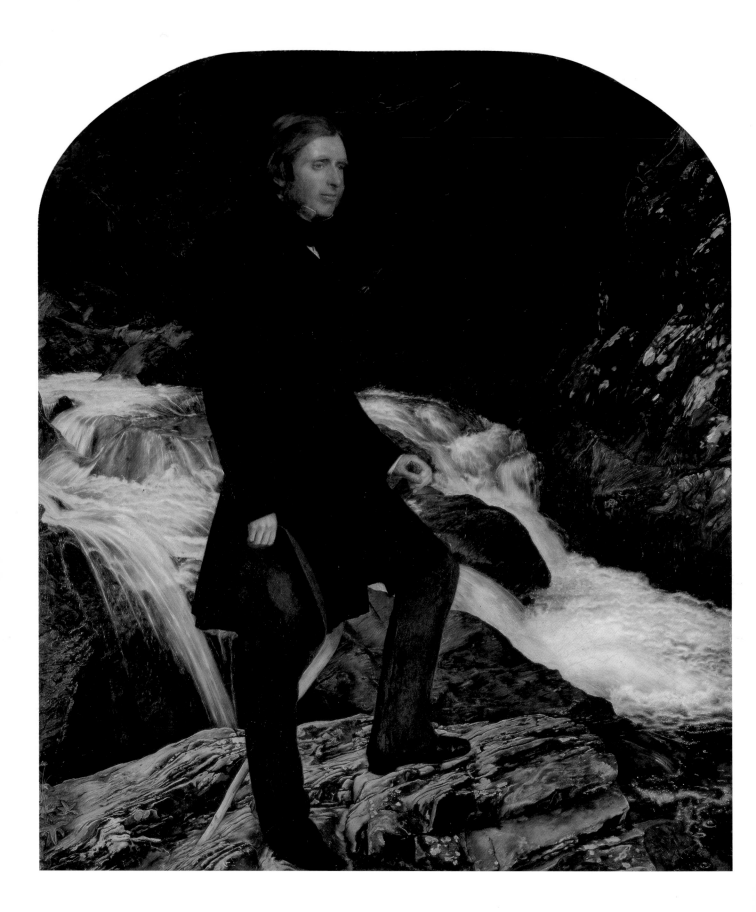

Chapter 2

MILLAIS *and the* RUSKIN CIRCLE

"We all sat down to a capital dinner, the damask cloth, silver, wine, and fruit reminding me of Boccaccio . . . I must confess that I drank pretty freely from the goblet."

JOHN EVERETT MILLAIS TO WILLIAM MICHAEL ROSSETTI
AFTER WATCHING ETON PLAY HARROW AT LORD'S CRICKET GROUND

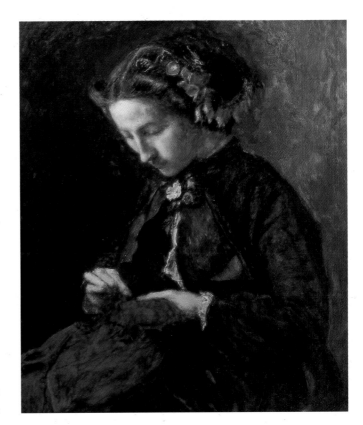

HE TRIANGLE FORMED by John Everett Millais, John Ruskin, and his young wife Effie is one of the geometrical givens of the Pre-Raphaelite movement. Everyone knows, or thinks they know, the story of how Ruskin was so repulsed on first seeing his bride naked and discovering that she had, unlike the smooth classical sculptures he so admired, pubic hair, that the marriage was never consummated.[1] Just as everyone knows, or thinks they know, that Lizzie Siddal's "delicate" state was exacerbated by the chill she caught while posing for Millais as Ophelia in a "dirty antique dress" in a tin bath of tepid water.

The truth was that theirs was a disastrous marriage. Euphemia Chalmers Gray was pert and pretty, used to being at the center of a bright social world. In her teens she had attracted a number of offers of marriage, and she is reported to have had to break an engagement in order to marry Ruskin. He, meanwhile, nine years her senior, the only child of doting parents, was learned and lofty, immersed in his work, convinced of its seriousness and importance. John Ruskin considered most social activities time-consuming and tedious; Effie was incandescent in company.

Despite their calamitous wedding night, Effie, who had been told little or nothing of what to expect by her mother, wrote cheerful letters home during the first month of her marriage insisting: "I am happier every day with John. He is the kindest creature in the world and is so pleased with me . . . We are always so happy to do what the other wants that I do not think we shall ever quarrel." But by 1850 her tone

ABOVE: ***EFFIE GRAY: THE FOXGLOVE*** *by John Everett Millais. A portrait of Effie with foxgloves in her hair painted at Glenfinlas in 1853.*

OPPOSITE: ***JOHN RUSKIN*** *by John Everett Millais. Millais and the Ruskins holidayed in the Highlands of Scotland for almost four months in 1853 during which time Millais embarked on this portrait of his great champion. On 28 July Ruskin wrote to tell his father that "my portrait is verily begun to day and a most exquisite piece of leafage done already, close to the head." The work was slow and, as Millais and Effie's feelings for each other deepened, increasingly difficult to finish.*

JOHN EVERETT MILLAIS TO MRS. THOMAS COMBE, 6 MARCH 1852

"Today I have purchased a really splendid lady's dress—flowered over in silver embroidery—and I am going to paint it for "Ophelia." You may imagine how good it is when I tell you it cost, old and dirty as it is, four pounds."

(*THE LIFE AND LETTERS OF SIR JOHN EVERETT MILLAIS*)

ABOVE: *John and Effie Ruskin imaginatively portrayed by John Everett Millais, who poses Ruskin, forever the scholar, pointing out the sights of Venice to his young wife.*

had turned to complaint. "Mr. Ruskin is busy all day till dinner time, and I never see him except at dinner," Effie wrote from Venice to Lady Trevelyan. "He sketches and writes notes on the subject at hand . . . I cannot help teasing him about his sixty doors and hundreds of windows, staircases, balconies, and other details he is occupied with every day." That something was missing from their marriage she certainly knew for, over the years, she and Ruskin discussed the possibility of children, and he promised to "make her his wife" when she was twenty-five.

She was a virginal twenty-three and had been married for just over three years when, on the afternoon of 30 May 1851, she first called at 83 Gower Street, the home of John Everett Millais. She was accompanying her influential husband who, in that morning's *Times*, had publicly come out in support of the Pre-Raphaelite Brotherhood. Ruskin's remarks turned the tide of hostile opinion, opened the way for success, and laid the foundations for a burgeoning friendship. Millais, at twenty-two, a full ten years younger than Ruskin, was an attractive man whose appearance made an immediate impression. Henrietta Ward described him in her *Reminiscences* as having a "magnificently shaped head, faultless classic features, a superbly elegant figure, tall and slim . . . one of the handsomest men I have ever seen. In conversation he was charming, not the least affected . . . so frank, boyish, and breezy that he completely captivated the hearts of the fair sex."

Over the next few weeks the Ruskins took him up, inviting him to their elegant Park Street home and to accompany them to Switzerland, an offer he declined as he had already made plans to spend the summer painting with William Holman Hunt.

Ruskin's continuing championing of the Pre-Raphaelites ensured that when Millais's painting of Lizzie as Ophelia was exhibited in the Royal Academy's West Room the following year it caused a logjam. According to Fred Stephens: "Crowds stood all day. People lingered for hours, went away, and returned again and again." Gabriel wrote to Woolner in Australia to report Millais "conquering" not just artistic but social circles. Had he not been invited to meet their great hero Tennyson at the Coventry Patmores?

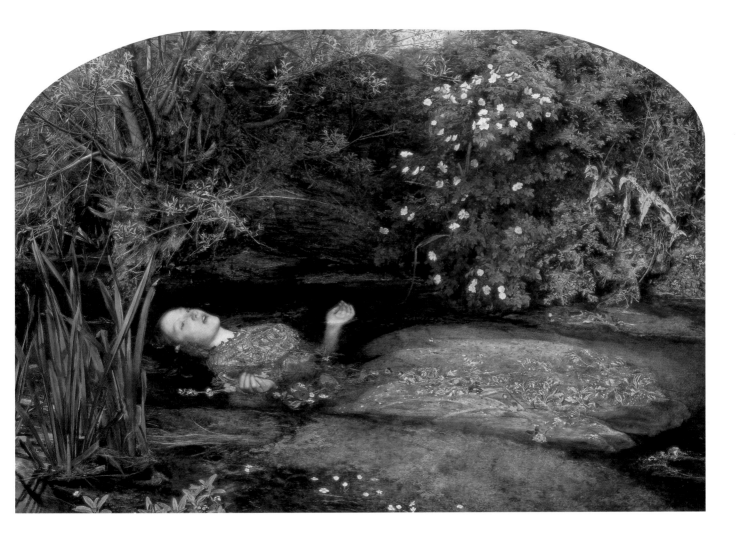

Millais was going up in the world, but Effie was beginning to feel increasingly sidelined after her move to south London. Her married life had begun in a substantial house in Mayfair, which Ruskin's indulgent father had leased for the couple. No. 31 Park Street had come with aristocratic neighbors and a smart brougham to convey Effie to glittering social events. Ten glorious months had been spent in an airy apartment on the Grand Canal in Venice, where Ruskin had been gathering material for the second and third volumes of *The Stones of Venice*.[2] But the Mayfair house was expensive and all three servants had to be paid while John and Effie were abroad. The elder Ruskins, who had often grumbled about what they perceived as Effie's extravagance, decided that they wanted their beloved son closer to their own comfortable Georgian house, which stood in seven acres of orchard and garden on the crest of an outcrop of the Surrey Downs at 163 Denmark Hill, overlooking both Dulwich and Camberwell. So, in July 1852, John and Effie moved to "a small ugly brick house partly furnished in the worst possible taste and with the most glaring vulgarity" at 30 Herne Hill.[3] Effie set about improving the place, which she described as "inconceivably cockney."[4] But the contrast between their apartment on the Grand Canal and her new home, strewn with builders' rubble, in suburban

*ABOVE: **OPHELIA** by John Everett Millais. True to Pre-Raphaelite precepts Millais painted the background to this famous picture by the river near Ewell in Surrey through the summer of 1851. Lizzie Siddal posed for the figure in Millais's Gower Street studio in a bath of water, which was supposed to be kept warm.*

JOHN EVERETT MILLAIS TO WILLIAM HOLMAN HUNT, JUNE 1853

"Mrs. Ruskin is the sweetest creature that ever lived . . . the most pleasant companion that one could wish."

(*THE LIFE AND LETTERS OF SIR JOHN EVERETT MILLAIS*)

south London was soon insupportable. In Venice she had enjoyed a great deal of personal freedom, but now, without a carriage, she was restricted to making once-weekly trips into town in her mother-in-law's, and, while the house was being restored, to dining with her in-laws in Denmark Hill at the unfashionably early hour of 4:30 P.M.

One consolation was provided by Millais, who invited her to model for his new painting, *The Order of Release*. "He says nobody has painted me at all yet, that the others have cheated themselves into making me look pensive in order to escape the difficulties of colour and expression," she wrote in one of her regular Sunday letters to her mother.[5]

Conscientiously adhering to Pre-Raphaelite principles, Millais went daily to the Tower of London to paint a real prison gateway, although Effie sat for him at home in Herne Hill. "I have been sitting to Millais from immediately after breakfast to dinner, then through all the afternoon till dark, which gave me not a moment to myself," Effie wrote to her mother on 20 March 1853, adding, "I am rather tired and have a stiff neck, but I was anxious to be as much help as possible as the whole importance of the picture is in the success of this head . . . He found my head immensely difficult, and he was greatly delighted last night when he said he had quite got it."[6]

The exhibition opened on 2 May and the following day Effie was writing excitedly to her mother: "Millais' picture is talked of in a way to make every other Academician frantic. It is hardly possible to approach it for the rows of bonnets." The sensation caused by *The Order of Release*, which soon had to have a protective railing placed in front of it, eclipsed the storm *Ophelia* had provoked the year before and catapulted Millais to new heights. Ruskin, who considered the young painter his protégé, shared the glory. In the summer of 1853 he proposed that John Everett join him and Effie on holiday in the Highlands. Millais accepted with pleasure and began work on an ambitious portrait of his friend and great champion perched on a boulder by the river at Glenfinlas against Ruskin's favorite background of rock and leaf and moss. Ruskin wrote to his father: "Millais has fixed on a place, a lovely piece of worn

OPPOSITE: ***THE ORDER OF RELEASE*** *by John Everett Millais. Effie modeled for the loyal Highland wife whose efforts have secured the release of her rebel Jacobite husband, captured after the battle of Culloden. Later her own desire for "release" from her marriage to John Ruskin would be the subject of much scandalous talk.*

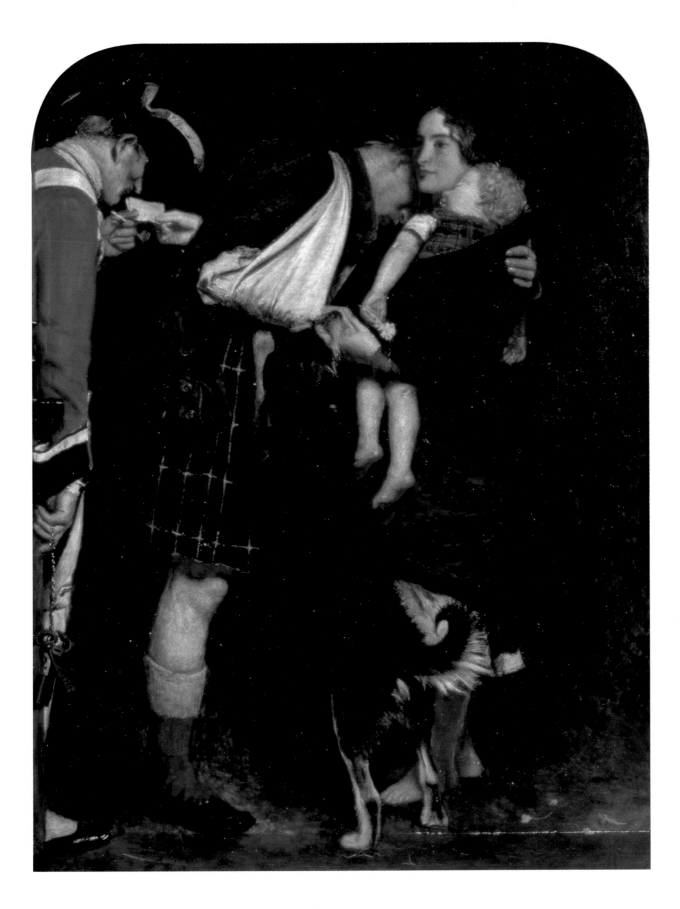

rock, with foaming water and weeds and moss, and a whole overhanging bank of dark crag . . . I am sure the foam of the torrent will be something quite new in art."[7]

After a few weeks in an hotel, the small party moved into a one-story, whitewashed, mossy stone cottage at the foot of Ben Ledi. "Our new residence," Millais wrote, "is the funniest place you ever saw. My bedroom is not much larger than a snuff box. I can open the window, shut the door, and shave without getting out of bed."[8]

To his mother he reported that it was "delightful" to wake in the morning in his "little emigrant crib, Ruskin, his lady and me all talking whilst dressing." In truth, however, he was beginning to find the proximity to Effie disturbing. Ruskin was completely taken up with the index for *The Stones of Venice* so Effie and Millais were thrown together, taking walks or playing battledore and shuttlecock (the forerunner of badminton) either outside or in a barn when bad weather showed no sign of improving. His growing attachment to Effie reveals itself in the many tender sketches he made of her in Scotland and in his letters. To Hunt he wrote: "[she] is the most delightful, unselfish, kind hearted creature I ever knew, a woman whose acquaintance is a blessing."

*BELOW: **THE WATERFALL** by John Everett Millais. Millais wrote to Mrs. Combe, 10 July 1854, "Every day that is fine we go to paint at a rocky waterfall and take our dinner with us. Mrs. Ruskin brings her work and her husband draws with us, nothing could be more delightful. . . ."*

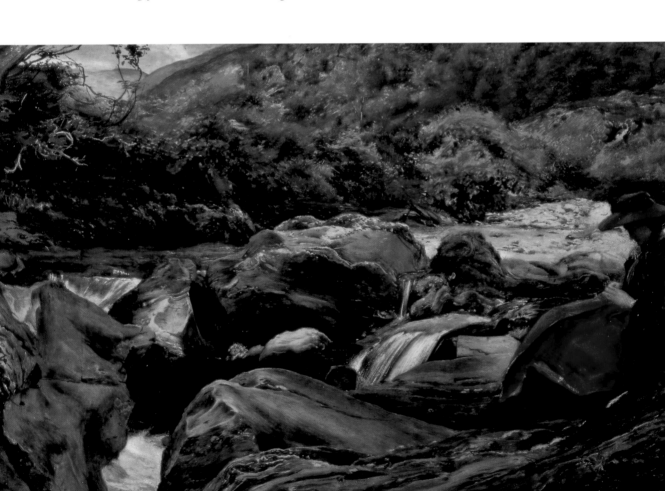

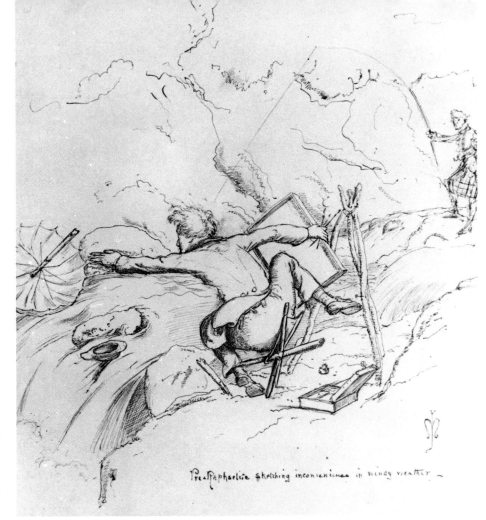

RIGHT AND BELOW: Two humorous sketches by Millais, entitled "PRE-RAPHAELITE SKETCHING INCONVENIENCES IN WINDY WEATHER" and "AWFUL PROTECTION AGAINST MIDGES," which amply demonstrate the local difficulties.

Effie, who liked the idea of looking after her creative household, packed hampers with "sherry and tea and sugar" to fortify the painting party against the "Scotch mist" and arranged for a greengrocer at Stirling to send more exotic foodstuffs, "for there seems no certainty of anything to eat but trout out of the Tummel."[9] They often ate out of doors and John Everett describes a dinner of "roast lamb and peas, afterwards blackcurrant pudding, cream and champagne" taken on the rocks, "each of us resting our plates uncomfortably on our knees seated on pitiless summits of small Mont Blancs."[10] To his old friend and patron Mrs. Combe he confessed the only drawback "to this almost perfect happiness" was attack by midges. "They bite so dreadfully that it is beyond human endurance to sit quiet."[11]

As the intimacy between Effie and Millais grew, she confided the truth of her unconsummated marriage on one of their evening walks. This startling revelation threw Millais into confusion, fuelled his mounting passion for Effie, and turned him against her husband. He began to give her drawing lessons and told Hunt, "I am certain she has learnt in the month I have taught her more than I did in six years." Ruskin did not see it quite like that. He wrote to Lady Trevelyan: "My saucy little wife has taken it into her head to try and paint in oil, just like a monkey, after seeing Everett do it—but the jest is she did it, and has painted some flowers and leaves nearly as well as I could do them."

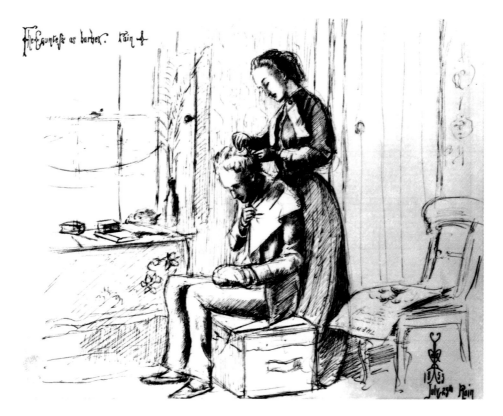

The Countess as barber. Rain

1853 July 29th Rain

ABOVE: Millais's tender sketch captioned "THE COUNTESS AS BARBER" shows the growing intimacy between the young couple.

After almost four months in Scotland, Effie and Ruskin left Brig o'Turk on 26 October 1853. When Millais returned to London he discovered that he had been elected an Associate of the Royal Academy at the unprecedentedly early age of twenty-four.

The unravelling Ruskin marriage now began to deteriorate seriously. Millais could not see Effie without compromising her, so for news of her he relied upon her ten-year-old sister, Sophie, who accompanied Ruskin on his regular visits to the Gower Street studio, where Millais was struggling to finish the portrait he had begun in Scotland that now thoroughly depressed him. The atmosphere between the two men was strained and tense. In December John Everett felt moved to write an extraordinary letter to Effie's mother, whom he had met only once before, warning her that "one is never safe against such a brooding selfish lot as those Ruskins." He emphasized "*the wretchedness* of her position" and complained of Ruskin's "delight in selfish solitude," which meant that his wife was often "left to herself in the company of any stranger present . . . Why he ever had the audacity of marrying with no better intentions is a mystery to me."[12]

Neither Effie's mother nor Mrs. Ruskin (who longed for a grandchild) seems to have known that the marriage had not been consummated although both were about to be let in on the secret. Effie's admission to her parents set in motion a sequence of events that led her father to consult lawyers and steamship and train timetables. Her escape was carefully planned. On the morning of 25 April 1854 her unwitting

JOHN EVERETT MILLAIS TO EFFIE RUSKIN, 26 JULY 1854

"What a good brave girl you have been to get your freedom. I used to be terribly distressed in thinking on the advice I had given you, for there was such frightful responsibility attached to your position."

(*MILLAIS AND THE RUSKINS*)

husband put her on a train at King's Cross station in London, believing his wife to be making a brief trip to Perth, Scotland, to visit her parents. Effie, however, disembarked at Hitchin, the next station, where she was joined by her mother and father. Acting upon legal advice, they forwarded, through a lawyer, a parcel directed to Mrs. Ruskin containing Effie's accounts, wedding ring, the household keys, and a letter in which Effie, explaining everything, wrote, "The Law will let you know what I have demanded, and I put it to you and Mr. Ruskin to consider what a very great temporal loss, in every point of view, your son's conduct has entailed upon me for these best six years of my life."[13] The marriage was over.

Ruskin told his solicitor during the uncontested divorce that "I married in order to have a companion—not for passion's sake; and I was particularly anxious that my wife should be able to climb Swiss hills."[14] On 15 July Effie received her decree. It stated that the marriage was annulled because "the said John Ruskin was incapable of consummating the same by reason of incurable impotency."[15]

Undeniably there was a scandal. "That Ruskin row seems to have grown into a roar," Gabriel wrote to Madox Brown. "Mrs. R will get a divorce it seems—he her husband is—or *is not*—I know not what . . . It seems Mrs. R's seven years of marriage have been passed like Rachel's seven marriageable years—in hope."[16]

Millais, who had neither seen nor corresponded with Effie during this trying time, now wrote to his "dear Countess" from The Peacock Inn in Derbyshire, where he was painting, to let her know that "I was surprised to find your Mother's letter upon the breakfast table, for I knew at once the news it contained. The best news I have ever received in my life . . . This time last year there seemed no more chance of what has happened than that the moon should fall, and now you are Miss Gray again . . . I feel half frightened at the thought of meeting you again."[17]

Much has been made of the Ruskin-Effie-Millais triangle. Just as society took sides at the time of the scandal, so have biographers. Some view Effie as a flirty miss who set out to destroy a great man, while others see a much-misunderstood woman compelled by love to risk social ostracism when she baled out of a deeply

dissatisfying marriage and entered into a new one with another genius. For, before a year was out, Effie and Millais were married.

During his honeymoon in Scotland Millais wrote ecstatically to Mrs. Collins (the mother of his friend Charles Collins): "The Countess [the nickname Effie had acquired in the Highland Trossochs] sings every morning and is very cheerful. We are the happiest couple in the world. I was wise . . . to venture. All my friends should follow my example. It doesn't matter now what people may think about the propriety of our marriage. If they knew what a blessed change has come upon two bodies in this world, they would hold their tongues . . . Effie looks well again and is a strong woman. I am so proud of such a wife."[18]

They started their married life in Scotland at Annat Lodge, "such a *sweet place*, truly comfortable, and pretty," where their first child, a boy, was born the following year on 30 May.[19] A deliriously happy Millais dashed off a hasty note to Hunt to let him know "that another PRB has just come into the world."[20] It is hard not to reflect on the extraordinary contrast between Effie's two marriages: the first to a man said to be

*BELOW: **THE SEAMSTRESS*** *by John Everett Millais. The mood of intense serenity and tidy domesticity evoked by this painting matches Millais's own at this time.*

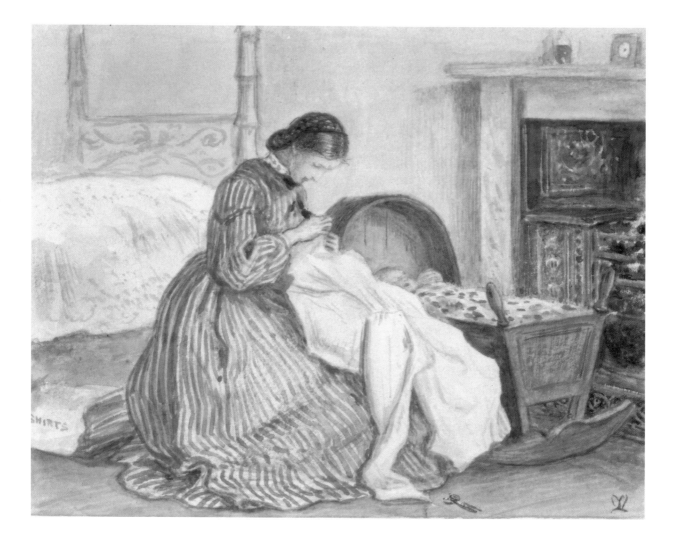

JOHN EVERETT MILLAIS TO WILLIAM HOLMAN HUNT, JUNE 1855

"Next month please God I shall be a married man. What think you of that? . . . Good gracious! fancy me married, my old boy . . . All London knows of my marriage and comments upon it, as the best thing I could do, the noblest, the vilest, the most impudent, etc. etc."

(THE LIFE AND LETTERS OF SIR JOHN EVERETT MILLAIS)

impotent, the second to one so amazingly fertile that she had nine confinements and eight live births in thirteen years. After this feat, in a rather extreme attempt at contraceptive control and, perhaps, because she very much minded the social ostracism occasioned by her divorce (an exemption from society that did not, however, extend to her husband, who was fêted in the best circles) she spent long intervals with her parents in Scotland. It is intriguing to note that as Effie's actual person was banished from society circles, her image insisted on its annual presence in Millais's Royal Academy submissions.

With a wife, four sons and four daughters to support, Millais stepped up production and it is popularly thought that the high standard of his work declined after his marriage to Effie. He moved away from his careful Pre-Raphaelite style to portraiture and "sentimental images" like that of *My First Sermon* and *Bubbles*, which commanded excellent prices. While Gabriel was still muddling along in relative penury, Millais and Effie were learning how to live in high style.

BELOW: EVER AND EFFIE REX by John Everett Millais. Effie's mother Sophia Gray pasted this charming sketch of her daughter and her second husband into her scrapbook.

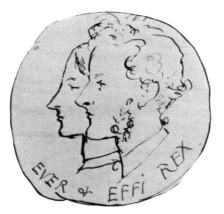

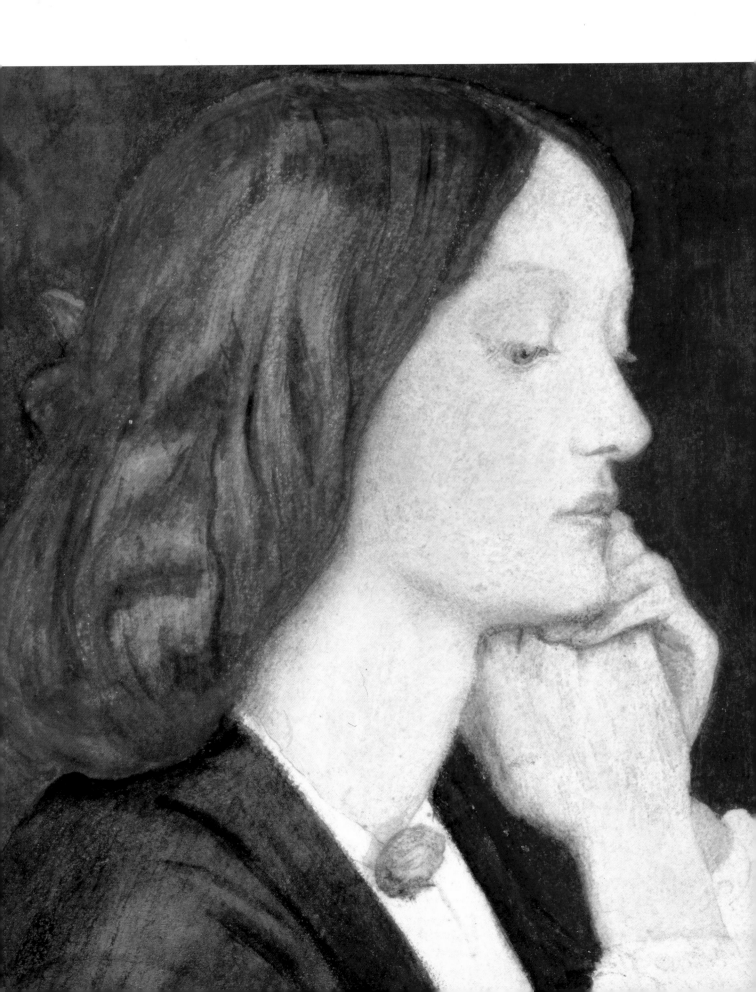

Chapter 3

The DREAM UNFOLDS

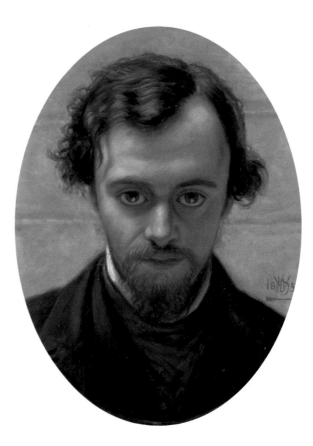

"My dear Brown,
What has become of you? . . . Lizzy and I would
be very glad if you could both fix an evening to
come here—*only* I fear a bed upstairs would not
be possible, as those rooms are taken.

Lizzy has been very unwell lately. I have
introduced her to the Howitts, and we have spent
several evenings there. They are quite fond of her,
and most delighted with her productions. I have
also brought her and my sister Christina together,
as our family are now in London again."

DANTE GABRIEL ROSSETTI TO FORD MADOX BROWN,
CHATHAM PLACE, LONDON, 30 MARCH 1854

ABOVE: **PORTRAIT OF DANTE
GABRIEL ROSSETTI** *by William
Holman Hunt. This stunning
portrait was one of those sent
to Thomas Woolner by his PRB
brothers after his emigration
to Australia in 1853.*

F LEGEND SURROUNDS Gabriel, then Lizzie's life is the stuff
of fairytale. One told by the Brothers Grimm perhaps. She was
born in 1829, the third of seven children, to Elizabeth Eleanor
Evans, of petit-bourgeois origin, and Charles Siddall, a
Sheffield-born cutler who ran an ironmongery business in
Southwark. Like her sisters, she became a dressmaker and
milliner and it was while working in this capacity that she met
Mrs. Deverell and her son Walter, who introduced her to the painters in the
Pre-Raphaelite Brotherhood, of which he was an honorary member. She was just
twenty and living with her large family above her father's shop at 8 Kent Place, off
the Old Kent Road, when Gabriel, who was a year older and also living at home, first
met her. Before long he was claiming he had found in her "the image of his soul" and
in her famous hair "the golden veil through which he beheld his dreams."

OPPOSITE: **PORTRAIT OF
ELIZABETH SIDDAL** *by Dante
Gabriel Rossetti painted in 1854
when their romantic relationship
was as its height.*

ABOVE: *A characteristically serene drawing of Lizzie Siddal reading in a chair by Dante Gabriel Rossetti.*

What can we be sure we know about Lizzie? Very little. Lizzie's languorous eyes, large-lidded and lovely, gaze demurely down in most of Gabriel's portraits of her, contributing to her air of mystery and self-containment. "Her inner personality did not float upon the surface of speech or bearing," according to William Michael, who found her aloof and enigmatic and may have resented her presence at Chatham Place where he was, nominally at least, co-tenant. No doubt she felt the insecurity of her position. There was a wide disparity between the secluded lives of upper- and middle-class Victorian women like William Michael's sisters, who were expected to make the home their sphere, and working-class women like Lizzie, who had to engage with the outside world, unmediated by chaperones, and make their own living. Lizzie lacked social or educational advantages. She soon gave up her work in the "bonnet shop" for the more lucrative business of modeling, but the fact that she was paid marked her out as not quite a lady. Christina Rossetti, who was one, had to be chaperoned by her mother when she modeled for William Holman Hunt and, as a friend, was unpaid. Lizzie charged by the hour.

After her death Gabriel was eager to burnish her reputation and excised all references to Lizzie—however unobjectionable—from the Pre-Raphaelite journal

kept by William Michael. She does, however, make an appearance in the diary of
Ford Madox Brown, a loyal friend to Gabriel and to Lizzie, and comes across there
as a much more vital figure and a good friend to his young wife, Emma, with whom
she had a great deal in common. Emma, too, had been her husband's model (and
mistress) before she became his second wife and, like Lizzie, came from a working-
class background. Lizzie's father was an ironmonger, Emma's a bricklayer. Indeed,
there is a pattern in the lives of many of the Pre-Raphaelite painters of marrying
beneath their social class—witness William Morris marrying Janey Burden, daughter
of an Oxford hostler; William Holman Hunt's hopes for Annie Miller, whom he
rescued from a Chelsea slum and polished until she shone brightly enough to pass
for wife material; Fred Stephen's union with the illiterate Clara; and Arthur Hughes's
marriage, after an excruciatingly long engagement, to Tryphena Foord, whose father
managed a local plumbing and decorating business.

It was unlikely, however, that marriage was the prompt for Gabriel's move to 14
Chatham Place in November 1852. More probably he was propelled by a desire to
prolong the peace and privacy he had found for a short while during the summer in
a tiny cottage studio in the garden of a large house in Highgate West Hill belonging
to his Quaker friends William and Mary Howitt. The main house, which was empty,
was undergoing repairs and Gabriel spent "the jolliest [time] of my life," in the tiny
two-roomed cottage called, appropriately enough for a young man's first home away
from home, The Nest.[2] Gabriel found it idyllic and described the cottage as "a perfect
fairy palace." The roof was thatched and the walls covered "in an exuberant growth

*BELOW: AN ENGLISH
AUTUMN AFTERNOON
by Ford Madox Brown.
The view from a back window
of the artist's lodging house above
a China shop in Hampstead High
Street, looking northeast across
Hampstead Heath to Highgate.
The suggestion has been made that
Brown chose the unusual oval
shape to suggest the full range of
the eye from a high viewpoint.*

JOHN RUSKIN TO HIS FRIEND AND FELLOW PATRON ELLEN HEATON, 1855

"There is one of Rossetti's pupils—a poor girl—dying I am afraid—of ineffable genius—to whom some day or other a commission may be encouragement and sympathy be charity—but there is no hurry as she don't work well enough yet and Rossetti and I will take care of her till she does, if she lives."

(*SUBLIME AND INSTRUCTIVE*)

ABOVE: Lizzie, drawn by Gabriel, against the studio window at Chatham Place, with Blackfriars Bridge in the background.

of ancient ivy" that Gabriel passed on the outside staircase and gallery whenever he mounted to the first floor room. There, "in the romantic dusk of the apartment," he could be alone with Lizzie.

When the Howitts returned he felt the need for a place of his own press upon him with a new urgency. He settled on a site every bit as magical as The Nest, but in Chatham Place, the last house by Blackfriars Bridge, built out into the river with windows on all sides on the north bank of the Thames, the magic was murkier; it came and went with the tide and sometimes lay malevolent and heavy on the house, like the pools of stagnant water that collected and increased the threat of cholera and typhoid that often broke out in the city at this time. Despite a recurring ulcerated throat, Gabriel kept on at "the crib," as he called it, for nine years, extending the range of his apartments in 1860 when he finally married Lizzie and leaving only after her suicide made it impossible for him to remain at the site.[3] When the sun shone and a fresh wind chased away the putrid smells from the exposed mudbanks it was paradise, but mostly it proved a damp and unhealthy spot, hardly suitable for someone as delicate as Lizzie.

At first, though, they were very happy. Gabriel threw a party within days of moving in, but thereafter visitors (and co-tenants) were actively discouraged. Gabriel and Lizzie retreated from the world. The huge number of drawings Gabriel made of Lizzie during their first years together at Chatham Place suggest a relaxed contentment. Lizzie is shown sitting in an armchair, or reading; the mood is calm and quietly domestic.

"You cannot imagine what delightful rooms these are," Gabriel wrote to a friend, describing the chief charm as a "jolly" balcony overhanging the river, from which he and Lizzie could watch the reflection of the lights on the bridge and quays and the movement of the barges between the wharves. They had a large living room connected to a small bedroom by a corridor, lined with books. There was also a spacious studio, in which they both worked, but no kitchen or cooking facilities. Lizzie and Gabriel would therefore have either eaten out in restaurants or had food

Sept 1853

sent up. From time to time Gabriel would throw a bachelor party (from which Lizzie absented herself) and the painter George Boyce recalled "roast chestnuts and coffee, honey, and hot spirits . . . Conversation throughout delightful, resulting methought from the happy and gentlemanly freedom of the company generally."[4]

In 1854, shortly after the tragic death of Walter Deverell (probably of Bright's disease), Gabriel seems to have made more of an effort to advertise his relationship with Lizzie. He arranged for her to meet his sister Christina and mooted the idea that Lizzie might illustrate Christina's forthcoming collection of poems. Kindly Ford called often. In October he noted in his diary that Lizzie was "looking thinner and . . . more beautiful and more ragged than ever." During the visit Gabriel showed him a drawer full of drawings of "Guggums" (Gabriel's nickname for Lizzie) "each one a fresh charm, each one stamped with immortality . . . God knows how many . . . it is like a monomania with him. Many of them are matchless in beauty . . . and one day will be worth large sums."[5]

That day must have seemed some way off, though, to Gabriel whose income from painting was sporadic to say the least, making Ruskin's arrival on the scene all the more welcome. Ruskin had lost one disciple, in the shape of Millais, to his wife and was in search of another. The two men discussed Dante, and Ruskin commissioned a series of watercolors from Gabriel, who took the opportunity to show his new patron a dozen or so of Lizzie's drawings. The effect was electric. "Ruskin," Gabriel wrote in March 1855, "saw and bought on the spot every scrap of design hitherto

ABOVE: Gabriel's sketch captures the intensity and intimacy of his relationship with Lizzie, but also privileges her as the portrayed artist. The pair are linked by the central chair on which Lizzie leans her drawing-board and Gabriel, a dashing figure with his hands rammed in his pockets, rests his casually crossed feet.

OPPOSITE: **ECCE ANCILLA
DOMINI** by Dante Gabriel
Rossetti. Gabriel's sister, Christina,
who was engaged at the time to
James Collinson, one of the original
members of the PRB, posed as the
Virgin Mary in this painting.

*ABOVE: CLERK SAUNDERS by
Elizabeth Siddal. Sir Walter
Scott's poetry was the inspiration
for this depiction of another
doomed romantic pair, seen here
re-exchanging their vows. The
idea of romantic love enduring
beyond the grave was one with
which Gabriel and Lizzie would
both have been familiar.*

produced by Miss Siddal. He declared that they were far better than mine, or almost than anyone's, and seemed quite wild with delight at getting them. He asked me to name a price for them, after asking and learning that they were for sale, and I, of course, considering the immense advantage of their getting into his hands, named a very low price, £25, which he declared to be too low even for a low price, and increased it to £30. He is going to have them splendidly mounted and bound together in gold and no doubt this will be a real opening for her, as it is already a great assistance and encouragement."[6]

Indeed, Ruskin thought so highly of Lizzie's work that he offered to pay her an annual stipend of £150, conditional upon her giving him first refusal of all her drawings and watercolors, and it seems that Lizzie accepted this offer, at first at least, going straight out to buy her own supply of paints and brushes.

To put Lizzie's promised £150 into context, at this time a typical middle-class English family with one servant would have lived reasonably well on an income of between £250 and £300 a year. Between 1849 and 1853 Gabriel muddled along on earnings of little more than £30 a year—a sum supplemented by his indulgent family. His first major PRB painting, *The Girlhood of Mary Virgin*, had sold quite quickly to the Marchioness of Bath, but the second, *Ecce Ancilla Domini*, took longer to find a

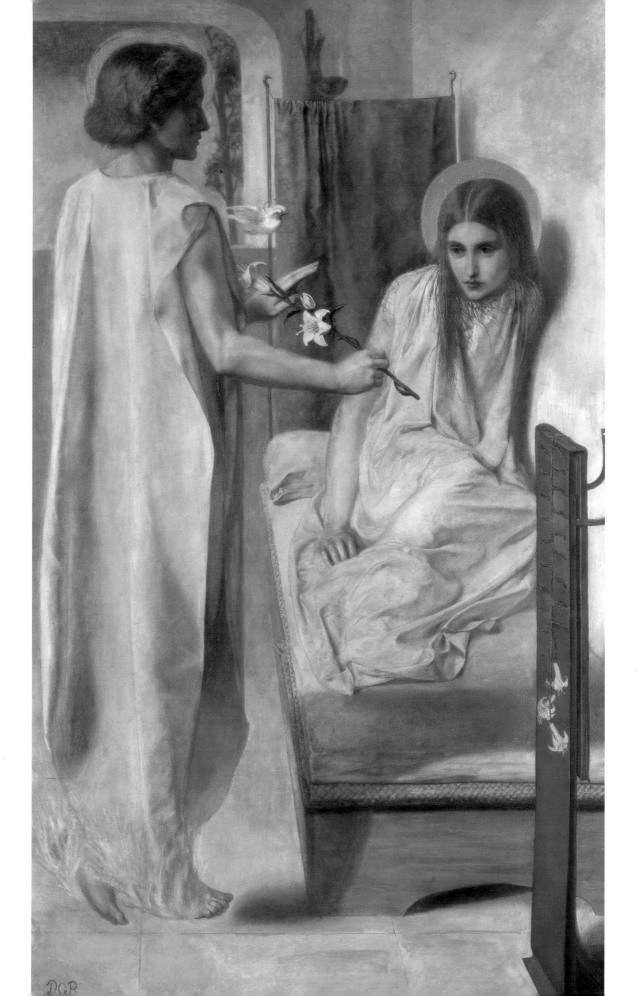

ABOVE: *A photograph of Dante Gabriel Rossetti arm in arm with his great champion and patron John Ruskin.*

purchaser. Finally Francis McCracken, a shipping agent described by Rossetti as "an Irish maniac," bought the picture for fifty guineas.

Gabriel's chaotic mode of life drove the careful and controlling Ruskin to distraction, but was it in fact necessary for Gabriel to live on the verge of poverty and dire emergency in order to find an impetus to paint? He certainly never used his money wisely. He frittered away McCracken's money on a holiday and then had to borrow from the long-suffering William Michael in order to be able to eat. In 1855 he spent New Year's Eve with Madox Brown, who described him as "such a swell as I never saw before . . . looking really splendid" and talked grandly of buying "a 'ticker' but not of paying me back my £15, alas!"[7]

Ruskin was not alone in valuing Lizzie as an artist. Madox Brown called her "a real artist, a woman without parallel for many a long year."[8] The suffragist and painter Barbara Leigh Smith Bodichon declared that "Miss Siddal is a genius," although she went on to lament to her friend Bessie Parkes, "Alas! her life has been hard and full of trials, her home unhappy, and her whole fate hard. D. G. R. has been an honorable friend to her and I do not doubt if circumstances were

"Great art is precisely that which never was, nor will be taught, it is pre-eminently and finally the expression of the spirits of great men."

(JOHN RUSKIN, *MODERN PAINTERS*)

favourable would marry her. She is of course under a ban having been a model (tho' only to two PRBs)."[9]

So much for progressive thinking.

Although Barbara Leigh Smith Bodichon felt that Lizzie, by posing for Gabriel and other painters, had put herself beyond the pale of respectability and marriage, this was not a view shared by Ruskin, who was forever urging Gabriel toward marriage and wrote delicately to ask "whether you have any plans or wishes regarding Miss S., which you are prevented from carrying out by want of a certain income and if so what certain income would enable you to carry them out?"[10] Madox Brown was more direct: "Why," he wailed, "does he not marry her?" Madox Brown genuinely liked and admired Lizzie, calling her "a stunner and no mistake," and felt the precariousness of her position.[11] However, there was one advantage at least to her unconventional relationship with Gabriel: it provided Lizzie with the space and freedom in which to work. Her paintings, idealized evocations of a medieval period in subdued, yet rich, tones, lacked technical perfection but had an undeniable charm and Ruskin, who was a "benevolent despot" in his personal relations with artists, was eager for more.

Unfortunately Ruskin was also a meddler, constantly offering unsolicited advice and keen to steer Lizzie away from what he called her "fancies" toward his own favored subjects—stones, leaves, and rock. Lizzie discontinued their arrangement after the first year. There was, though, one residual benefit: If Lizzie could impress Ruskin, perhaps she might impress Mrs. Rossetti. Gabriel now felt sufficient pride in Lizzie to introduce her to his mother.

"Lizzy will take tea, perhaps dinner, at my mother's tomorrow," he announced to Ford. The meeting took place on 14 April 1854 in Albany Street but it did not go well. Lizzie was tongue-tied and stiff, her shyness interpreted as a rather haughty silence, which Ford did his best to dispel as he sat up chatting with Mrs. Rossetti long after Gabriel and Lizzie had left. Friendship would never flourish between Lizzie and the Rossetti women: The gap between them was too wide and it is unlikely that the recently widowed Mrs. Rossetti welcomed the idea of linking her family to one of shopkeepers.

Chapter 4

NEW KNIGHTS
at the
ROUND TABLE

"Oxford is a glorious place; godlike! at night I have walked round the colleges under the full moon, and thought it would be heaven to live and die here."

EDWARD BURNE-JONES, JANUARY 1853

MEANWHILE, IN STUDENT ROOMS at Exeter College, Oxford, the name of Dante Gabriel Rossetti had taken on an almost talismanic significance for two young and, at first sight improbable, friends. William Morris and Edward Burne-Jones, who were both studying with a view to entering the Church, had met on their first day at Oxford and formed an instant, and, as it turned out, lifelong attachment through their shared passion for Tennyson, Keats, and all things medieval. Oxford was still largely medieval in the 1850s, and many of the houses were ornamented with wood carvings or little sculptures. It was a city built without brick, composed instead of romantic soft gray or pale yellow stone, fringed by green meadows. When recalling Oxford in later life, the image that for ever afterward flashed upon William's inward eye was "a vision of gray-roofed houses and a long winding street and the sound of many bells."[1] It was here that William forged the friendships that would shape his life and first encountered "the stunner" who would become his wife. For a romantic such as he it held enormous appeal.

Their rooms, Edward wrote, were in "tumbly old buildings, gable-roofed and pebble-dashed," with little dark passages leading from staircases to cloistered sitting rooms with windowseats where the two friends sat poring over Chaucer in the evening and "the painted books in the Bodleian" during the day. They made an unlikely pair—the solid energetic William with his mop of wiry hair that had gained him the nickname Topsy and the tall pale fragile figure of Edward (then known to

ABOVE: *The young William Morris, a "slight figure" in those days, according to his great friend Ned Burne-Jones.*

OPPOSITE: ***APRIL LOVE*** *by Arthur Hughes. In this ambivalent, yet radiant, painting the beautiful young girl turns tearfully away from her lover (seen in shadow) with an expression that Ruskin explained as "just between joy and pain . . . all a-quiver—like an April sky." The Victorian audience would have read a happy end into the narrative of the painting, however, for ivy stands for constancy in the language of flowers and Hughes uses it abundantly.*

close friends as Ted) with his wide light blue eyes and face "oddly tapering toward the chin." Where Edward was hesitant, William was impetuous, often hitting the air, or his own head, with a kind of smothered exasperation. Edward, the only child of a Birmingham gilder and framer, was poor; William came from a large and wealthy family. They neglected their studies, preferring to immerse themselves in a mystical world of chivalry and beauty, lost history and romance. Edward had found a fine edition of Malory's *Morte d'Arthur* in an Oxford bookshop and used to go each day to linger longingly over it until William bought the "treasure" for him. One day, when Edward was working in his room, William burst in with Ruskin's newly published Edinburgh lectures and "there we first saw the name of Dante Gabriel Rossetti." The discovery fueled Edward's decision to abandon the Church and become a painter. William, too, had switched careers, deciding instead to become an architect, but from this point they resolved to devote their lives to art, and as soon as Edward moved to London he sought his hero out at the Working Men's College in Great Ormond Street where Gabriel taught evening art classes. It was to prove a turning point in the lives of all concerned. Vernon Lushington introduced them and Gabriel casually extended an invitation to his studio in Chatham Place.

"I was two and twenty and had never met, even seen a painter in my life," Edward wrote home, but within a short space of time he and William, who came up from Oxford every weekend, had met Ford Madox Brown (whom he found "a lark"), Arthur Hughes (one year older than Edward, three years younger than Millais, and

ABOVE: Edward Burne-Jones, looking every inch the serious young theology student, as he would have appeared to William Morris when they first found themselves side by side in the hall where they sat the matriculation examination to Exeter College.

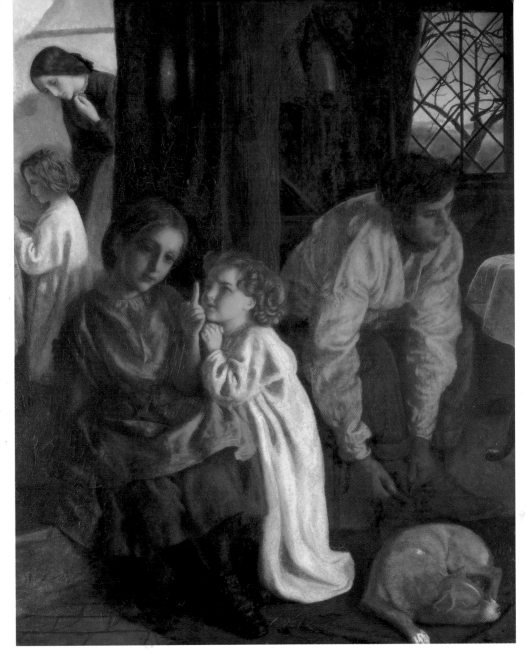

outside the Brotherhood but as important a Pre-Raphaelite follower as Madox
Brown) and the sculptor Thomas Woolner. They had even visited Ruskin, who had
bowled Edward over by replying by return to his first shy note. To his old
schoolfriend, Crom Price, he wrote proudly of his transformation: "I'm not Ted any
longer, I'm not E. C. B. Jones now—I've dropped my personality—I'm a
correspondent with RUSKIN, and my future title is 'the man who wrote to Ruskin
and got an answer by return.' I can better draw my feelings than describe them, and
better symbolise them than either."[2] There follows a drawing of himself prostrate on
the ground before an aureoled and nimbused presence intended to be Ruskin.

Soon they were meeting regularly, as this breathless letter home testifies: "Just
come back from being with our hero for four hours—so happy we've been: he is so
kind to us, calls us his dear boys and makes us feel like such old friends. To-night he

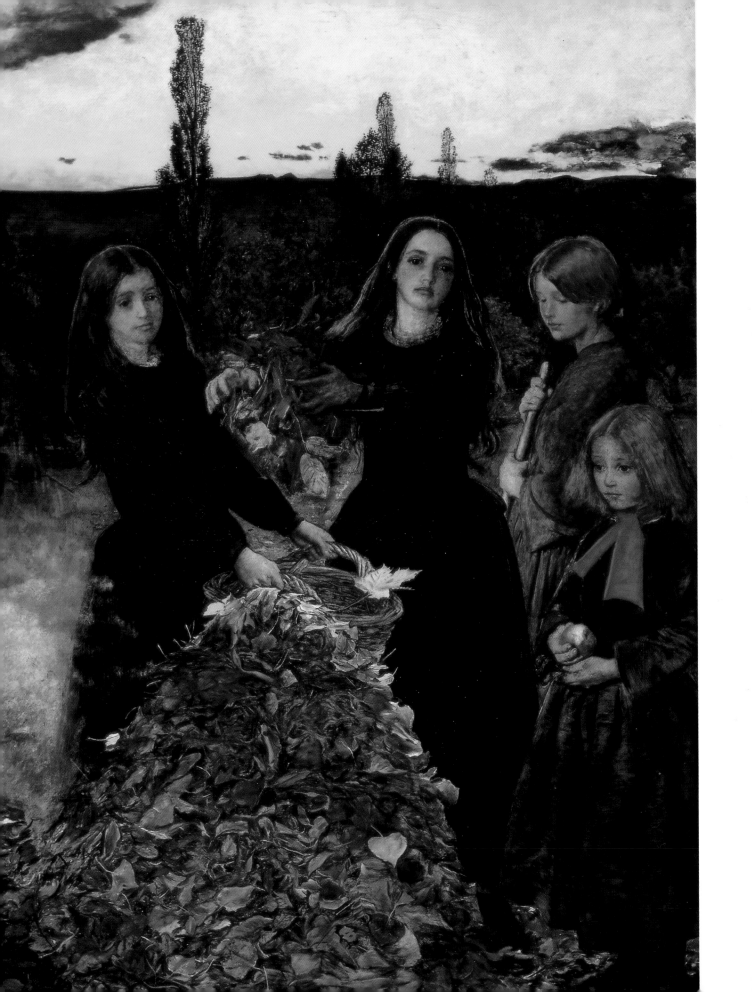

*OPPOSITE: **AUTUMN LEAVES***
by John Everett Millais.
Millais set out to paint "a picture
full of beauty and without
subject," capturing Effie's sisters
Sophie and Alice in their winter
dresses of "green Linsey Wolsey"
burning leaves in the garden of
Annat Lodge in Perth. Effie had
found the younger girls locally,
one in a workhouse, and
introduced them to her husband
as promising models.

Georgiana Macdonald aet.16
from a photograph.

ABOVE: Georgiana Macdonald
photographed at sixteen, a year
after she became officially engaged
to Edward Burne-Jones. Born
in 1840, Georgie was the fifth
of eleven children born to Methodist
minister George Macdonald and
his wife Hannah. Four daughters
made "important marriages"
and two were mothers of major
twentieth-century figures, Rudyard
Kipling and Stanley Baldwin.

comes down to our rooms to carry off my drawing and shew it to lots of people . . . isn't that like a dream? Think of knowing Ruskin like an equal and being called his dear boys."[3]

When not being entirely overawed by Ruskin, William and Edward rattled around London with Gabriel ("the planet round which we all revolved"), going to plays or visiting galleries. He took them to the Summer Show at the Royal Academy where Holman Hunt's *The Scapegoat*, Henry Wallis's *Death of Chatterton*, and five of Millais's canvases were exhibited. William, however, fell in love with a painting by Arthur Hughes. Back in Oxford he wrote to Edward: "Will you do me a great favour, viz. go and nobble that picture called *April Love*, as soon as possible lest anybody else should buy it."[4] Shy Edward, whom Gabriel called "the nicest young fellow in Dreamland," nobbled it for £40, even though Ruskin was trying to persuade his father to buy it, calling it "Exquisite in every way; lovely in colour."

There were just six years between Gabriel and Edward but Gabriel (who had taken to calling his new friend Ned), with his southern charm, sophisticated set-up, and lovely Lizzie in the background, seemed so much more worldly. He took Ned, newly engaged to the fifteen-year-old Georgiana Macdonald, under his wing and Georgie recalls being "led to the shrine of Rossetti at Blackfriars" for a "short awestruck visit." The great painter, with his "olive skin, so different from that of a dark Englishman," continued painting the whole time they were there.[5] Lizzie was nowhere to be seen. Indeed, the ambivalence of Lizzie's position is underlined by the fact that Georgie, a clergyman's daughter, was not introduced to her until 1860 when she returned from her honeymoon, safely and properly Mrs. Rossetti.

Much later, when Ned was a well-respected painter and Royal Academician, he claimed that the only art lessons he had ever had consisted of being allowed to go for several days and watch Gabriel paint a picture, although "I never saw how he had it out of the hard stage and made it all soft and delicious."[6] In fact he was going every evening, with William (now in London working for G. E. Street, the Gothic revivalist, whose best-known building is the Law Courts in London), to a life class

"I think to see me in the midst of a removal is to behold the most abjectly pitiable sight in nature; books, boxes, boots, bedding, baskets, coats, pictures, armour, hats, easels—tumble and rumble and jumble. After all, one must confess there is an unideal side to a painter's life—a remark which has received weight in the fact that the exceedingly respectable housekeeper we got has just turned in upon us in the most unequivocal state of intoxication!"

(*THE MEMORIALS OF EDWARD BURNE-JONES*)

in Newman Street, and later attended Cary's art school in Bloomsbury Place, but he insisted that Gabriel "taught me practically all I ever learned . . . he gave me courage to commit myself to imagination without shame."[7] Gabriel's breezy encouragement also extended to William who now, much to his mother's dismay, abandoned architecture as lightly as he had the Church and resolved to become a painter. At Oxford he had been famous for wearing purple trousers. Now he adopted the badge of the artist and grew his hair and the vast Viking beard with which we associate him. He moved in with Ned, who had rooms at 1 Upper Gordon Street in unfashionable Bloomsbury, where the dingy stucco facades were so similar that Ned had once sprinted halfway up the staircase and called for his dinner before he realized he was in the wrong house.

"Topsy and I live together," Ned wrote that August, "in the quaintest room in all London, hung with brasses of old knights and drawings of Albert [*sic*] Dürer."[8] After a few weeks they moved on, at Gabriel's suggestion, to the same unfurnished rooms at 17 Red Lion Square that he had once shared with Walter Deverell. There they had three rooms on the first floor of an early eighteenth-century brick townhouse into which they crammed a great mass of "books, boxes, boots, bedding, baskets, coats, pictures, armour, hats, easels—tumble and rumble and jumble."[9] There was one large front-facing room with a central window that had been extended upward to meet the ceiling to provide good painting light, and two smaller rooms beyond.

William took the smallest room, referred to as a "powdering closet" by his first biographer, even though his income was far in excess of that of any of his friends, allowing him to indulge his many generous impulses, buying books for them and paintings from them. He had great plans for Red Lion Square. Finding the ready-made furniture available of insufficient standard, he designed his own on monumental medieval lines: a vast settle that was too large to transport up the stairs to the first floor and had to be winched in through the window; a round table "as firm and heavy as a rock," according to Gabriel; some colossal chairs, including one

surmounted by a box that Gabriel thought would be ideal for keeping owls in. Indeed, for a time an owl *was* resident at Red Lion Square, although Gabriel, who would later have his own menagerie in Chelsea, quarreled with it. Other visitors have left descriptions of the "noble confusion" of the room chaotically packed with furniture, broken fragments of Flemish or Italian pottery, stray suits of armor, half-finished pictures, and sketchbooks.

It was a curiously male world of camaraderie with practical jokes, late hours, and unrestrained freedom and friendliness. Gabriel basked in the adulation, and, despite their unofficial engagement, continually put off fulfilling his promise to marry Lizzie, despite urgent promptings from Ruskin and Madox Brown. Besides, he was enjoying initiating his young pupils into the darker side of metropolitan life. He took them to the Argyll Rooms in Piccadilly and other "nighthouses," where prostitutes and their clients drank and danced into the early hours, and to Leicester Square to visit the *poses plastiques,* or semi-nude shows.

ABOVE: This satirical drawing by Sir Max Beerbohm is entitled "TOPSY & NED SETTLED ON THE SETTLE, RED LION SQUARE."

The Brotherhood convened at Red Lion Square, where models came and went—some, like the golden-haired and voluptuous Fanny Cornforth, of dubious reputation. Victorian London, just then undergoing a population explosion, was full of young women tempted to turn to prostitution by the possibility of making in one week the same £12 they could expect to earn in a year as a domestic servant. A Metropolitan police tally taken on 20 May 1857 indicates that there were some 8,600 professional prostitutes in London, a little under half of whom operated from expensive premises and catered for wealthy clients, while the rest were called "low." For some women it was a temporary measure undertaken in order to set themselves up in a more respectable trade, but many were sucked under and the public condemnation of their behavior was swift and brutal. The Brotherhood's attitude toward prostitutes was generally friendly, although Gabriel was not above involving them in his practical jokes. Once, full of mischief, he paid a young prostitute five shillings to follow the tender-hearted Ned, telling her, "I was very shy and timid and wanted her to speak to me. I said no, my dear, I'm just going home—I'm never haughty with those poor things, but it was no use, she wouldn't go, and there we marched arm in arm down Regent Street."

Despite this teasing incident, the young artists were not chauvinistic in their attitudes to women or art and on the whole promoted progressive ideas of female independence, encouraging their wives, sisters, or daughters to pursue artistic ambitions of their own (albeit under a somewhat smothering paternal guidance or the "benevolent despotism" of Ruskin).

The incipient chaos of Red Lion Square was kept from overwhelming its occupants entirely by their housekeeper, Mary Nicolson, who became known as

RIGHT: The house in Red Lion Square, home to both Walter Deverell and Gabriel Rossetti and, years later, to William Morris and Ned Burne-Jones. The central window of the first floor apartment was extended to let in more light.

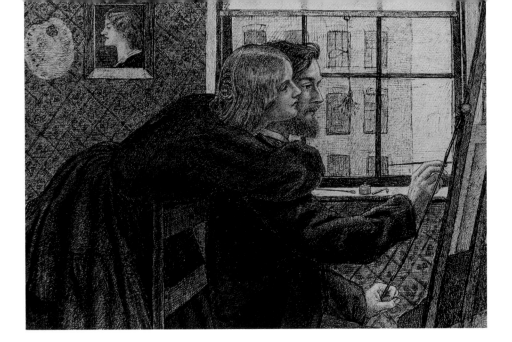

"Red Lion Mary."[10] Unlike their first housekeeper, who had been found one day in "the most unequivocal state of intoxication" and had to be dismissed, Mary had an unfailing good temper and ministered to the bedraggled young women Ned was known to bring home for restoration and repair.

"Cleanliness, beyond the limits of the tub, was impossible in Red Lion Square," Georgie explained, "and hers was not a nature to crash itself against impossibilities, so the subject was pretty much ignored."[11] Mary was relatively cultivated and soon made herself indispensable to the young men. She could write and spell and, even more importantly to William, she could embroider. Her sympathetic and flexible nature ensured that Red Lion Square was endlessly hospitable, for she never knew quite who "her boys" might bring home. She cheerfully spread mattresses on the floor, and when they ran out "she built up beds with books and portmanteaus."[12] One night she had to improvise beds for a weary band who had been out rowing on the Thames. George Birkbeck remembered that she rolled up the carpets and spread out five mattresses "and there I slept amidst painters and poets. Next morning I watched Burne-Jones painting some lilies in the gardens of the square. It was, I believe, the first time he painted in oils."

At Red Lion Square they pursued a rioting boisterous artistic life, gathering round the fire in the evenings to tell "Gothick" ghost and horror stories, after gargantuan feasts, with plenty of wine, which had a pronounced effect on William's waistline— "By God, I'm getting a belly." To the despair of their landlord, they had a lot of fun and they made a lot of noise. In 1858 Ned wrote to Madox Brown urging him to come to a small evening party promising "victuals and squalor at all hours, and a stunner or two to make melody," this last a reference to Georgie and her sister, who were to play a piano specially hired for the evening.[13] He came, and was so taken with Ned's little fiancée that he agreed to give her art lessons. Georgie, now, like Lizzie, a student of art, wrote of "Madox Brown's incredible kindness in allowing me . . . to come and try to paint from a model in his studio."[14] But still the two women were not introduced.

ABOVE: *FANNY CORNFORTH AND GEORGE PRICE BOYCE* by Dante Gabriel Rossetti. George Price Boyce had the studio beneath Gabriel's at Chatham Place and shared Fanny's favors.

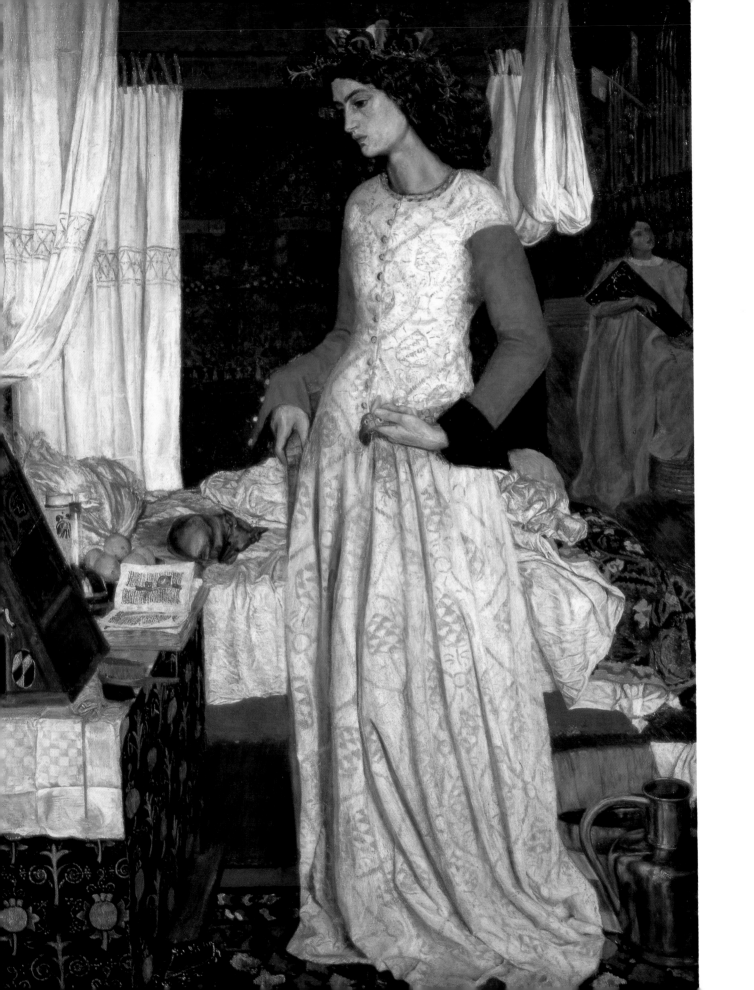

Chapter 5

THE OXFORD FRESCO FROLIC

"Paradise must surely be a rose garden full of stunners."

CHARLES ALGERNON SWINBURNE

 N THE SUMMER OF 1857 the residents of Red Lion Square decamped to Oxford, where Gabriel had secured a commission to decorate the new Debating Hall of the Union building with Arthurian murals. He had hoped to persuade Madox Brown and William Holman Hunt to join him in his "fresco frolic," but the only other well-known painter was Arthur Hughes. William and Ned (who, despite their inexperience, began to look like veterans besides youngsters such as Val Prinsep, the nineteen-year-old son of Sara Prinsep) were sent on ahead and took lodgings in the High Street at No. 87. Here they installed themselves in paint-spattered clay-smoking bohemian splendor, turning their backs on the formal invitations to Oxford dinners. The whole enterprise was marked by energy and amateurism. Fueled by vast quantities of soda water brought in from the neighboring Star Hotel, the painters started work at eight, sending out for sandwiches and frequently disturbing the students in the library next door with "their laughter and songs and jokes and the volleys of their soda water corks."[1] They worked diligently that summer but the scheme was ambitious and, despite the "voluptuous radiance" of the murals, was never finished. Worse, after only six months, the paint began to deteriorate and William admitted later that "the whole affair was begun and carried out in too piecemeal and unorganised a manner to be a real success."[2] But for Ned they had been "wonderful seething days" and Val Prinsep recalled the "fun we had! What jokes! What roars of laughter."

ABOVE: The Old Debating Hall (now the library) of the Oxford Union, which Morris, Rossetti, Burne-Jones, Spencer Stanhope, Arthur Hughes, Hungerford Pollen, and Val Prinsep decorated with murals in 1857.

OPPOSITE: **LA BELLE ISEULT** *by William Morris. Jane Burden was the model for this painting of an almost trance-like Iseult longing for Sir Tristram.*

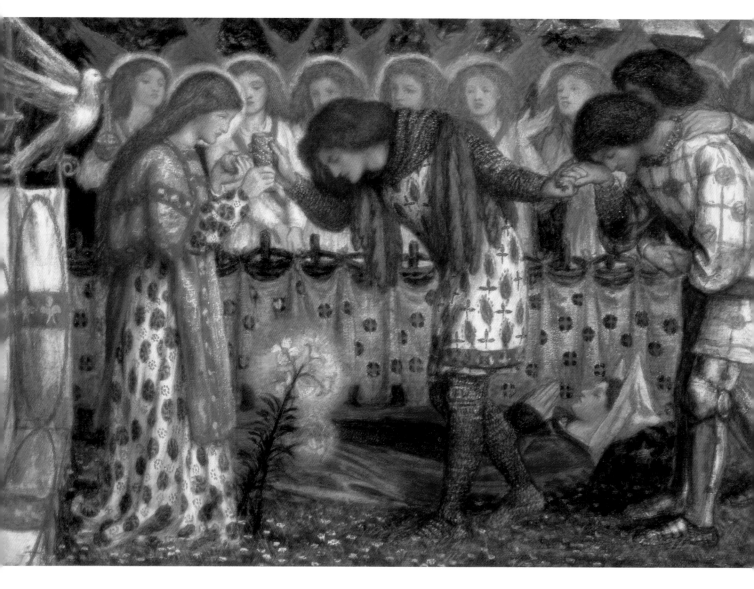

ABOVE: *HOW SIR GALAHAD,*
SIR BORS AND SIR PERCIVAL
WERE FED WITH THE SANC
GRAEL by Dante Gabriel
Rossetti.

The single most important event of this Oxford period, however, was the sighting, by Gabriel and Ned one night in the shilling seats at the theater, of an eighteen-year-old beauty named Jane Burden. Gabriel persuaded her to model for him and was much taken with her exotic dark and melancholy loveliness, but William, who "raves and swares like or more than any Oxford bargee about a 'stunner' that he has seen," was incandescent with love.[3]

Little is known about Jane's early life save that her father worked in a local stable and her mother signed her marriage certificate with a cross, the sign of an illiterate. When she met William she had never seen the sea or been to London. Disapproval of the marriage came not just from family quarters. The red-headed Swinburne, referred to as "dear little Carrots" by Ned, declared that "Topsy" should be "content with that perfect stunner of his—to look at or speak to. The

"Until I saw Rossetti's work and Fra Angelico's, I never supposed that I liked painting. I hated the kind of stuff that was going on then."

(*THE MEMORIALS OF EDWARD BURNE-JONES*)

idea of marrying her is insane. To kiss her feet is the utmost men should dream of doing."[4]

But William could not resist. She so perfectly fulfilled all the prerequisites for an ideal courtly love. She was aloof, silent, and beautiful. He yearned to rescue her from the dragon of poverty and painted her as La Belle Iseult (ironically an unfaithful wife). His clumsy handling of the figure in this, his only easel painting (which can be seen in the Tate), might be read as a metaphor for his personal relations with women. Loud and boisterous, he was always a man's man. He liked to worship women, serve and be awed by them. Later in life, as a socialist, he argued for a true equality between the sexes and his permissive views on sexual tolerance and freedom were ahead of his time, but he was always, in his personal life, "hampered by his chivalric urges."

Their engagement lasted a year, during which time Gabriel, bent on sowing the seeds that ultimately sabotaged any possibility for enduring happiness between William and Jane, returned to Oxford in William's absence, and made a particularly intense and soulful drawing of Jane as Queen Guenevere. Much later he would write *The Cup of Cold Water*, an allegorical tale in which a king who has been betrothed since boyhood to "a Princess, worthy of all love" develops a "new absorbing passion" for a humble forester's daughter. Unable to break his troth, he persuades her to marry a faithful Knight "whom he loves better than all men." In this transparent little tale the emotional entanglements are exposed. Gabriel appoints himself king, Lizzie is his Princess, Jane is the irresistibly beautiful peasant's daughter, and William—still, at this point, hero-worshipping Gabriel—is the unfortunate Knight, whose happiness will soon be exchanged for cuckold's horns.

Years later Jane admitted that she had never really loved William. She had been dazzled by the collective admiration of the group of young painters, led, of course, by Gabriel, who had "discovered" her and taught her how to model. But Gabriel was caught up with Lizzie and the offer of marriage came from his clumsy friend, the turbulent, restless, and noisy one who, when he tried to paint her, had scribbled "I cannot paint you but I love you" on the canvas and turned it round for her to see.

Jane was poor and William's proposal was, quite simply, too good to refuse. They were married by license in the spring of 1859 in the late Anglo-Saxon parish church of St. Michael in Oxford. The bride, whom William had taken to calling Janey, was described as a "spinster" and "minor," Morris as a "bachelor" and "Gentleman." The ceremony was performed by William's friend and fellow collaborator on the Oxford Union ceiling, Richard Dixon, a poet as well as a newly ordained priest. Charley Faulkner, with whom William would go on to found the Firm, was best man. Both Janey's father and sister signed the register, but no member of William's family appears to have attended. Ned attended, though without Georgie. She would have to wait until the newlyweds returned from their six-week honeymoon in Bruges, Paris, and the Rhine before she was introduced.

Gabriel was notably absent. His relationship with Lizzie seemed stalled. In 1857 she had exhibited her work alongside Millais, Rossetti, Hunt, and Madox Brown in a Pre-Raphaelite exhibition held at Russell Place in Fitzroy Street and sold one picture to Ruskin's American friend Charles Eliot Norton for forty guineas. This modest success determined her in her ambition to pursue her artistic education. That summer she left London and enrolled in the ladies' class at Sheffield Art School.

She had family connections in Sheffield but chose not to stay with them; instead she rented a house and threw herself into her studies. Gabriel had proved as dilatory a teacher as a student, and she felt the lack of formal training. Unfortunately, she was barred from the life class, which was open only to male students either married or over twenty-one.

Their geographical distance seems to have created an emotional one, or perhaps Lizzie had just become tired of waiting for Gabriel to do the right thing by her, for in the spring of 1859, around the time Janey and William were married, their unofficial engagement was broken off. In the following year her father died and Lizzie herself was far from well.[5]

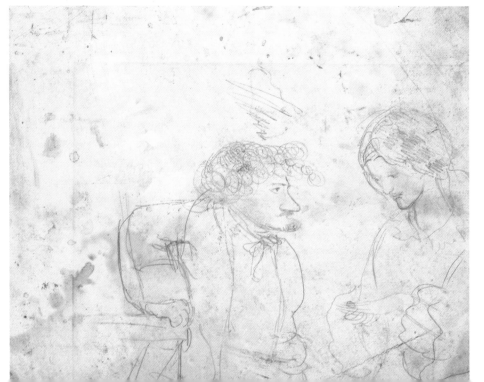

LEFT: WILLIAM MORRIS PRESENTING A RING TO JANE BURDEN, HIS FUTURE WIFE by Dante Gabriel Rossetti. Unlike William, Janey was not head over heels in love, but she was dazzled by the brilliance of the match. She had nothing to recommend her to a suitor save her unusual beauty and William, rich and intensely in love, was captivated by her.

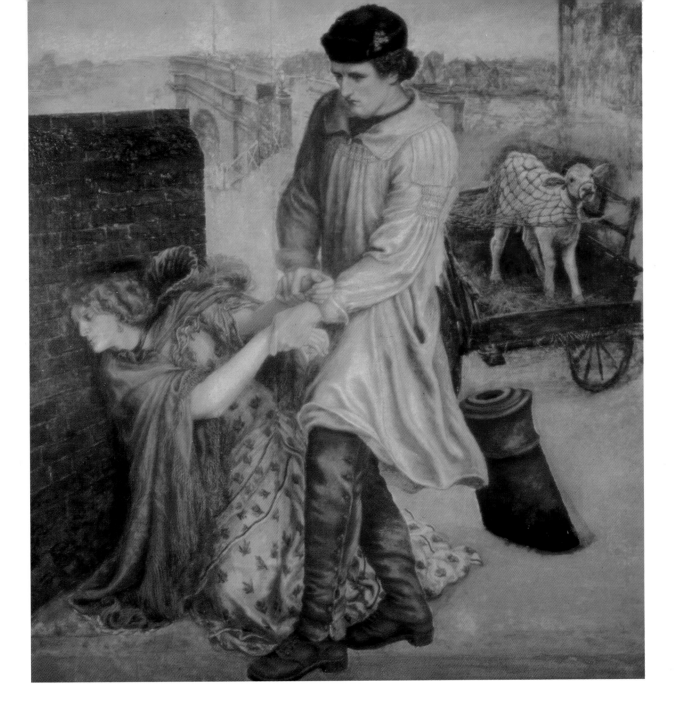

Gabriel, meanwhile, had found a new source of inspiration in Fanny Cornforth, a vivacious and direct young woman who had accosted him during a firework display at the Royal Surrey Gardens, a pleasure garden along the south bank of the Thames. According to accounts, "As they passed each other on the path she cracked a nut between her teeth and threw the shell at him," which captivated Gabriel. Soon she was sitting for a painting he entitled *Found*, which shows a prostitute covered with shame, turning her head toward a river wall, as a healthy young fellow in country clothes, plainly an old admirer, attempts to raise her from the ground. Fanny, whom William Michael described as "a pre-eminently fine woman, with regular and sweet features, and a mass of the most lovely blonde hair—light golden or harvest yellow"

ABOVE: ***FOUND*** *by Dante Gabriel Rossetti. Gabriel explored the idea of prostitution in both his painting and his poetry. Here the fallen woman, modeled by Fanny Cornforth, slumps to the ground in shame, although in his poem "Jenny" the "lazy, laughing languid Jenny" who is "fond of a kiss and fond of a guinea" shows no similar remorse.*

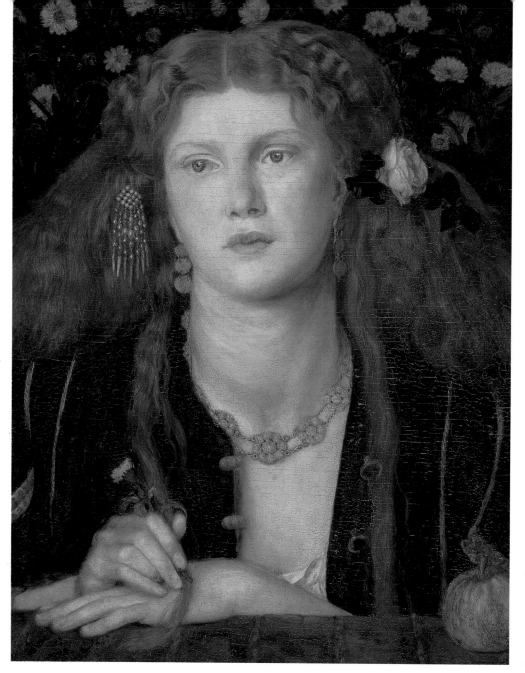

*LEFT: **BOCCA BACIATA**
by Dante Gabriel Rossetti.
Opinions were divided on Gabriel's
painting of Fanny. Swinburne
thought the picture "more stunning
than can be decently expressed,"
while William Holman Hunt
complained that it exhibited a "gross
sensuality of a revolting kind."*

appears in a number of Gabriel's paintings, most notably *Bocca Baciata* (which means simply "the kissed mouth," a reference from Boccaccio to lips that remain fresh despite being used many times). This picture marks the emergence of a new sensuousness and passion in Gabriel's art and if, as biographers have suggested, his work can be seen as offering a running commentary on his emotional life, it is hard to avoid concluding that Fanny and Gabriel had already embarked upon an affair. Gabriel was undoubtedly attracted to other women, and Fanny's ample charms and easy affections may have provided a welcome contrast to the intensity of his relationship with Lizzie and the confusion of his attraction to Janey.

Around this time he was also flirting with William Holman Hunt's protégée, the lovely Annie Miller, whom Hunt had rescued from the slumyard just behind his

ABOVE: **ANNIE MILLER** by Dante Gabriel Rossetti. William Holman Hunt was furious with Gabriel when he returned from the Middle East to find that his protégée had been posing for him.

studio at 5 Prospect Place, Chelsea, and left in the care of another member of the Brotherhood, Fred Stephens, while he was away in the Holy Land. Fred was meant to oversee a sort of polishing process, paid for by Hunt and performed by a former governess called Sarah Bradshaw, who was to teach the young Annie the correct way to stand, speak, sit, and conduct herself in public and private—the point of all this being to make her shine brightly enough to pass as wife material. Fred was also supposed to keep her away from the attentions of Gabriel and his louche friend George Boyce, another painter, although both men in fact took the willing Annie to Bertolini's and to Cremorne Gardens in Chelsea, causing a rift between Gabriel and Hunt that was never repaired and moving Madox Brown to complain that "Gabriel, sad dog, is forgetful it seems of Guggum."[6] (In any event, no doubt driven to distraction by Hunt's conditions and suspicions, Annie never did marry him but later made an advantageous match with Major Thomson, Lord Ranelagh's cousin.)

Gabriel, vain and sexually competitive, delighted, it seems, in disrupting his friends' relationships. That he was attractive to women seems beyond dispute. Years later Ned admitted in conversation that he was "quite sure there's not a woman in the WHOLE world he couldn't have won for himself," adding ominously, "Nothing pleased him more though, than to take his friend's mistress away from him."[7]

Ruskin, meanwhile, had kept up a delicate campaign on Lizzie's behalf, offering Gabriel the wherewithal to marry if that was all that was preventing him, and later, more directly, writing: "My feeling at the first reading is that it would be best for you to marry, for the sake of giving Miss Siddal complete protection and care, and putting an end to the peculiar sadness and want of you hardly know what, that there is in both of you." Ruskin had been convinced for some time that Lizzie was terminally ill and now he appears to have persuaded Gabriel that she was dying. So, in the spring of 1860, he effected a reconciliation that led to their marriage at St. Clement's in Hastings on 23 May, a few weeks after Gabriel's thirty-second birthday. Neither friends nor family were present.

Chapter 6

SALON SOCIETY

"By and by, as the light faded and all who were mere visitors departed those who belonged to the more intimate coterie of friends remained on to an impromptu dinner-party. The seats were carried indoors, the lights within gleamed in rosy cheerfulness, and conversation flowed into fresh and delightful channels."

A. M. W. STIRLING, *A PAINTER OF DREAMS*

ABOVE: A photograph by Julia Margaret Cameron, an important pioneer of the new art form, of her youngest sister, Sophia, posing in the garden of Little Holland House with the painter George Frederick Watts.

EANWHILE, THERE HAD OCCURRED in Ned's life an interlude that almost threw his own marriage arrangements off track. Gabriel was, accidentally this time, the catalyst. "One day," Ned recalled, "Gabriel took me out in a cab—it was a day he was rich and so we went in a hansom, and we drove and drove until I thought we should arrive at the setting sun—and he said, 'You must know these people, Ned; they are remarkable people: you will see a painter there, he paints a queer sort of pictures about God and Creation.' So it was he took me to Little Holland House."[1]

Those three words came to evoke for Ned a picture of an enchanted garden, where it was always Sunday afternoon—"afternoons prolonged, on rare red-letter days, into moonlit evenings full of music and delicate delight."[2]

*OPPOSITE: **APPLE BLOSSOMS** (detail) by John Everett Millais.*

ABOVE: *Lord Holland granted*
Sara and Thoby Prinsep
a twenty-one year lease on Little
Holland House in 1851
at the suggestion of G. F. Watts.
The house—despite being only
two miles from Hyde Park
Corner—was then in the depths
of the country and provided Ned
with a welcome refuge from the
unbearable heat in the center
of the city. The summer of 1858,
one of the hottest on record, became
known as the year of the "great
stink" because of the smell from
the Thames, which was still little
more than an open sewer.

Little Holland House in Melbury Road was the dower house of Lord Holland's great mansion on his vast Kensington estate and was leased to Thoby Prinsep and his wife Sara, one of the famously beautiful Pattle sisters (the pioneer photographer Julia Margaret Cameron was one, while Virginia Woolf's grandmother Maria Jackson was another) and a renowned society hostess who made the house famous, creating a salon around G. F. Watts (Gabriel's painter of "a queer sort of picture"). A studio was built for "Signor" or "The Divine Watts," who, in Sara's famous phrase "came for three days and stayed thirty years." He became both artist-in-residence and the chief attraction at Mrs. Prinsep's regular talent-spotting salon until 1875 when the house was demolished. For Ned, though, there was another enticement.

During the summer of 1858 Ned was taken seriously ill and convalesced at Little Holland House, where he was looked after by Sara Prinsep and her sister Sophia. Despite the fact that he was engaged to Georgie, Ned was smitten with the vivacious Sophia. "At the time," Val Prinsep explained, "we were under the influence of Rossetti's great personality and, as our minds were filled with thirteenth-century tradition, we lived more or less in a world of dreams."[3] Ned's imaginative life had always been rich and there was an exquisite pleasure to be found in this forbidden unrequited unfulfilled and unsatisfactory love. For Sophia was married, although her husband, John Warrender Dalrymple (later the seventh baronet), was, like many Victorian husbands, away building the empire and pursuing his career in the Bengal civil service.

Georgie, too, was out of sight. Her father, a Methodist minister, had a new posting and the whole family had to decamp to Manchester. What began as a crush developed into a deep attachment that Ned unleashed via a torrent of poems by Keats, Tennyson, Rossetti, and Walter Scott. These he illustrated and collected into an exquisite handmade book (a modern version of the compilation tape) that he entitled "The Little Holland House Album" and presented to the lovely Sophia shortly before his marriage in 1860. Georgie, writing nearly fifty years later in her *Memorials*, excuses Ned entirely as, quite simply, intoxicated. At Little Holland

House, she explained, "he found himself surrounded without any effort of his own by beauty in ordinary life, and no day passed without awakening some admiration or enthusiasm. He had never gone short of love and loving care, but for visible beauty he had literally starved through all his early years."[4]

In fact loving care had been in very short supply during Ned's early years. As a child he had grown up in a dark terraced house on Bennett's Hill in the commercial center of Birmingham, in the brooding company of his widowed father who so blamed the boy for the death—a week after his birth—of his mother that he felt unable even to touch him for the first four years of his life. At the age of seven he had been sent away to a small school at Henley-in-Arden, where we can assume from his description of himself as "the kind of little boy you kick if you are a bigger boy" he had not had the happiest of times.

The contrast between his solitary and impoverished home life and the glittering and hospitable Little Holland House was marked. Daringly bohemian in the most

*BELOW: **THE STUDIO, LITTLE HOLLAND HOUSE** by Thomas Matthews Rooke. London was expanding rapidly and Watts and the Prinseps were forced to quit Little Holland House in 1875. The house, now deemed "discreditable and ugly" was demolished, and Watts built himself a new Little Holland House and this studio "about a hundred yards beyond the old place."*

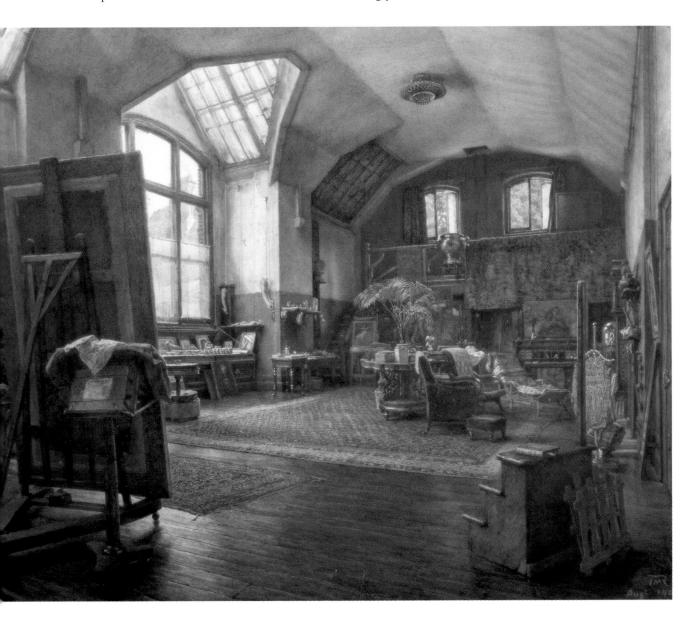

ABOVE: TENNYSON READING
"MAUD" by Dante Gabriel
Rossetti, 1855. Alfred, Lord
Tennyson, who succeeded William
Wordsworth as Poet Laureate
in 1850, was a great hero to the
Pre-Raphaelite Brotherhood and
one of the stars frequently
to be found at Sara Pattle's salon.

upper-class way, the house was shadowy inside with walls painted a cool green to show off the "Venetian color" of Watts's glowing canvases. On the deep blue drawing-room ceiling the planetary system was traced in gold. Outside, the large and fragrant garden was filled with parties of "the fashionable, literary, artistic, political, and what not" who would gather on colorful Indian rugs laid out on the rolling lawns to eat strawberries from a local Kensington farm and listen to Tennyson read his poetry aloud beneath the spreading trees. Croquet was played and bowls. Gabriel and his brother William Michael came often; William Holman Hunt, who described the Pattle sisters as "Elgin marbles with dark eyes" who "could not but make an Englishman feel proud of his race," was a regular. The *Punch* cartoonist, George du Maurier, in a rare note of dissent, complained that "the women offer Tennyson, Browning, and Thackeray cups of tea almost kneeling," and Millais's young wife Effie found "The Little Holland House society too much for my practical turn. Poets and artists have their own place in the world like other people, but Tennyson- and Watts-worship is very disgusting."[5]

There was a loose amorous atmosphere about the house that prompted the high-society matron Lady Charlotte Schreiber to veto visits by her daughters, although she herself was frequently among the "shoals of people" to be found in the Prinseps' drawing room. "I know," she wrote, "there cannot be a worse place to go alone than

Little Holland House, amidst artists and musicians—and all the flattery and nonsense which is rife in that (otherwise) most agreeable society."[6]

The upper-class eccentricities of the beautiful Pattle sisters were tolerated within high society because of the delicious frisson such breezy bohemianism produced. People said their lives were like a work of art. Watts drew and painted Sophia often and Harry Prinsep, nephew of Thoby, described her as "a lovely vision . . . dressed in a gown of some rich colour, all full of crinkles . . . before she had been amongst us three minutes, the whole party was laughing and talking."[7]

Fortunately for Georgie she was able to re-establish her position in Ned's affections in April 1860 when the indefatigably kind Madox Brown invited her down "for a happy month in Fortess Terrace, seeing Edward constantly."

Emma and Madox Brown and their three children lived in Kentish Town, in a terraced house set well back from the street, for which they paid an annual rent of £52 10s.[8] Madox Brown did not enjoy the patronage of the influential critic John Ruskin or the rewards that brought and, as a consequence, he had suffered years of impecunious obscurity. When they moved into Fortess Terrace he had intended to let the first floor but Emma, who was looking forward to the extra space after their cramped time in a small cottage in Finchley, had "a sad fit" so he decided to use those rooms for his painting and leave more of the house for the family.[9] At last, Georgie and Ned, who had first met when Georgie was just ten and he an intense nineteen, were able to be together without interruption. They had been engaged for four years and Ned's financial prospects had not improved at all, but Madox Brown, who was well used to poverty and had survived it with children, took Ned aside and insisted "he had better be married without delay."

RIGHT: AN ENGLISH FIRESIDE by Ford Madox Brown. The artist depicts his second wife Emma quietly sewing while their son Oliver sleeps outstretched on her lap before the fire.

"A small house and slender means were made spacious and sufficient by their generous hearts, and my recollection is of one continuous stream of hospitality. Who that was present at it could ever forget one of their dinners, with Madox Brown and his wife seated at either end of a long table, and every guest a welcome friend who had come to talk and to laugh and to listen? . . . He had so much to say and was so happy in saying it that sometimes he would pause, carving-knife in hand, to go on with his story, until Mrs. Brown's soft voice could be heard breathing his name from her distant place and reminding him of his duties."

(*The Memorials of Edward Burne-Jones*)

So Ned and Georgie took their own path down the aisle, following in the footsteps of William and Janey, Gabriel and Lizzie. They were married in Manchester on 9 June, the fourth anniversary of their engagement. Ned was twenty-seven and had £30 to his name; Georgie was nineteen and brought to the marriage "a small deal table with a drawer in it that held my wood-engraving tools,"[10] They had planned to travel to France and meet Lizzie and Gabriel there but Ned fell ill almost immediately and Georgie, who had been looking forward so much to her first trip abroad, spent her wedding night nursing a sick husband in a strange hotel room in Chester.

Gabriel and Lizzie had more success in making it to France, and Lizzie's health appeared to improve. "Paris certainly agrees with her," Gabriel wrote home.[11] Wishing to maintain her recovery, on their return they found themselves "a very nice little lodging" well away from the unhealthy districts of London, high up in Hampstead, while keeping Chatham Place on as a studio for Gabriel.[12] Spring Cottage in Downshire Hill was not far from Keats House and it was here that the newlyweds entertained their friends. Emma and Madox Brown were the first dinner guests. There were trips to Hampton Court and the Zoological Gardens (one of Gabriel's favorite haunts and the appointed spot—"Place of Meeting: The Wombat's Lair"—for Georgie's first introduction to Lizzie. Afterward Georgie recalled: "We went home with them to their rooms at Hampstead and I know that I then received an impression which never wore away, of romance and tragedy between her and her husband. I see her in the little upstairs bedroom with its lattice window, to which she carried me when we arrived and the mass of her beautiful deep-red hair as she took off her bonnet: she wore her hair very loosely fastened up, so that it fell in soft, heavy wings."[13]

With a baby on the way the house was too small, however, and failing to find anything larger that suited their pockets in Hampstead they returned, fatally, to Chatham Place, taking the apartment next door to Gabriel's old one as well. They persuaded the landlord, who owned both No. 13 and No. 14, to link the two apartments with a new door, and retained a Mrs. Birrell as their housekeeper. They redecorated. Gabriel, whose

LEFT: **GIRL AT A LATTICE**
*by Dante Gabriel Rossetti. Ford
Madox Brown's maidservant was
the model for this painting, which
George Price Boyce bought from
Gabriel for £30. The willow-
pattern jug and dish in the right-
hand corner reflect Gabriel's
interest in blue-and-white china.*

taste for blue-and-white china was just forming, had the fireplace surrounded by old blue glazed Dutch tiles to match his willow-pattern china and even began making designs for his own Venetian Red wallpaper (ahead of William, who would go on to become one of the most famous of wallpaper designers). Gabriel's was based on a pattern of graceful fruit-bearing trees, which he asked the paper manufacturer to print "on common brown packing paper and on blue grocer's-paper" so that he could decide which looked best. Nothing more seems to have come of it, however, and instead Gabriel covered the distempered walls with Lizzie's "poetic" watercolors.

He had high hopes for his wife's talent, writing to Professor Norton in Harvard early in 1861 to claim, "She will, I am sure, paint such pictures as no woman has painted yet."[14] In the census taken that year, either Lizzie or Gabriel (we do not know which) took the trouble to list her occupation, like that of her husband, as "Artist: Painter," at a time when it was unusual for a married woman's occupation to be given at all. But Lizzie's promising flame had not long to burn and soon would be extinguished altogether.

Chapter 7

THE TOWERS
of TOPSY

"O how I long to keep the world from narrowing
in on me, and to look at things bigly and kindly!"

WILLIAM MORRIS TO AGLAIA CORONIO, 21 NOVEMBER 1872

ABOVE: **WILLIAM MORRIS**
by Charles Fairfax Murray.

O F THE THREE YOUNG BRIDES, it was Janey, from the humblest beginnings, who found herself living in the highest style, for William had commissioned a house bigger than any she had lived in before from his friend, Philip Webb, a progressive young architect much in sympathy with Pre-Raphaelite ideals whom William had met when they worked together in the Oxford offices of the architect G. E. Street. The idea for Red House had developed during a walking trip in France that the two friends had made in the previous year. It was Webb's first important commission and very much a collaborative vision. William, who scribbled enthusiastic notes on the back of French train timetables, wanted a house "very medieval in spirit" that suited his personality and fitted in with the natural surroundings. Accordingly they chose a site ten miles outside London in the small hamlet of Upton (now Bexleyheath) that commanded sweeping views over the Cray Valley and was conveniently close to the newly opened North Kent line. The location, near to the remains of an Augustinian priory and on the pilgrims' route to Canterbury, appealed to William's deep love of the past. The work, which would take a year to complete, began at once.

At first William and Janey lived in rented rooms at 41 Great Ormond Street, conveniently close to Webb's office at No. 7, but they soon moved down to Aberleigh Lodge, next to the site, from which they could supervise the final stages of the building. The new house, which Gabriel fondly referred to as The Towers of

OPPOSITE: **DANTIS AMOR,**
*the unfinished central panel for
the doors of Philip Webb's great
settle, painted by Dante Gabriel
Rossetti at Red House in 1860.*

Topsy, rose in the midst of an orchard of apple and cherry trees, some so close that
on warm autumn evenings the ripe red fruit would tumble in through open windows.
It was a deeply pleasing asymmetrical L-shaped house, built of warm red brick (hence
its name) in a scaled-down Gothic style that incorporated a great arched entrance
porch; steep irregular gabled roofs topped with tall idiosyncratic chimneys; and a
weathervane ornamented with the initials W. M. William's presence and personality
were stamped throughout the house in initials and mottoes such as *Ars Longa Vita
Brevis* (Life is short, but Art is long) and his personal one *Si je puis* (If I can), which
appears in embroideries and stained-glass windows.

"It was not a large house," Georgie wrote, "but purpose and proportion had been
so skilfully observed in its design as to arrange for all reasonable demands and give
an impression of ample space everywhere." Webb's plan allowed for an extension—
in effect another L-shaped building—that would enclose the charming cone-roofed
well in a central courtyard and eventually double the living space, for William
harbored a dream of creating at Red House a utopian community of like-minded
creative friends. For the time being, however, trellises, thickly covered with roses,
filled the spaces, creating a romantic enclosed medieval garden at the center of which
was the little well that provided the house with all its water and, according to
Georgie, "summed up the feeling of the whole place."[1]

Gabriel was effusive, calling it "a most noble work in every way, and more a
poem than a house."[2] William was in his element. Still only twenty-six years old,

he had a brand-new house, built to his own specifications, in which everything, including his young wife, was beautiful. Simplicity was the keynote. William detested the Victorian vogue for cluttered rooms where everything, including the piano, was draped in heavy layers and a perpetual state of gloom was maintained by shrouding the windows in up to four layers of curtains, moving out from lace or muslin through swathes of silk and satin to damask and velvet. William, in contrast, welcomed the light and, stocking up his cellar with wine, he prepared to welcome all his friends.

Ned and Georgie, whose married life had begun in much more modest circumstances in rented rooms in Russell Square, Bloomsbury, were more than happy to spend the summer at Red House, helping William achieve his dream of making it "the beautifullest place on earth." The adventure began the moment they stepped down from the London train at Abbey Wood station to find William's specially designed horse-drawn wagon awaiting them. This had leather curtains, pinned back to allow Georgie to inhale the "thin fresh air full of sweet smells" as they trotted gently through the Kent countryside, arriving at last at Webb's stout oak gates, with their great iron hinges, through which she glimpsed "the tall figure of a girl standing alone in the porch to receive us."

William's excellent eye for authentic detail had developed early. As a dreamy and somewhat delicate child, whose imagination had been stoked by Sir Walter Scott's *Waverley* novels, he had spent much of his childhood trotting around Epping Forest on the pony provided by his indulgent parents, extravagantly attired in a miniature suit of armor, storing up details of the medieval architecture and design of the local Essex churches. Oxford had deepened his fondness for medieval turrets, coiling

RIGHT: **RED HOUSE**
photographed by Emery Walker.
Red House has been described
as one of the most important
buildings of the nineteenth century
by some commentators, for whom
it marks the beginning of modern
architecture.

OPPOSITE: The great settle dominates the drawing room at Red House.

staircases and graceful spires; Red House gave him the opportunity to realize his dream of a home rich in such fairytale details.

It was never a grand house, but capacious and comfortable, with a hint of fantasy. There were four good bedrooms, another tiny one, and a partitioned dormitory for the cook and two maids at the far end of the western wing. Narrow stairs led down from this to the kitchen and scullery, while a magnificent oak staircase with tapered newelposts guided guests up from the deep expansive entrance hall to the upper rooms, romantically furnished with tapestried beds and high oak settles lit by candles. Webb had designed much of the furniture himself in a solid and monumental style, its heaviness lightened by the medieval scenes painted upon it by William, Ned, and Gabriel. William had planned the house so that the drawing room should be on the first floor, the ceiling, arched and ribbed with beams, extending right up into the roof space to give extra height. Here he installed the big settle from Red Lion Square with Gabriel's three painted panels, and Webb transformed it by means of a balustrade around the top into a miniature minstrel's gallery. Adjacent to this was a light-flooded studio, lit from three directions. Round—uncurtained—windows admitted more light into the corridors and afforded views across the orchard and the surrounding Kent countryside. The whole effect was of light and space and warmth. The walls were white, the soaring ceilings picked out with geometric patterns. Elaborate schemes were devised for embroidered panels to decorate the dining room and frescoes to be painted directly on to the fresh plaster in the drawing room. Ned painted William into a mural, depicting him as a medieval king at a wedding feast, in a deep blue robe with gold borders. Beside him, in a wimple, crowned as queen, sat Janey. Charley Faulkner helped to paint patterns on walls. Gabriel filled in the spaces left by William.

The Pre-Raphaelites believed in the ideal of woman as coworker and, with Janey working beside him, the early months of married life in Red House were radiantly happy for William. Together they worked on the painted ceiling and then, under William's instruction, Janey embroidered his simple daisy design on some indigo-

"The house and the household, with all that these words involve, were, to Morris, the symbol and the embodiment of civilised human life."

(J.W. MACKAIL, *THE LIFE OF WILLIAM MORRIS*)

dyed blue serge she had found by chance in a London shop. "The work went quickly," she wrote, "and when we finished we covered the walls of the bedroom at Red House to our great joy." Georgie, who helped as well, reported that "Morris was a pleased man when he found that his wife could embroider any design that he made, and did not allow her talent to remain idle." They taught themselves new techniques by unpicking old embroideries, and began an ambitious scheme (destined, like so much at Red House, to remain unfinished) for a dozen embroidered and appliquéd hangings of *Illustrious Women* drawn from the works of Chaucer.

Here in Red House life and art could merge. The young friends posed in medieval costume and painted themselves into Arthurian legend. Twenty years later in a lecture series entitled "How we Live and How we Might Live," William drew on this time for his definition of true domesticity: "It is not an original remark, but I make it here, that my home is where I meet people with whom I sympathise, whom I love." Every weekend

*BELOW: **RED HOUSE, BEXLEYHEATH**, by Walter Crane. Together with Webb, William had created a blissfully romantic first home for himself and Janey.*

OPPOSITE: There is a splendidly medieval feel to the hall of Red House, in which Janey and William, turning their backs on the Victorian age, welcomed their many guests.

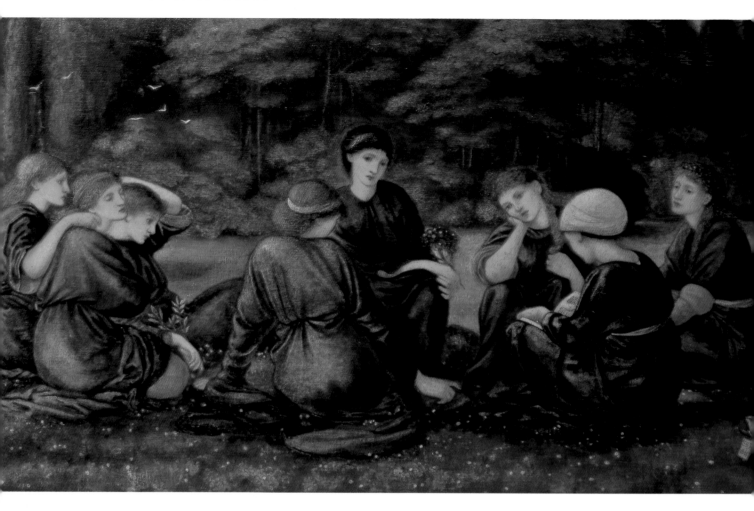

*ABOVE: **GREEN SUMMER***
by Edward Burne-Jones. Ned
complained that, whenever he tried
to paint out of doors, first flies
came and settled on his drawing,
and then rain came and glued
them on, so he painted this picture
in the studio of Red House.

guest was met at the station and ferried to the house in William's horse-drawn wagon. Swinburne came, Arthur Hughes and Charley Faulkner. Emma and Ford Madox Brown. Gabriel and Lizzie. Georgie and Ned. There were picnics in the orchard and garden and hide-and-seek in the house. Pranks were played. During one particularly high-spirited apple fight William was given a black eye by Charley Faulkner, armed with a pile of windfalls. Just before dinner William would descend to his wine cellar and return with bottles tucked under his arm and a broad smile on his face.

Their whole philosophy was in direct opposition to the age. Since the outset of the Victorian period the idea of progress had been linked to highly visible material abundance. It was a period of accumulation and display. Newly wealthy merchants and magnates (many of whom would become patrons of the Pre-Raphaelite painters) built conspicuous mansions that they filled with ornate furniture, screens, scientific instruments, *objets d'art,* and paintings, both original and reproductions. The Victorians embraced the replica with an enthusiasm that made William shudder. Through lithographs, photogravures, and engravings hundreds of copies of paintings such as William Powell Frith's *The Railway Station*, which reinforced society's image of

"If Morris had not been a genuine 'fine fellow' and had not had a rich sense of humour which enabled him to enter into a joke against himself as against any one else, he would never have stood it; he did stand it, and on occasion gave as good as he got. He was volcanic, and would rage and swear on very small inducement; but, being very easy-natured too, and knowing that the men of his circle truly delighted in the splendour of his genius, and gave full expression to the value they set upon it whenever opportunity offered, he took the chaff (in a double sense) along with the grain."

(WILLIAM MICHAEL ROSSETTI, *SOME REMINISCENCES*)

itself as progressive and purposeful, found their way into middle-class homes. Department stores were just beginning to make an appearance, but much of what our young couples would have seen in them was shoddy and mass-produced.

Georgie and Ned shared William's high ideals but not his income. Their prize possession was a solid oak table made at the Boys' Home in Euston Road. It arrived in time for their first dinner party, but Georgie's rush-bottomed chairs did not, so the guests—the poets William Allingham and Charles Algernon Swinburne—had to sit on the table. Though it was not nearly as grand as Janey's, Georgie thoroughly enjoyed having her own establishment and loved to be "amongst those who painted pictures and wrote poetry." Swinburne, only twenty but already fond of a drink, was a frequent visitor who often had to be sent home at the end of an evening in a cab, labeled, or decanted on to the pavement, where Gabriel reported him "describing geometrical curves."

Mrs. Catherwood, a relative, sent a small walnut piano that Ned set to work to paint, and soon it glowed with all the color and romantic suggestion of his early work. Despite their precarious financial position and Mrs. Beeton's recommendation that an annual income of £150 was the correct sum for employing domestic servants, Georgie had a little maid of all work, and, as well as entertaining at home, the couple made trips to the theater with friends "in our thousands." Georgie would tell the story of one startled usher who, taking fright at the sight of Lizzie's tumbling red hair at one end of the row and Swinburne's at the other, exclaimed, "Good Lord, there's another of 'em!"

The constant money worries of Ned's childhood were still a feature of the Burne-Joneses' early married life, but Georgie was used to scrimping and they were kept afloat somehow by small checks from Mr. Plint, a businessman who had commissioned a painting from Ned, and the serendipitous discovery of a half-sovereign lodged in Ned's waistcoat pocket. Ned never quite overcame his anxiety about money and, since he did not have a bank account, tended to be "hopelessly bewildered" by Plint's small checks, preferring "coin of the realm" that he could "put into a box and sit upon."[3]

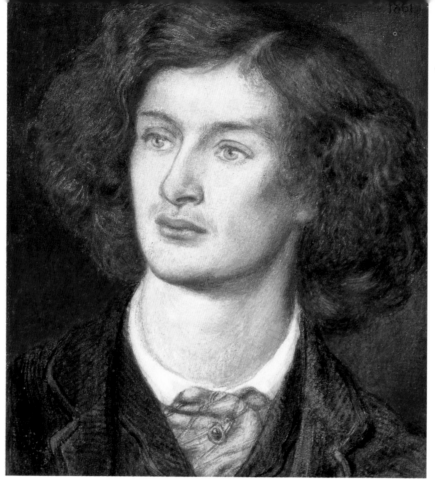

ABOVE: ***PORTRAIT OF***
ALGERNON CHARLES
SWINBURNE *by Dante Gabriel*
Rossetti.

Early in 1861 the Burne-Joneses were back at Red House, celebrating the birth of Jane Alice Morris, always known as Jenny. William was a more enthusiastic and delighted father than this terse note to Madox Brown might suggest. "Kid having appeared," he wrote on the morning of 17 January, "Mrs. Brown [who had been assisting Janey] kindly says she will stay till Monday, when you are to come and fetch her please." He enclosed a list of train times and added, "Janey and kid (girl) are both very well." The christening was carried off in high style with a lavish medieval banquet. There were so many guests that the drawing room at Red House had to be turned into a dormitory for the men. Swinburne collapsed on the sofa. Georgie marveled as Janey, looking pale and lovely in a long flowing gown, organized a bed to be made up on the floor for the Scottish artist Peter Paul Marshall. Her friends seemed to her heroic figures from a legendary age.

However, the responsibilities of parenthood were beginning to weigh on William. For the first time he felt the lack of a proper "profession." Gabriel was successfully launched as a painter, Ned was beginning to attract commissions, Webb could confidently describe himself as an architect, but William's own career path was less clear. His first volume of poetry, *The Defence of Guenevere*, had been neither a critical nor a financial success and, although a man of means, the income from his shares in Devon Great Consuls was prone to fluctuation (it had declined from a peak of £819 per annum in 1857 to £572) and Red House had already set him back £4,000.[4]

In a long autobiographical letter to Andreas Scheu, an Austrian furniture designer, he describes how, finding "that all the minor arts were in a state of complete degradation, especially in England," he set about "with the conceited courage of a young man . . . reforming all that: and started a firm for producing decorative articles." A few short months after Jenny's birth, with £100 worth of backing from his ever-supportive mother, he "set up a sort of shop" at 8 Red Lion Square, where he and six friends (making the magical seven again), all partners with a nominal investment of £1 each, could produce and sell painted furniture. Gabriel, who envisaged "a shop like Giotto! and a sign on the door," was a partner and so was Ned, who was the first to recoup his investment with four tile designs, for which he was paid five shillings each. Madox Brown came in with them, as did Philip Webb and William's best man, Charley Faulkner. The seventh partner was Peter Paul Marshall, who did less work in the early years than his inclusion in the name of Morris, Marshall, Faulkner & Co. might suggest.

ABOVE: Jane Morris and baby daughter, Jenny. Janey, although helped by servants, now found her hands full for William had put her in charge of the Firm's embroidery workshop.

The partners of what was soon being referred to as the Firm were paid five shillings for attending meetings, which provided Ned, now an expectant father, with some financial security. He and Georgie moved to a larger set of rooms at 62 Great Russell Street where their neighbors were the *Punch* illustrator George du Maurier and his new wife, Emma. They became friends, although Ned later fell out with du Maurier over his parodies of Rossetti and Swinburne in *Punch*. The new rooms were conveniently close to the Firm, where Georgie, too, was now employed in the painting of tiles, while Janey, whose keen eye for color and design was developing quickly, supervised the embroidery workshop. William's lofty aims for simplifying life are exemplified in his much-quoted exhortation: "Have nothing in your houses that you do not know to be useful, or believe to be beautiful." But at the Firm he also wanted to evoke the spirit of a medieval workshop, where there was pride in work and joy in working together. There were frequent practical jokes—almost always played on Topsy—like the time when a roll of parcel, made entirely of wrapping, was delivered to him.

Gabriel referred to the workroom as the Topsaic laboratory. William was much in evidence, ensuring that, despite Philip Webb's assertion that business was conducted "like a picnic," the Firm flourished. The contrast between the dim interior of the Firm's first-floor showroom and the new dazzling department stores springing up in the West End was marked. These great emporia of luxury and ostentatious display set out to entice their customers, while curious visitors to the showroom on the first floor of Red Lion Square found themselves in a shadowy space filled with "bewildering treasures," which William, dressed in his blue worker's shirt and round hat, and with dirty hands, would show them with the impatient air of a busy man torn from something else that he would much rather be doing. Boosted by such eccentricity, business boomed.

In the light of William's subsequent zeal for socialism, the irony was that only the wealthy could afford the beautiful objects he sold and his bohemian behavior seemed only to fuel aristocratic demand. Much later he would complain about having to "spend my life in ministering to the swinish luxury of the rich!" But for now he saw himself as waging a battle against the great tidal wave of industrialization, mass-production, and greed he saw all around him. His hobbies of woodcarving and

ABOVE: A photograph of the "Medieval Court" at the International Exhibition, London, 1862, giving a glimpse of the highly ornate fireplace, candlestick, lantern, bas-relief, and an impressive carving of a bird of prey.

embroidery stood him in good stead at the Firm, as did the experience of decorating Red House, and—much to Gabriel's surprise—William rapidly combined his genius for design with his talent for business, turning himself into a creative shopkeeper who made and sold the things he himself would like to buy.

The International Exhibition at South Kensington in 1862 provided a platform for the first public showing of the Firm's work and William rose to the challenge, creating a "Medieval Court" (a great novelty in a predominantly modern and industrial exhibition) that included a sofa by Gabriel and half a dozen of his own pieces, such as a cabinet painted with scenes from the life of St. George, as well as screens, embroidered hangings, chests, chairs, an inlaid escritoire, and bookcases.

The popular press had a field day. "Pre-Raffaelistism has descended from art to manufacture," trumpeted the *Illustrated Exhibitor*.[5] *The Building News* complained that the pieces "are no more adapted to the wants of living men, than mediaeval armor would be to modern warfare, middle-aged cookery to civic feasts, or Norman oaths to an English lady's drawing-room."[6] Nevertheless, plenty of pieces sold and the Firm had further orders for painted cabinets at fifty and thirty guineas, plain black-stained chairs at twenty-five or thirty shillings, and serge and cotton embroidered hangings at twelve and fifteen shillings a yard, as well as considerable interest in William's first designs for wallpapers and tiles.

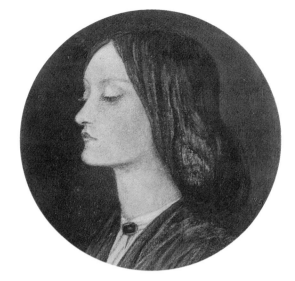

LEFT: ***MISS ELIZABETH ELEANOR***
SIDDAL *from a watercolor*
drawing by Dante Gabriel
Rossetti, dated 1854.

I N 1861, LIZZIE, GEORGIE, AND JANEY were all pregnant. Georgie was safely delivered of a boy.[7] Lizzie's pregnancy, sadly, was more problematic, and in May she gave birth to a stillborn child. "My dear Ned, Lizzie has just had a dead baby" Gabriel wrote sadly on 2 May, entrusting him with the job of telling "Top and all." The baby—a girl—had been dead in her womb for two or three weeks and the trauma tipped her into madness. Ned and Georgie, visiting soon afterward in Chatham Place, found her crouched in a low chair over the empty cradle. Her face looked more than usually pale against the striking mass of her red hair. "Hush, Ned," she cried as they approached, "you'll waken it."[8]

It was important to get Lizzie away from the site of so much sadness and illness. The malodorous river gave Gabriel an ulcerated throat and left Lizzie weak and listless. Friends rallied. Lizzie spent some dislocated weeks with Emma and Ford Madox Brown in Kentish Town. Janey and William invited her to spend the summer at Red House, but there her laudanum addiction continued unchecked and she never really recovered. In February 1862 she died in the cold dark rooms at Chatham Place, a phial of laudanum by her side. She was thirty-two years old. A fog of rumor and speculation surrounds this episode in Gabriel's life. His niece, Helen Rossetti Angeli (daughter of William Michael and his wife Lucy, Madox Brown's eldest daughter, who married in 1874), made her intentions to restore Rossetti's reputation clear when she subtitled her biography of her uncle "His Friends and Enemies." In her account, Lizzie took the drug intentionally, "*so far as intention and responsibility can be attributed to one already at the moment under the influence of drugs* [Angeli's italics]." Gabriel made a brief statement at the inquest insisting that Lizzie was, on that Monday evening, "perfectly well." She had accompanied him and Swinburne to dinner at the Sablonière Hotel in Leicester Square, where "she seemed somewhat between flightiness and drowsiness, a little excited." Gabriel had taken her home in a cab at 8:00 P.M. then left again an hour or so later for the Working Men's College, just as she was going to bed. On his return at 11:30 P.M. he had found her in bed, snoring

"I mean by a picture, a beautiful romantic dream of something that never was, never will be—in a light better than any light that ever shone—in a land no one can define or remember, only desire—and the forms divinely beautiful."

(*THE MEMORIALS OF EDWARD BURNE-JONES*)

and "utterly without consciousness." A doctor had been called. She had not, Gabriel insisted, ever spoken of wishing to die. Indeed, he told the court, she had bought herself a new mantle the day before and talked of going to the country. He was open about her dependence on laudanum, which, like so many Victorian women, he explained, she took "for her nerves."[9] The coroner returned a verdict of "accidental death." But, according to his biographer, Gabriel had kept a single and significant detail from the court. Before summoning the doctor he had detached a note he found pinned to Lizzie's nightgown. The scribbled message said simply: "Take care of Harry." Harry was her brother, the youngest of the family and mentally retarded, and Gabriel did continue to support him with small amounts of money throughout his life. This note was said to have been burnt by Madox Brown, who stayed beside his friend "through the last agonising hours."[10] We will never know if Lizzie did indeed leave a suicide note, but we do know that Gabriel, distraught, haunted, and consumed with guilt, melodramatically placed the only manuscript of his poems in Lizzie's coffin before she was buried in Highgate Cemetery. Four weeks later, on 25 March 1862, Janey Morris gave birth to a second daughter, Mary, always known as May.

Gabriel grieved and could not believe that Lizzie was dead. Chatham Place was a ghastly ghostly place to him now, and he could no longer sleep there. For a while he lodged in chambers in Lincoln's Inn Fields, but he then took a house in Chelsea, in Cheyne Walk, where, over a period of several years, he painted what may well be his best picture. *Beata Beatrix* purports to be a painting of Dante's Beatrice but is actually all about Lizzie. Eyes closed, she leans yearningly forward flanked by two figures. One is Dante, the other Love. A haloed bird drops a white flower into Lizzie's hand—not a lily but a poppy, the symbol of sleep and death, and also the source of opium, the drug from which she died.

Lizzie's death rocked the residents of Red House and made William more determined that ever to draw his friends about him. The Firm was increasingly successful but the journeys up and down to Red Lion Square were beginning to take their toll on him. He wanted to build the proposed extension to Red House, install

*OPPOSITE: **BEATA BEATRIX** by Dante Gabriel Rossetti. Gabriel painted this picture of Lizzie from drawings and memory after her suicide in 1862.*

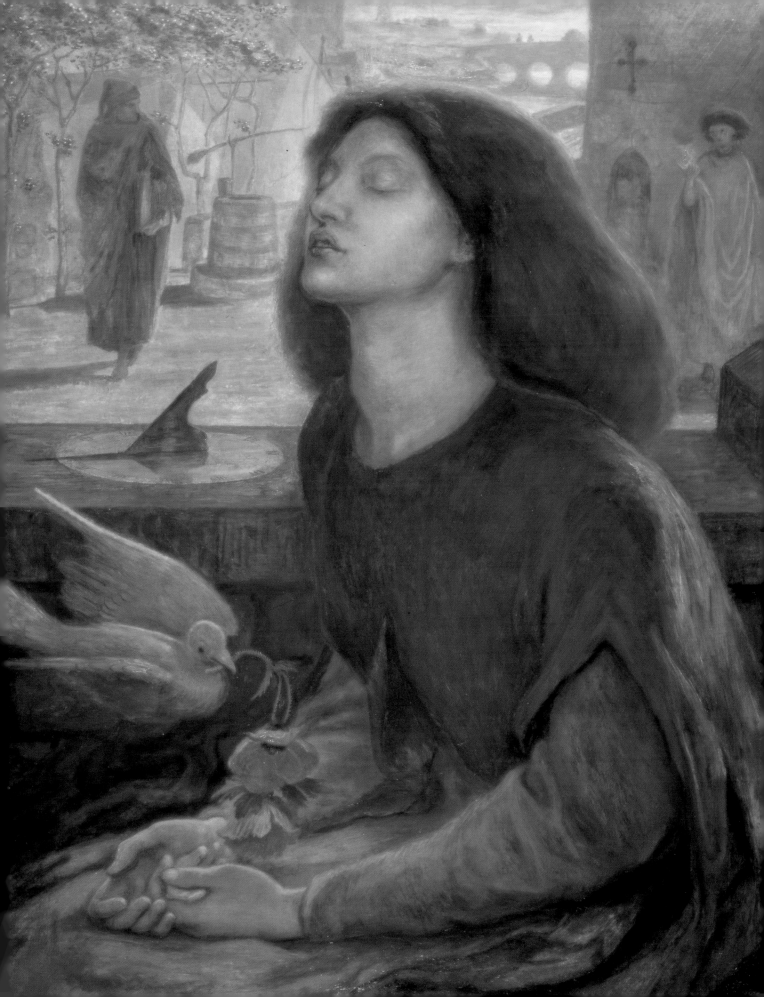

his dearest friends the Burne-Joneses and relocate the Firm to Kent. Ned and Georgie, who were fast outgrowing their Great Russell Street rooms, were enthusiastic about the idea of joining forces. Georgie referred wistfully to "the lovely plan" that was made for them all to be united under one roof at Red House. The proposal gave them separate entrances and privacy if they needed it.

In happy anticipation, in the late summer of 1864, the two families went away on holiday together with the Faulkners to Littlehampton, on the Sussex coast. "Three most happy September weeks we spent there," Georgie recalled. "Time passed lightly for Janey and me, with all responsibility of housekeeping taken from us by kind Mrs. Faulkner [Charley's mother]." They spent their days on the beach, building sandcastles, which William reinforced with gingerbeer bottles, and "the evenings were always merry with Red House jokes revived and amplified: laughs with so little cause, and yet the cause remembered still! For instance; the broken spectacles hurled from the window one night by Morris, in momentary rage at their failure and in firm belief that he had another pair to replace them—then his discovery that spectacles number two were not at hand, his wretchedness at having cast away number one, and his search for them before breakfast next morning, bareheaded, painfully examining every step of the road in front of the house on the chance of finding and humbly taking them to be mended."[11]

Writing much later with the plans "clean and unused" before her, Georgie reflected on "how differently all our lives would have gone if this scheme had been carried out."[12] But it was not meant to be. On their return from holiday their little son Phil developed scarlet fever. It seemed a slight case and at first Georgie was unconcerned enough—or rash enough—to pay a visit to Red House, where she might have spread the disease among the Morris children, for soon she caught the

BELOW: SKETCH OF LITTLEHAMPTON BEACH by Charles Edward Conder.

illness herself. This brought on the premature birth of her second son, Christopher, who became infected and died. It was "an evil time" for Georgie, who was delirious, and Ned, beside himself with grief. Ruskin, who had grown very close to the couple and taken them to Italy with him the year before, had the street outside laid as "deep as a riding school with tan" to keep the horses' hooves from disturbing Georgie.[13]

After three months, during which Ned "lived most anxiously from day to day," Georgie recovered, but the scheme to live together at the "Palace of Art" at Red House was at an end. Ned had been unable to work and, as he wrote to his friends, he could no longer afford the expense. William, just then confined to bed with rheumatism, admitted frankly to Ned that he had cried at first with disappointment, but then another emotion had surfaced: relief that his friend had survived the crisis. "Suppose," he wrote, "in all these troubles you had given us the slip what the devil should I have done? . . . it frightens me to think of, Ned."

It was time for a radical rethink. Commuting from Upton to Red Lion Square was proving unworkable and so, in the middle of 1865, William made the painful decision to abandon Red House and move his family to London. In September Georgie and Ned paid their last visit to Upton. The afternoon was lovely and the four friends took "a farewell drive through some of the beautiful little out-of-the-way places that were still to be found in the neighborhood," but it was a painful business for William who was so distraught at leaving Red House, the intensely personal expression of his own youthful, exuberant, artistic, and highly romantic self, that he would never return there.

The dream was unravelling.

ABOVE: Ned Burne-Jones's drawing of his burly friend encircling his little daughters perfectly captures the tenderness William felt for Jenny and May.

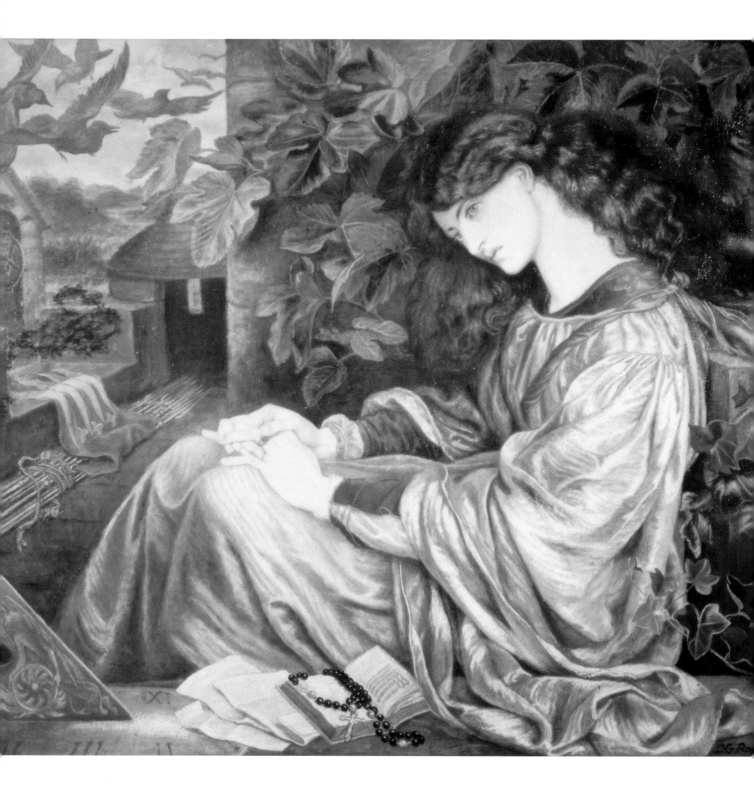

Chapter 8

TANGLED WEBS

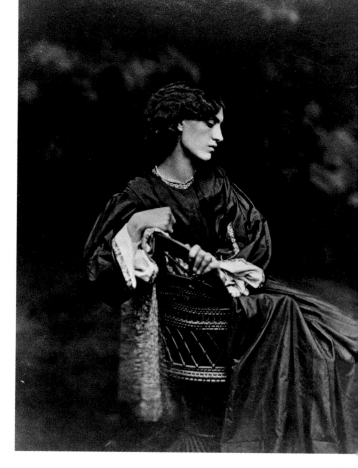

"To Queen Square, to dine with Morris and find just alighting Mrs. Ned in a gorgeous yellow gown: it is a full dress party! And I in velveteen jacket."

WILLIAM ALLINGHAM

HANGE WAS IN THE AIR. Georgie, weakened by her illness and the tragedy of losing little Christopher, was sent to Hastings to recuperate while Ned set to work to find them a new home, for Georgie had a horror of returning to their old rooms in Great Russell Street, with all their sad and painful associations. Ned resolved to move immediately and, with the help of his old friend Crom Price, began his search in Kensington. The past few years had seen a general artistic drift westward. Millais and Effie, for example, had signed a lease in 1861 on a newly built house at 7 Cromwell Road, across the road from where the Natural History Museum would stand. Speculative builders and developers were changing the face of South Kensington, which would soon become "the most residentiary quarter in the metropolis."

But the district around Kensington High Street was still relatively rural. Anne Thackeray Ritchie, in her novel *Old Kensington*, rhapsodizes about "the hawthorn spread across the fields and market-gardens that lay between Kensington and the river" and the lanes that ran to Chelsea and Fulham.

The house Ned and Crom found for Georgie at 41 Kensington Square, was tucked away and "undisturbed by the world, with nothing except gardens between it and the narrow High Street" (only widened in 1868 when the Metropolitan Railway opened and established Kensington as the latest fashionable suburb).[1] Its position on the north side of the square meant that the light was not perfect, but

ABOVE: "Mrs. Morris required to be seen to be believed, and even then she seemed dreamlike," wrote W. Graham Robertson, commenting on the striking likenesses of Rossetti's many portraits.

OPPOSITE: LA PIA DE TOLOMEI by Dante Gabriel Rossetti. Janey posed for this picture of an unhappy wife regretfully fingering her wedding ring. Swinburne described the "strange look of wonder and sorrow and fatigue" in her eyes and certainly it is a painting drenched in sadness.

ABOVE: Pomegranate design by William Morris. William's block-printed wallpaper patterns were more expensive than his competitors' roller-printed designs, but they lasted longer and proved enduringly popular.

there was a garden, long enough for a game of bowls, and Ned promised himself a pavilion and "a quiet summer at the back here to pay me for all my bothers."[2] The house, which still stands in the quiet square behind Kensington High Street Underground station, is very lovely: not deep, but tall with wide windows framed with black balconies echoing the elaborate wrought-ironwork of the high ornamental gate. It was late autumn when Georgie arrived and the sunlight slanted through the windows, while the golden trees outside in the square scattered their leaves on the grass. The house—with its four floors, plus good basements and attics—represented a fair leap up the property ladder from their rooms in Great Russell Street and Georgie expressed her approval. They moved in with their oak dining table and Mrs. Catherwood's little painted piano. Friends were generous. Ruskin, for instance, sent a set of Dürer prints. A sewing machine that G. F. Watts had given as a wedding present and that Ned described as "a most clever little thing" did sterling service.[3]

They threw themselves into the task of furnishing their new home. The Firm supplied the "Pomegranate" patterned wallpaper, rolls of blue and green serge, and "any fresh furniture that we needed."[4] For Ned's arrangement with the Firm allowed him to order anything it supplied—which included furniture, wallpapers, furnishings and wine—and offset it against the amounts he would earn for his stained-glass designs and tiles. Workmen came up from Red Lion Square (at seven shillings a day) to install shelves and even a bath.

EDWARD BURNE-JONES TO WILLIAM ALLINGHAM, 1865

"We are settling fast, even looking a bit comfortable—Topsy has given us a Persian prayer-carpet which amply furnishes one room. I have a little crib which I call a library because there I keep my tobacco and borrow books—this room shall be yours for quiet when you come."

(*THE MEMORIALS OF EDWARD BURNE-JONES*)

Within weeks of moving in Georgie arranged a party in Kensington Square to celebrate the marriage of her sister Alice to the artist John Lockwood Kipling. Agnes, the third sister, stayed on for a few weeks and wrote effusively home to their fourth sister Louise: "Oh Louise, if Providence should ever let us feel able to live in this neighbourhood, there is a complete nest of warm hearts which would welcome us and make our last days better than our first."[5]

It was a sociable house from the start. Although they had "left their youth behind" and Madox Brown's beautifully thick thatch of hair had turned quite gray, the friends still entertained each other frequently.[6] One friend or another would call by most evenings at Kensington Square—often it was William with "a glorious haul of picture books" under his arm, just as at Oxford. Alternatively the Burne-Joneses might go out to dine at Gabriel's riverside house in neighboring Chelsea, where they could count on excellent wine and a good meal, beautifully served by staff specially hired for the occasion. According to his studio assistant, Harry Treffry Dunn, Gabriel's "greatest pleasure was to gather round him those whom he liked and his little social dinners when they took place were events to be remembered."[7] Guests would find the table extended to its utmost limits with a silver epergne filled with flowers in the center, reflecting the two dozen wax candles that burnt brightly in the huge Flemish brass wrought candelabra above. Gabriel, who devoted much time to his seating plan, loved the point in the evening when "romances and racy tales" were told. The American artist James McNeill Whistler, a near neighbor of Gabriel famed for his bubbling, caustic wit, could be relied upon on these occasions.

Ned and Georgie's first Christmas in Kensington was a family one, although at the last minute Ned invited a "Firm" friend, the unmarried William de Morgan, whose stained glass and tiles were widely admired. William worked from the basement of his home in Chelsea, where he had set up a kiln. Once, experimenting with a lustre decorating technique, he had sent a sheet of flame up the chimney setting fire to it and burning down the roof of the house. His neighbors were thus mightily relieved

ABOVE: *41 Kensington Square, where Ned and Georgie lived for two years from 1865, now boasts a blue plaque.*

when he eventually transferred his business to Merton Abbey to be near the new workshops of Morris & Co.

The Pre-Raphaelite painters were beginning to benefit from a Victorian boom in the art world and the fortunes of all were improving, even those of Madox Brown and Emma, who had taken a new house in elegant Fitzroy Square. They gave a farewell party in Fortess Terrace, the scene of Ned's and Georgie's courtship, and invited all their friends. Gabriel was there, passing like a prince through the small rooms. Georgie recalled Whistler being at his "most frighteningly droll."

At this time Gabriel began to indulge his penchant for exotic animals, housing them—to the consternation of his Chelsea neighbors—in his garden. In 1865 he wrote to Ned to say that he was thinking quite seriously of buying a lion, although in the end he decided against it because he would have to heat the garden with hotwater pipes in the winter. He told the poet Robert Browning that he wanted an elephant "to clean the windows; and then, when some one passes by the house, they will see the elephant cleaning the windows, and will say, 'Who lives in that house?' And people will tell them, 'Oh, that's a painter called Rossetti.' And they will say, 'I think I should like to buy some of that man's pictures'—and so they will ring, and come in and buy my pictures."[8]

Janey and William were by now back in London. In the autumn of 1865 they moved to Queen Square in Bloomsbury, conquering what Georgie called "the dinginess of the neighbourhood" by making their house shine with whitewash, "a background that shewed better than any other the beautiful fabrics with which the house was furnished."[9]

The Morris family, swelled by the addition of Janey's sister Bessie Burden, shared the large Queen Anne townhouse with the Firm, which had long outgrown its old premises at Red Lion Square. The ground floor was turned into an office and showroom, where William himself, in a dark blue linen shirt, would show the wallpaper patterns and make out the bills. A large ballroom at the back of the house was converted into a principal workshop, with further workshops in the small court beyond.

LEFT: At Queen Square Janey's long oak table was laid with blue china, old silver, and delicate green glasses designed by Philip Webb and made by Powell for the Firm. May Morris described them as gleaming "like air-bubbles in her quiet candle-light."

On their first moving to Queen Square "a pleasant custom" had begun of Ned and Georgie dining once a week to meet other members of the Firm. "In these evenings," Georgie wrote, "the merriment of our youth was revived for a time." However, she soon noted that Janey was "now so much out of health that I fear her share of the entertainments was more fatigue than pleasure, and gradually they came to an end. The men never ceased to meet regularly though, at one house or the other."[10]

It was at these dinners, or "jollies" as William called them, that Ned and Georgie would be regaled with the latest batch of William's 15,000-line epic poem, *The Earthly Paradise*. Janey, supine on her sofa in the grip of a mysterious languor, would lie in a dreamy state while Georgie, who had recently given birth to a daughter, Margaret, and was consequently exhausted, was forced to stab herself with pins to keep awake.[11]

After the failure of his utopian plans for Red House, William faced forward. He threw his considerable energies into work. He restructured the Firm, appointing a new business manager, George Warington Taylor, and attracted exciting new commissions from the new South Kensington Museum (now the Victoria and Albert) and St. James's Palace. For Janey, though, "living above the shop" represented a move down in the world

ABOVE: One of Edward Burne-Jones's iconlike panels in the Green Dining Room, part of a trio of refreshment rooms in the new South Kensington Museum and one of the first important commissions to come the Firm's way. The stained-glass windows filter the light and lend a warm glow.

and she responded by lapsing into silence and, in the manner of the time, taking increasingly to her sofa. Her melancholy beauty and semi-invalid status reawakened Gabriel's interest and she began to pose for him at Cheyne Walk. From this point on William's personal happiness began to unravel. He had lost his beloved Red House and now found he was losing his Guenevere to the friend he had once hero-worshiped.

At first the proprieties were scrupulously observed; William would accompany Janey, even staying overnight when the sittings required it. But soon the pressure of business and the obvious strength of feeling between his wife and his friend, kept him away. Gabriel was possessed. As before with Lizzie, he made masses of drawings of Janey, capturing a sensual brooding beauty that is not always matched in the surviving, rather stiff, photographic studies of her. The way that Gabriel softened, smoothed, and idealized his female sitters was noted by his sister Christina, who wrote a poem entitled *In an Artist's Studio* about an painter who feverishly portrays his model "Not as she is, but as she fills his dream."

Janey certainly filled Gabriel's dream. They began a relationship, the strength of which is reflected in the drawings and paintings and particularly in his choice of subject matter. Gabriel painted Janey again and again in the guise of classical heroines such as Proserpine and La Pia, lonely beauties trapped in unhappy marriages, entombed by hated husbands underground or in fortresses, where they pined or died.

It was a difficult time for William, who appears never to have blamed Gabriel or his wife, who struck the novelist Henry James at this time as a "figure cut out of a missal." He certainly never contemplated a divorce or any other drastic action. Yet he felt the betrayal keenly and his inner anguish and lonely regrets were channeled into the spare, painfully honest poems he wrote, but never published, in this period.

In the late summer of 1869 Janey traveled, with a solicitous William, to the German spa resort of Bad Ems, where it was thought the waters might prove beneficial. We do not know exactly what was or might have been wrong with Janey. She suffered from excruciating backache from time to time and the suggestion is that her complaint was gynecological in origin. For the lovers illness was yet another

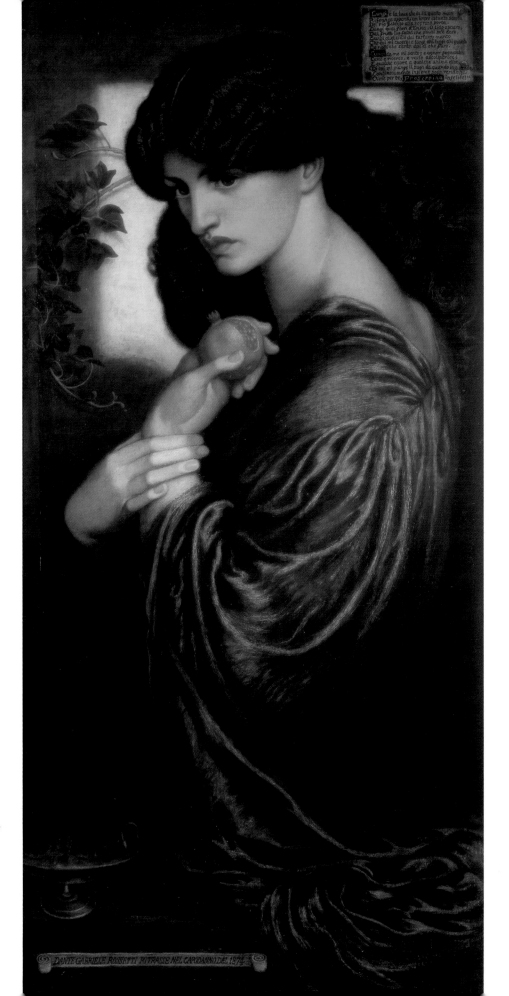

RIGHT: **PROSERPINE** *by Dante Gabriel Rossetti. One of eight versions of Janey as the reluctant wife of Pluto painted by Gabriel over a six-year period.*

bond, for Gabriel was something of a hypochondriac. His secretary, Harry Treffry Dunn, claimed that "his nervousness over trifling symptoms turned him at times into a veritable *Malade Imaginaire*."[12] Gabriel had corresponded clandestinely with Janey when she was on holiday in Southwold (their go-between being Charles Augustus Howell, Ruskin's secretary, who ingratiated himself with Gabriel by a gift of Madeira wine) but he now wrote openly, bombarding her with tenderly sympathetic letters. These began "Funny sweet Janey" or "Dearest kindest Janey" and often mentioned William, since it was likely that he might read them. "With love to Top" he finished airily, or, "Give my love to the dear old thing and bear in mind how much you are loved by Your affectionate D. Gabriel R." Perhaps Gabriel hoped to mask his passion by these cheery salutations, but his jealousy is revealed in the savagery and cruelty of the accompanying caricatures, which mocked William, who was shown adding to Janey's torment by reading from his voluminous *Earthly Paradise* while she was trapped in a bath of spa water, forced to drink yet more of the stuff.

Back in London, gossip began to circulate about "Gabriel being so fond of Mrs. Top."[13] He had acted "like a perfect fool" at a dinner at the home of the poet William Bell Scott, a friend, seating himself beside Janey, ignoring all the other guests, and doing nothing "to conceal his attachment" while her husband had sat grimly by. Worse was to come. In October it was Bell Scott's turn to attend a dinner at Queen Square where William read aloud from *Love is Enough*. Neither Gabriel nor Janey was there and Bell Scott was scandalized to discover that Gabriel's prior engagement was, actually, Janey at his own house for the night. "Is it not too daring, and altogether inexplicable?" he exclaimed.[14]

Divorce was relatively rare in Victorian times and always painful. A divorced woman had precious few rights and Janey, who we must remember had been elevated out of poverty by her marriage to William, would have risked social censure, public disgrace, and the loss of her daughters if she had contemplated this step, for the guilty party was always denied custody. Besides, both men doted on Jenny and May. Gabriel sent them a pair of dormice with a note that whimsically linked him to William: "I know you will take great care of them," he wrote, "and always give them anything they are fond of—that is, nuts, apples and hard biscuits. If you love them very much I dare say they will get much bigger and fatter and remind you of your papa and me."

RIGHT: Ned draws himself, left behind holding the baby, while the Morrises, Philip Webb, and Warrington Taylor, all being copiously sick over the side, sail for France.

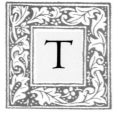

*ABOVE: **PORTRAIT OF A WOMAN** by Edward Burne-Jones. Mary Zambaco, who had recently left her husband, came into Ned's life at a period when he was feeling neglected by Georgie, whose attention was claimed by her young son and baby daughter.*

HERE WERE PROBLEMS, too, in the Burne-Jones household. In the summer of 1866 the birth of their daughter Margaret had prevented Georgie and Ned from traveling to northern France with Janey, William, and Philip Webb on a tour of churches. Cholera was again reported in the capital and Georgie, particularly fearful for the safety of her baby after the earlier scarlet-fever tragedy, gratefully accepted the poet William Allingham's invitation to the whole family to stay with him in the New Forest. They left London in the middle of August and were joined by William and Philip Webb a fortnight later. The picture painted in various accounts—including Allingham's diary—is of innocent fun and larky picnics on the beach, where William was buried up to his neck in shingle.

However, this innocent atmosphere masked the more turbulent emotions experienced by more than one member of the party. William had already felt the pain of betrayal and now Georgie's world, too, was about to tilt and rock, for Ned's emotional life had been turned upside down by a young woman of extraordinary beauty. Her name was Mary and her mother, Euphrosyne Cassavetti, known as The Duchess, was a wealthy Greek patron of the arts. She had decided that her high-spirited daughter, who had recently left her husband, should have her portrait painted by the new painter Edward Burne-Jones of whom she had heard so much.

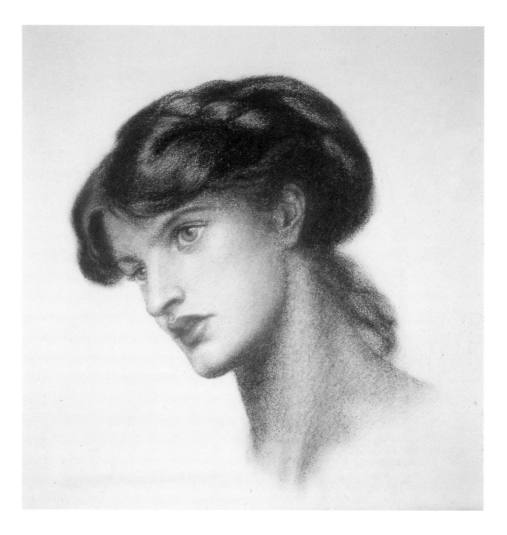

In her careful and celebratory biography of her husband, Georgie scarcely refers to Mary; she certainly writes nothing about the affair that ripped through her cosy domesticity like a forest fire, leaving her marriage scorched and tattered. But there are many clues, not least of them the fact that Georgie chose to end the first volume of the *Memorials* at the very point when the emotional touchpaper was ignited and resume the second volume at a later date, thus conveniently losing the whole episode.[15] If only life could be so tidy. Mary left an ineradicable mark on the Burne-Jones marriage, and much, much later Ned would still write nostalgically of that "strange & incredible" time and wish he had been thirty-five again.

Who was Mary Zambaco? Georgie refers to her only cryptically as "part of what may be called the Greek colony in London."[16] Born Mary Cassavetti, she was the granddaughter of Constantine Ionides, the patriarch of an extraordinary clan of successful Greek businessmen and influential and wealthy artistic patrons. At the age of fifteen, on the death of her father, she inherited a fortune said to make her worth £80,000. The *Punch* artist George du Maurier, an unsuccessful suitor and thinly disguised bounty hunter, called her "rude and unapproachable but of great talent and really wonderful beauty." She married Demetrius Zambaco, doctor to the Greek

ABOVE: PORTRAIT OF MRS STILLMAN by Dante Gabriel Rossetti. Marie Spartali Stillman was a lively likable woman who modeled for Gabriel and Ned and went on to become a painter of some distinction, exhibiting in England and America.

"There are two kinds of women I like; the very good, the goldenhaired, and the exceedingly mischievous, the sirens with oat-coloured hair. Perfect imps they are. Not that I've any theory about it. When I see red hair I like it. Rossetti's pictures of redhaired women I like exceedingly but I don't think red hair does well with my own work."

(BURNE-JONES TALKING)

community in Paris, in 1861 but left him after a few years and returned, with her two children, to live with her mother at 47 Gloucester Gardens in Kensington. She was part of a trio, with her cousins Marie Spartali and Aglaia Coronio, of beautiful and brilliant young Greek women who became known as "The Three Graces" and whose features can be discerned in Pre-Raphaelite painting. She had glorious red hair. This, according to her cousin Luke Ionides, framed "almost phosphorescent white skin." But it would be a mistake to think of her only in terms of a model, for she had a considerable talent of her own as a sculptress and portrait medalist. It was as a sitter, however, that she came to Ned and through studying her lovely face that he fell in love with her. Hers was "a wonderful head," he wrote; "neither profile was like the other quite—and the full face was different again."[17] For him she was "like the billows of the sea," a dangerous, unpredictable, and yet natural force. She came into Ned's life at a point when he had been married for the famously itchy period of seven years. Georgie's attentions were directed to her new baby and young son. And he could no longer count on the devoted attention of her lively younger sisters, for both Agnes and Louise had recently married. He was feeling neglected and here was a talented and intelligent young woman whose "beauty and misfortune" excited powerful impulses in him to protect and comfort.

It was a painful period for Georgie, who had worshiped Ned since she was a child, devoted herself to him and his career, weathered hardship, poverty and illness. Now, at twenty-eight, with her own looks fast fading, she was eclipsed by the blindingly lovely Mary Zambaco.

The progress of the affair can be read—as may Gabriel's with Janey—through the stylistic changes that Ned's work underwent during this period. Both men painted their mistresses in classical guise. In the early days of his infatuation Ned depicted Mary, lithe and lovely with tumbling hair and large tragic eyes, as Psyche struck by Cupid's arrow, but gradually, as guilt and panic set in, the tone changed to something more sinister. The vulnerable image gave way to a portrayal of her as a sorceress, a controlling woman, her hair alive with snakes, beguiling and imprisoning Merlin.

There is a young artist named Jones,
Whose conduct no genius atones:
His behaviour in life
Is a pang to the wife
And a plague to the neighbors of Jones.
(Dante Gabriel Rossetti)

The crisis came in 1869 and is here revealed in a letter from Gabriel to Madox Brown:

"Poor Ned's affairs have come to smash altogether, and he and Topsy, after the most dreadful to-do, started for Rome suddenly, leaving the Greek damsel beating up the quarters of all his friends for him and howling like Cassandra. Georgie has stayed behind. I hear today however that Top and Ned got no further than Dover. Ned being now so dreadfully ill that they will probably have to return to London. Of course the dodge will be not to let a single hint of their movements become known to anybody, or the Greek (whom I believe he is really bent on cutting) will catch him again. She provided herself with laudanum for two at least, and insisted on their winding up matters in Lord Holland's Lane. Ned didn't see it, when she tried to drown herself in the water in front of Browning's house &x.—bobbies collaring Ned who was rolling with her on the stones to prevent it, and God knows what else."[18]

Gossip and rumor swirled around artistic London. The writer David Cecil records rumors that Ned went to live with Mary at this time and that the two had a suicide pact to drown themselves in the Serpentine. The affair put a strain on all Ned's friendships, especially when a public struggle between the two lovers on the Regent's Canal threatened to tip the business into farce. What seems to have happened is that Ned called off a planned secret flit, and Mary threatened to kill herself by taking an overdose of laudanum. The police had to be called out when she tried to drown herself in the canal "in front of Browning's house" at Little Venice. Ned panicked. The intensity of her emotion and her tempestuous behavior frightened him, and quite simply he ran away. William, hoping to defuse the situation, attempted to take him off to Rome, leaving Janey instructions that she must not sit for Gabriel during his absence abroad (having damped down one fire he did not want to return to find another sensational scandal blazing on his own doorstep). In any event, however, Ned was too ill to travel and they got no further than Dover.

OPPOSITE: *THE BEGUILING OF MERLIN* by Edward Burne-Jones, from "Idylls of the King" by Alfred Tennyson.

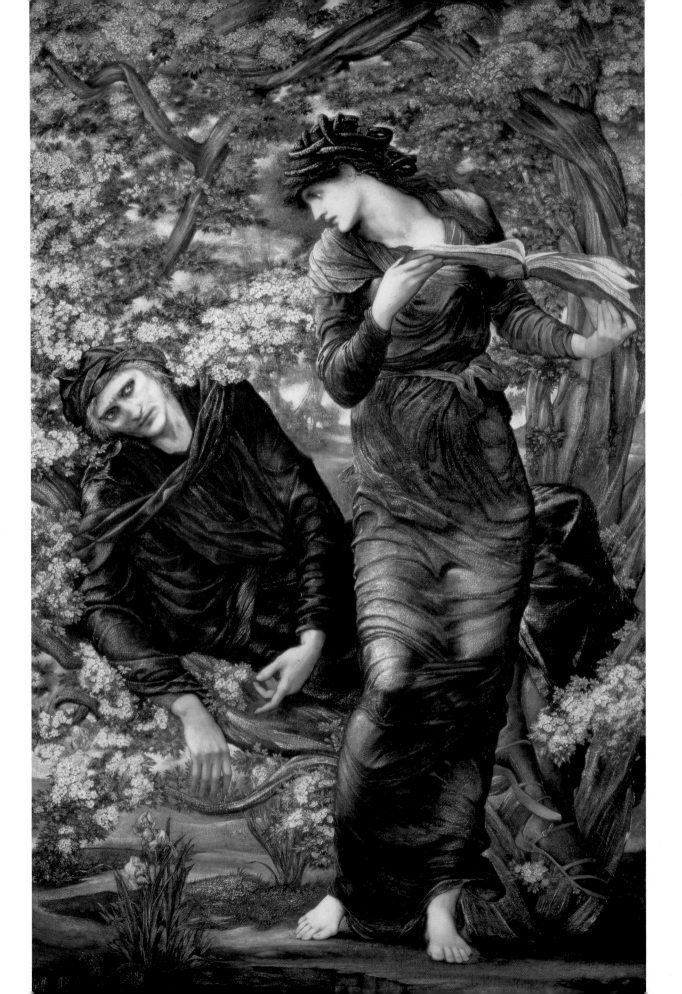

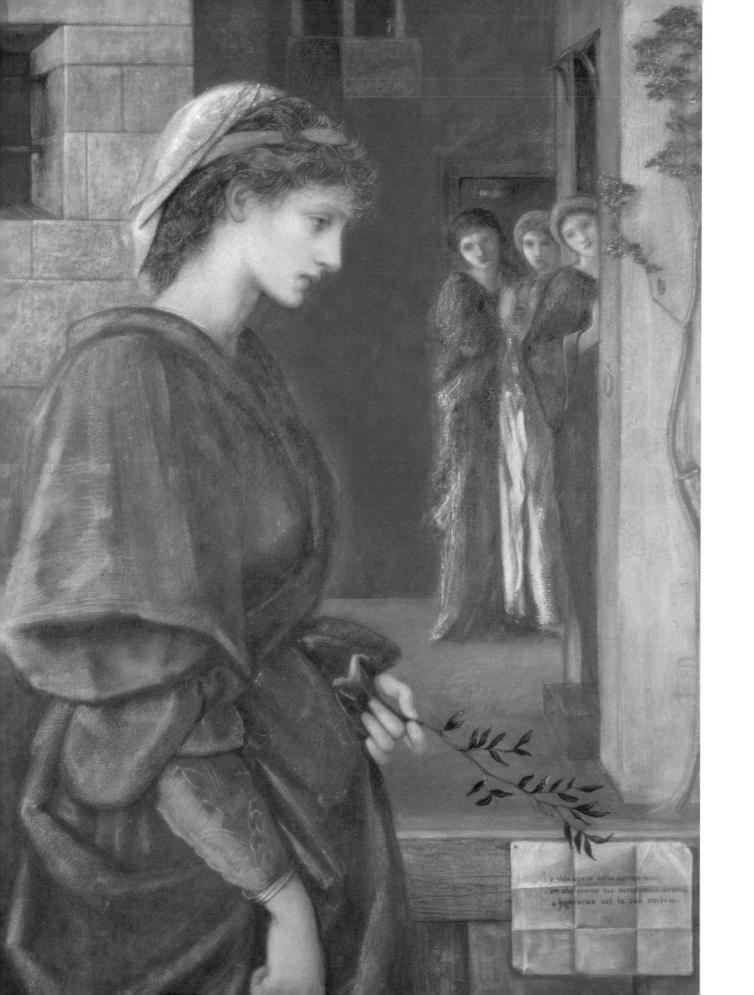

Io vidi donne colla donna mia;
Non che ninna me sembrasse donna,
Ma figuravan sol le sua embria.

EDWARD BURNE-JONES TO HELEN GASKELL, 1895

EDWARD BURNE-JONES TO HELEN GASKELL, 1895

"I wish I was thirty-five—do you know I once was—isn't it strange & incredible?—but it's quite true—and stranger still I was once three and twenty!"

[It is significant that he should have highlighted the two ages which marked turning points in his life—the first, 1856, when he decided to become an artist and the second, 1868, when his affair with Mary was at its stormy height.]

If Ned's love for Mary tested his friendships, it tested his marriage to the limit. "I have been a bad man and am sorry for it," he wrote to Olive Maxse, "but not sorry enough to try to be a good one." "I have been a nuisance to everyone," he admitted to George Howard, "I have been intolerable even to Georgie."

He did not leave Georgie. They lived on together for a further thirty years, but was either ever really happy again? Georgie, who was not yet thirty, continued to run the house smoothly, to cope with the many visitors, and to provide Ned with the stable base he needed for his work. But they had no more children; indeed, from this point on they slept in separate rooms and took separate holidays. Ned continued to draw and paint Mary regularly over the next few years and his response to a drawing that Gabriel made of Mary—at his request—reveals much. The likeness "excited and exhilarated" him "and made me silly—I was so glad," he wrote, "to have such a portrait . . . I can't say how the least kindness from any of you goes to my heart." And his expressed desire to put the drawing in a locked frame, so that only he could gaze upon it, hardly suggests he was trying to break off the affair.

Georgie's stoicism earned her the respect of those around her. Her loneliness excited William's sympathy especially, for was not he in the same boat, married to a spouse who loved another? The evidence of his poems seems to point to a very strong emotional attachment to Georgie, which, however much he may have hoped it would be, was never physically returned.

The Pre-Raphaelites may have rebelled against the art establishment but they remained imprisoned by Victorian conventions. The social stigma attached to divorce blighted the lives of not just the couple concerned but also their children, and Georgie was not prepared to sacrifice her children, even if she was one of the few people to call upon and publicly receive the novelist George Eliot (Marian Evans) and her lover George Henry Lewes when they returned from Germany unmarried but living together as man and wife. Georgie would have heard first hand from her friend of the potential pitfalls and social ostracism awaiting her should there be any alteration in her married state. She resolved to weather the storm.

*OPPOSITE: **BEATRICE** by Edward Burne-Jones, from Dante's "Divine Comedy."*

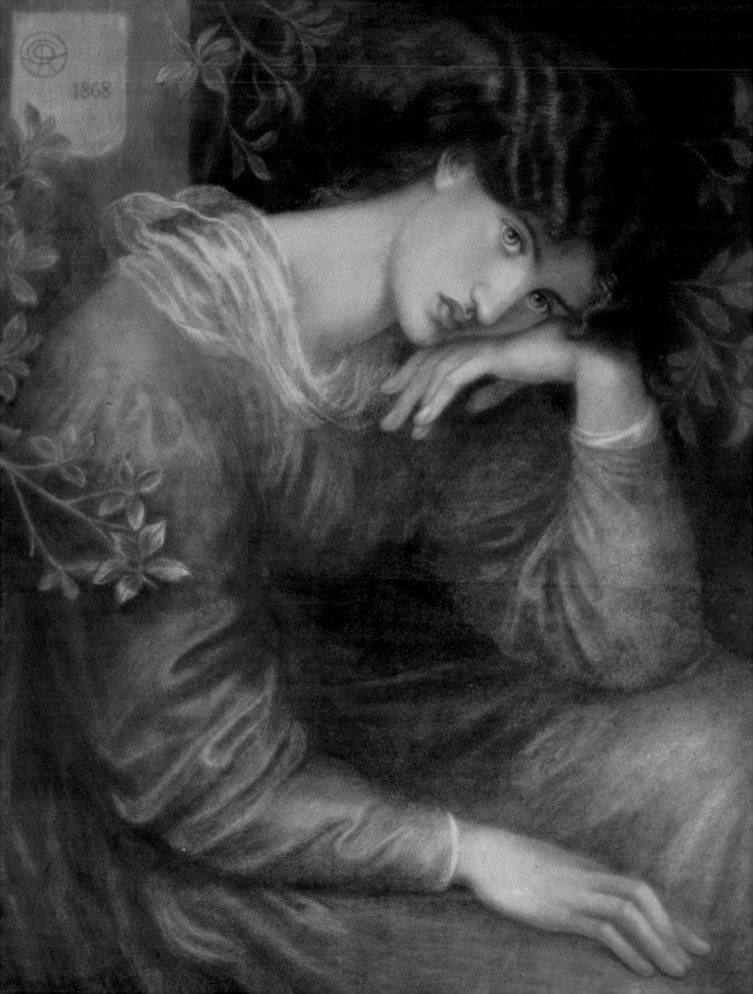

Chapter 9

A PRIVATE EDEN

"16 Cheyne Walk, Chelsea,
5th January, 1863

My dear Mamma,
Can you and sisters, Maria and Christina and
W[illiam] of course, dine here at 6 on Tuesday
next—this day week—to meet Ned Jones and wife?
Also perhaps Browning. Do please as else I shall
have to write appointing a fresh day to all the lot.
<div align="right">Your affect: son,
D.G.R."</div>

ABRIEL'S HOUSE ON THE RIVER at Cheyne Walk deserves a special mention. Extravagantly furnished, bizarrely stocked with exotic animals and much more Victorian in tone than any of William's and Janey's homes, it was the house he sought refuge in after Lizzie's death made it impossible for him to remain in Chatham Place. According to Gabriel's brother, William Michael, Tudor House was the remains of a mansion built by Catherine Parr, the sixth wife of Henry VIII. Gabriel called it a "strange, quaint, grand old place, with an immense garden, magnificent paneled staircases and rooms—a palace." It was certainly large. He paid £225 for the lease of his riverside palace, plus an annual rent of £100 to Earl Cadogan, the landowner, and occupied the house for twenty years until the last months of his life. In those days to rent a house was not just socially acceptable but relatively common when large swathes of London were

*ABOVE: **TUDOR LODGE,
CHEYNE WALK** by Walter
W. Burgess. Gabriel's imposing
house on the river at Chelsea,
which he rented from 1862
until his death.*

*OPPOSITE: **REVERIE**
by Dante Gabriel Rossetti.*

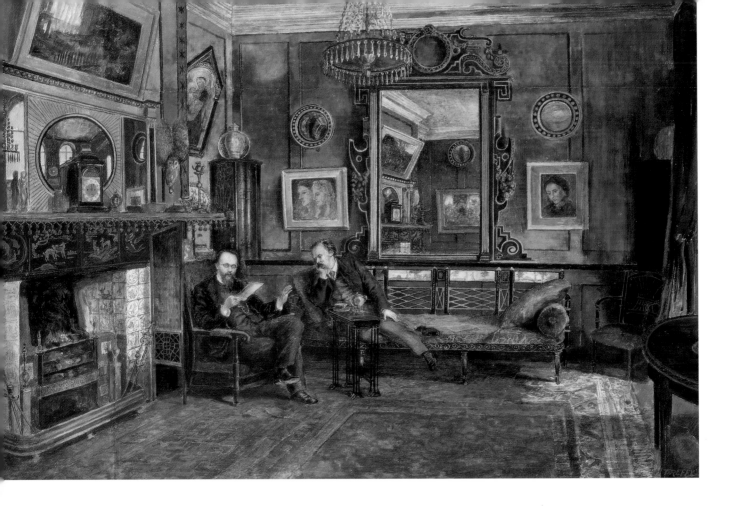

ABOVE: *In this watercolor,*
Henry Treffry Dunn shows
Gabriel reading proofs of his
Sonnets and Ballads *to his*
great friend the solicitor Theodore
Watts Dunton in the sitting room
at 16 Cheyne Walk.

laid out with leasehold properties owned by a few immensely wealthy, often aristocratic, individuals or institutions like the Church or public schools. Gabriel's time at Cheyne Walk began companionably and colorfully enough, although it would deteriorate into dark reclusiveness, the crowding and cluttering of the rooms a literal metaphor for the emotional congestion of his life.

Chelsea was a socially mixed area in the nineteenth century. Gabriel's neighbors included Bram Stoker, the author of *Dracula*, at No. 27; upright couples like Thomas and Jane Carlyle, who had lived at 24 Cheyne Row since 1834;[1] and irregular households like that of the raffish James MacNeill Whistler, who lived at 2 Lindsey Row with his mistress Joanna Heffernan, the model for *White Girl*. The pleasure gardens of Cremorne were just a short stroll from Tudor House and the cry of the shrimp vendor or the apple-woman a constant reminder of the poorer residents of the borough.

Gabriel loved the rakish atmosphere of Cremorne Gardens, which covered roughly twelve acres between the King's Road and the Thames, and offered a variety of outdoor amusements, from dancing under the elaborate pagoda-style ironwork of the dance platform to acrobats, clowns, and music-hall equestrian displays, balloon ascents, fireworks, and spectacles such as cosmoramic pictures and a stereorama.

Many lively accounts of the early years at Tudor House surface in the recollections of his friends, assistants and members of his family. These leave an impression of agreeable intimacy and long jolly evenings in the masculine company

"That fine old building in Cheyne Walk was beyond all comparison the roomiest and sightliest that I had ever as yet inhabited, nor indeed have I to this day been so handsomely housed elsewhere."

(WILLIAM MICHAEL ROSSETTI, *SOME REMINISCENCES*)

of Swinburne, Meredith, Whistler, Alphonse Legros, Frederick Sandys, "and the questionable but fascinating"[2] Charles Augustus Howell, an art agent and adventurer (then working as a secretary to Ruskin) who played a crucial role in one of the least savory episodes in Gabriel's life.[3]

William Michael, who lived mostly at the Rossetti family home in Albany Street but used Tudor House rent free on Mondays, Tuesdays, and Fridays, remembered the period fondly in his *Reminiscences*. But, with the family honor to protect, he is a circumspect chronicler. He gives no hint of any anguish or scandal beyond the irritation of having to sack a slovenly servant, ever disturbing the masculine household.

Gabriel's art assistant, Henry (Harry) Treffry Dunn, another writer of immense tact, paints a charming picture of a pleasantly eccentric establishment but makes no mention of the larger-than-life Fanny Cornforth, who was much in evidence at this time. (William Allingham described her as Gabriel's housekeeper, often a euphemism for mistress.) Nor does he have anything to say about the scandal surrounding the exhumation in 1869 of Lizzie's grave in Highgate Cemetery to recover the book of poems Gabriel had buried with her. Janey Morris's visits are a subject as closed as the cabs she arrived in. And he makes no reference to Gabriel's reliance on chloral, despite the fact that he helped procure the drug for him.

The house at 16 Cheyne Walk still stands, prosperous looking and tidier than it can ever have appeared in Gabriel's time, guarded by big black gates and now cut off from the Thames by the traffic that thunders night and day along the curving Embankment. The surviving sign on the wall of the mews behind Tudor House, requesting "drivers of vehicles to walk their horses through this archway," harks back to a quieter, gentler age, when horse-drawn hansom cabs and omnibuses were the standard method of transport. In the mews the traffic sounds are muffled. The whitewashed walls give off a cool, slightly musty smell. It is almost possible to imagine a time when there were no motor cars and no Embankment, a time when the atmosphere was as "slumbrous as a cathedral close, drowsing in the autumn sun to

LEFT: A watercolor of Gabriel's gloomy bedroom at 16 Cheyne Walk by his assistant Henry Treffry Dunn.

the murmur of the river which flowed in front, and the rustle of the trees that grew between."[4]

During Gabriel's residency the seven windows of the elegant first-floor drawing room looked straight over the Thames toward a distant church with a copper-lined steeple and the old wooden Battersea Bridge, gas-lit at night. Then the Thames was much more of a public highway, bustling with barges, steamships, and light sailing craft.

Stone steps led up to Gabriel's door, adorned by an old-fashioned knocker in the impractical shape of a dragon. As callers waited to gain admittance, the scent of the jasmine that bloomed across the lower part of the wall would assail them. Once they were inside, the assault on their senses would continue. The entrance hall was lined with "looking-glasses of all shapes, sizes, and design" and "curiously furnished old-fashioned parlours" could be glimpsed beyond half-open doors. The house was huge, boasting "a dozen or so bedrooms." On the ground floor a breakfast room overlooked an acre of grass at the back of the house that grew less and less tidy during Gabriel's tenancy and became, bizarrely, the grazing ground for an increasingly exotic range of animals. Gabriel's bedroom was at the back of the house, a dark gloomy room with a stained oak floor covered with Persian rugs and hung with heavy Genoese velvet curtains that shut out the light. When Harry first entered the room he was hard-pressed to find something—beyond a box of Bryant and May's safety matches—that might be called modern. The antiquated four-poster bed bought from an old furniture shop "somewhere in the slums of Lambeth" was also shrouded by curtains, and the room was stuffed with gigantic chairs and a dark green velvet-covered sofa on the back panels of which Gabriel had painted figures representing Love, The Lover, and The Beloved (now in the Fitzwilliam Museum, Cambridge). An ornate mantelpiece, fitted with shelves and cupboardlike recesses, stretched up to the ceiling, filled with everything from his beloved blue-and-white china, to peacock feathers, candlesticks, and "Chinese monstrosities in bronze." It was Harry's belief that the gloom of the bedroom was partly responsible for Gabriel's increasing insomnia, but he could never persuade his employer to lighten it.

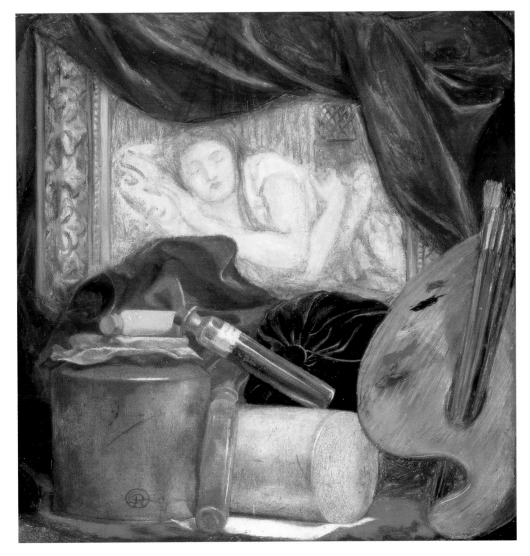

RIGHT: **BOTTLES** *by Dante Gabriel Rossetti. A still life fraught with images of deep drug-induced sleep, which Gabriel has "signed" a second time by including his palette in the right-hand corner.*

Gabriel was a magpie, and the house filled up slowly with his treasures. He stashed the overflow in the huge cellars, lacy with cobwebs and prone to flooding. There Indian cabinets leaned against seventeenth-century iron grates. Gabriel loved to collect rich fabrics, candlesticks, china, and jewels. After a day's painting, when the light failed, he would take a cab to Hammersmith or Leicester Square and spend the evening hours in junk shops, hunting out curiosities and bargaining for a Chippendale chair or a piece of blue-and-white china. His ground-floor studio, with its tall windows overlooking the ancient mulberry tree and a lovely avenue of limes, was stacked with props for his pictures: lutes, mandolins, and dulcimers were placed against the walls (although, in all the years Harry lived in the house, he never heard a note of music); necklaces and feathers and Japanese crystals were housed in an old Portuguese cabinet in a corner; and costume dresses hung in a huge wardrobe at the back. It was of necessity a large room. Gabriel's pictures were never as monumental as

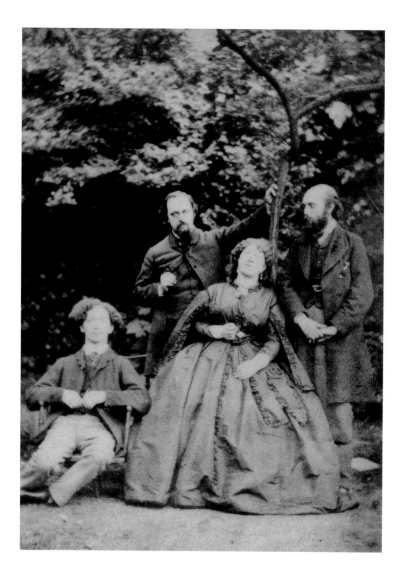

ABOVE: The garden at Tudor House provided a backdrop for a great number of photographs, for Gabriel was very interested in the art form. Here he poses with his brother, Fanny Cornforth, and the poet Algernon Swinburne.

Ned's, but just the basic furniture and equipment—cabinets for the colors, library steps, a "throne" for models to raise them into the painting light, a coke stove to keep them warm, and the easel and canvas that had to be maneuvered in and out—took up a great deal of space. Room also had to be made for visitors. Gabriel never exhibited his work publicly and so relied on private patrons and the occasional dealer.

Gabriel was not the only Tudor House resident with eccentricities. Despite being a terrible liability, the red-haired young poet Algernon Swinburne had been persuaded to give up his Dorset Street lodgings and share the rent of Tudor House with Gabriel and George Meredith, author of *Modern Love*, who had also been co-opted. Swinburne had a study on the same floor as the studio, while Meredith had two rooms on an upper floor, but the plan was that all three, or four, when William Michael was in residence, would dine together with Gabriel. The arrangement was doomed to failure. Meredith was the first to leave. "He hardly used the rooms," William Michael explained. But darker hints of disagreement circulated that William felt compelled to address: "It has also been alleged, and I am sure with *some*

"Then there was the large garden, nearly an acre in extent; it was not very carefully kept, and to me its haphazard luxuriance was all the more delightful. My brother had a big tent set up on its turf: we dined there occasionally, and lounged in it oftener."

(WILLIAM MICHAEL ROSSETTI, *SOME REMINISCENCES*)

measure of truth, that Mr. Meredith, being more fastidious in such matters than Rossetti, disliked the diet in Cheyne Walk."[5] It was certainly true that Gabriel favored huge midmorning breakfasts of "plates of small-shop ham, thick cut, grisly with brine: four smashed eggs on it," but Meredith's fastidiousness probably extended to Fanny, who, as the many voluptuous paintings and drawings of her made between 1863 and 1865 demonstrate, was almost a permanent fixture at this time, although Gabriel maintained her in her own establishment at 36 Royal Avenue, Chelsea, just a few streets away. For their part, despite spending many "glorious evenings in Swinburne's company" listening to the young poet read from *Atalanta in Calydon*, both Gabriel and Meredith were finding him a tempestuous housemate.[6] Pandemonium reigned when Swinburne took to drink, which made him violent or crazy. His biographer describes him sliding down the banisters naked. Finally, in 1864, behind with the rent, he was asked "with all possible apology" to leave Cheyne Walk.[7] Nevertheless, Gabriel was rarely alone in the early days. Often he dined out, or invited friends to dinner. "Any day you can, look in and take potluck with me at half past 5," was a typical invitation to male friends. Hospitable evenings at Tudor House could last until five in the morning, the potluck meal followed by games of whist and brag all fueled with plenty of wine and spirits.

The servants' quarters, pantries, and a sequence of kitchens were found in the basement. Domestic help was erratic and often of uneven quality, but Gabriel, who complained of being "a martyr to unsatisfactory servants,"[8] employed a cook, a housemaid, and a man for the heavy jobs of carrying coal and running errands. The place was chaotically run. Howell and Harry once ventured down to the kitchens in search of supper and found "a mouse eating a haddock." William Allingham preferred to stay with the Burne-Joneses when in town, even though they could only offer him a sofa whereas Gabriel had "a dozen or more rooms" to spare.

Gabriel's inability to keep pace with the bills, despite growing success, mystified and depressed him. His servants milked him shamefully. It was not just his household accounts that were in disarray. The shambles in his studio meant that

important sketches and cartoons for stained-glass windows regularly disappeared, whether lost or actually purloined by the unscrupulous Howell or equally light-fingered Fanny being hard to establish.

By 1865, out of mourning, Gabriel was giving larger parties. In April that year he invited Emma and Madox Brown, with their twenty-one-year-old daughter Lucy (who would eventually marry William Michael Rossetti in March 1874 when he was forty-four and she was thirty); Ned and Georgie with Georgie's sister Aggie; William Bell Scott; the sculptor Alexander Munro and his wife; Fred Stephens; Arthur Hughes and his pregnant wife, Tryphena; Alphonse Legros and his wife ("a nice little woman"); Philip Webb; and Swinburne.[9]

Harry referred to these regular parties as "festivals of exuberant hilarity" and enjoyed them immensely. He was living at Cheyne Walk, firmly established as a member of the household in 1867, when Janey Morris started to sit once more for Gabriel. Harry was then twenty-nine, ten years younger than his employer and the soul of discretion. Expected to deal with correspondence and carry messages, he was much more than an "art assistant." He was Gabriel's companion, secretary, personal bodyguard, and unofficial manager, "a buffer between him and the domestic storms which seemed always about to break over his head."[10]

It was Harry who fathomed the mystery of why, despite earning "a very considerable income" (around £3,000 in 1867), Gabriel was often short of the necessary "tin" to pay the tradesmen's bills, and instituted new weekly systems that

BELOW: *DANTE GABRIEL ROSSETTI IN HIS BACK GARDEN* by *Sir Max Beerbohm.*

ABOVE: *WOMAN WITH A FAN*
by Dante Gabriel Rossetti.
Gabriel provides Fanny with
a punning prop in this sultry
portrait.

allowed for more scrutiny. He set up, for the first time in Gabriel's life, a bank account that replaced the famous "money drawer" and soon held "a handsome sum."

Harry moved busily and anxiously across the domestic scene, privy to Gabriel's financial and spiritual troubles, for, despite a host of friends and an outward show of conviviality, Gabriel was often lonely and prone to melancholy. Harry was devoted to him and never complained when the lack of "tin" meant his salary was not paid, carrying on with his duties, which included painting replicas of Gabriel's pictures, ordering brushes, paints, and canvases, and obtaining the extraordinary range of objects Gabriel might need:

"There is another thing I want—to wit, a dragon-fly or two to paint in my picture, you know they are quite blue and I want one with his wings spread upwards as they do when they fly or sometimes when they stand. You might, if possible, get me 2 or 3 set up in different positions. I am wanting them as soon as possible. Also you might get me a few blue or blue-grey butterflies. These also to be set up in action flying or resting."[11]

A not inconsiderable artist himself, Harry painted an oil portrait of Gabriel that now hangs in the Uffizi Gallery, Florence, and another of Gabriel with Theodore Watts-Dunton (now in the National Portrait Gallery, London). Gabriel called him "the best of fellows and my guardian angel" but Fanny Cornforth resented his influence and the two often quarreled, leaving Gabriel, whose loyalty to Fanny never wavered, to placate his "Dear Good Fan" with cheerful, affectionate notes and cash presents.

The year 1868 was a prolific one for Gabriel, and Harry opened the door of Tudor House to a number of beautiful young women, who arrived daily to sit for his employer. One of these was Miss Alexa Wilding, whose extraordinary face and golden-auburn hair Gabriel first spotted one summer evening in 1865 as he walked along the Strand toward the Arundel Club. She was then a dressmaker with dreams of the stage. As she passed him and seemed in danger of being lost in the crowd, Gabriel chased her down a side street and begged her to pose for him. Startled and confused, she agreed to go to Cheyne Walk the following day, but failed to appear. Gabriel was disappointed as he needed her for *The Blessed Damozel*. When, weeks later, he again glimpsed her in the Strand, he insisted she accompany him in a cab to Cheyne Walk. Before long Alexa realized she could earn more by sitting still for an afternoon in Gabriel's studio than she could in a whole week making dresses, so she gave up her situation and "at a liberal arrangement" sat for him entirely.

Gabriel liked Alexa and paid her a handsome retainer of thirty shillings a week, but he found her dull company. Janey, by contrast, was almost too exciting. Both women visited Tudor House as models, but Alexa came alive for Gabriel only on the canvas, while Janey consumed and obsessed him in paint, poetry, and life. Gabriel took her to the opera (which her husband loathed) and, as her importance to him increased, began to celebrate her in his poetry:

"Was I most born to paint your sovereign face,
Or most to sing, or most to love it, dear?"

On 2 April 1868 Gabriel gave a party in Janey's honor to celebrate the fine pictures he was painting of her. Everyone was invited: Georgie and Ned, Emma and Madox Brown, Charley Faulkner, Philip Webb, her sister Bessie, and, of course, William, her husband. William was also writing poetry. He poured his frustrated feelings out in a flood of verse, writing up to thirty-three stanzas of *Pygmalion* in a single sitting. In a letter to an unknown correspondent he complained of feeling neglected: "If you

OPPOSITE: ***THE BLESSED DAMOZEL*** *by Dante Gabriel Rossetti.*

DANTE GABRIEL ROSSETTI TO JANE MORRIS, 18 FEBRUARY 1870

"I never cease to long to be near you and doing whatever might be to distract and amuse you. To be with you and wait on you and read to you is absolutely the only happiness I can find or conceive in this world, dearest Janey; and when this cannot be, I can hardly now exert myself to move hand or foot for anything."

(*DANTE GABRIEL ROSSETTI AND JANE MORRIS, THEIR CORRESPONDENCE*)

want my company," he wrote, "(usually considered of no use to anybody but the owner) please say so."[12]

Lavish dinner parties now became the occasions of conflict and display. William followed Gabriel's party with a banquet of his own for eighteen guests at Queen Square on 27 May to celebrate the publication of his *Earthly Paradise.* Gabriel responded by erecting a large marquee in his garden, which he described as "an approach to a private Eden," and inviting Janey, William, Philip Webb, Georgie, and Ned to a formal dinner. The food served at these usually took the form of a clear soup, cold salmon served with cucumber and a sharp sauce, a saddle of mutton with jelly, or roast chicken or quails with potatoes and Brussels sprouts, followed by meringues and ices or jelly and fresh fruit, and finally a savory—say devils on horseback or anchovy savory cream cheese—all washed down with copious amounts of champagne, Sauternes, and burgundy. The marquee soon took on a permanent air as it filled with couches, comfortable chairs, Indian cabinets, and Persian rugs. There were flowers in profusion and a wire laid under the rugs communicating with a bell in the kitchen so that dinner could always be served in the tent on warm summer evenings. Here Gabriel dabbled in seances. Whistler, Bell Scott, Fanny, and a few other guests would join him for some "spirit-rappings" and questionable gyrations of the table.

Beyond the marquee his eccentric menagerie was growing. In 1869 he purchased a wombat and wrote a letter to his patron Miss Losh, with the wombat "burrowed deep in the sofa cushions" beside him and a parrot on his shoulder. He described his new acquisition as "a round furry ball with a head something between a bear and a guinea pig, no legs, human feet with heels like anybody else, and no tail," and added, damningly, "Of course I shall call him 'Top.'"[13]

It was his penchant for wombats (and worse) that made Gabriel a far from ideal neighbor. The shrill trumpetings of his peacock caused so many complaints that a clause was introduced into all the leases of tenants on Lord Cadogan's property that no peacocks should be kept in the gardens. Unfortunately for the neighbors no such

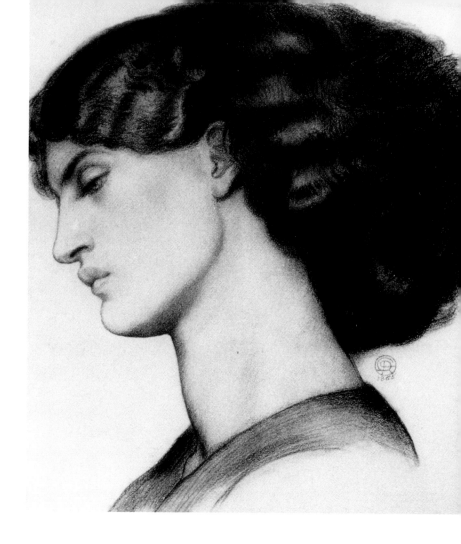

clause relating to fallow deer, squabbling kangaroos, plant-loving armadillos, or egg-snatching raccoons was inserted. Gabriel's fondness for unusual animals probably dated back to his childhood. As well as the usual quota of tabby cats and caged birds, the Rossetti children had kept a pet squirrel with a wheel, and their favorite jaunt had been to the newly opened Zoological Gardens in Regent's Park, where Gabriel used to keep Christina entertained by making up fanciful biographies for the animals. The parrots, armadillos, and sloths were their favorite creatures.

Now in adulthood he found himself able to indulge his passion. He purchased "queer outlandish creatures" from an animal importer called Jamrach in Whitechapel who kept him supplied with salamanders, a chameleon, and even an Indian bull (acquired, it was said, because it had eyes like Janey Morris). He bought a zebu, a fierce little humped ox not much bigger than a Shetland pony, for £20 at a wild-beast show in Cremorne Gardens.[14] Finding himself a little short of "tin" he wrote to William Michael at his office at Somerset House asking him to make the down payment of £5. He had been assured, he in turn assured his brother, by the zebu's owner that the animal was "quite tame" and would cost only "about 2s 6d a week for keep." Of course, it was a disaster. The poor creature had to be carried through the house and out into the garden, where it finally tore up the tree to which it was tethered and—or so the story goes—chased Gabriel round the garden.

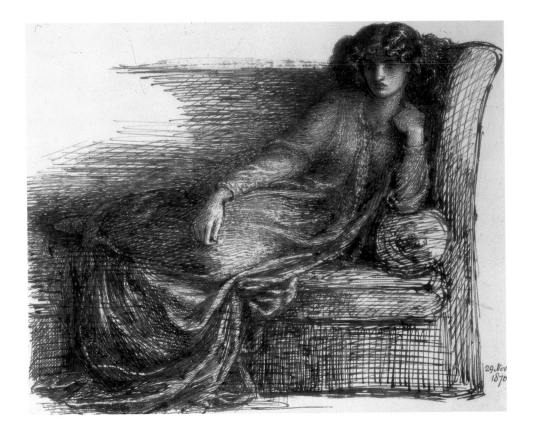

ABOVE: ***MRS. WILLIAM MORRIS***
RECLINING ON A SOFA *by*
Dante Gabriel Rossetti.
The Victorians believed that
reading in bed was unhealthy,
which accounts for the popularity
of daybeds and chaise longues in
middle-class homes.

The armadillos attracted almost as many complaints as the peacocks and had to be poisoned with beef saturated in prussic acid—which failed, however, to kill them. Eventually the pair, in a "sadly mangy, out-at-elbows state," were donated to the Zoological Gardens. The raccoon ("does not it look like a devil?") was housed in a large packing case supposedly secured by a heavy slab of Sicilian marble, which proved laughably easy to skirt around for nocturnal raids on a neighbor's hencoop. This time the letter of complaint came accompanied with a bill for the eggs the raccoon had destroyed.

The menagerie was not restricted to the garden. Indoor pets included "a singularly morose parrot" whose one joy in life was to bite the fingers of visitors unwise enough to stroke its head and, for a time, the raccoon, which had escaped into the house and could not be found for some days, during which time it stalked the corridors at night, frightening the housekeeper who had just lost her husband and was "in a chronically hysterical state." It was eventually discovered in the bottom drawer of a massive Elizabethan wardrobe, where it had gnawed to bits some poetry manuscripts.

For more than a year Gabriel had been thinking of publishing a collection of his poems. William Morris, whose wife was proving such an inspiration to Gabriel, had already published three. There was a problem, however, for most of his poems were in the bound manuscript he had slipped into Lizzie's coffin just before her burial. He shared the difficulty with friends—although not with his brother William Michael—and it seems to have been Howell who was most instrumental in proposing, arranging, and executing the exhumation of Lizzie's grave at Highgate

> He feeds upon her face by day and night,
> And she with true, kind eyes looks back on him…
> Not wan with waiting, nor with sorrow dim,
> Not as she is, but was when hope shone bright;
> Not as she is, but as she fills his dream.
>
> (CHRISTINA ROSSETTI, "IN AN ARTIST'S STUDIO")

Cemetery. But the deed was clearly done at Gabriel's behest. He sought to justify his actions in a letter to Swinburne:

"The truth is, that no one so much as herself would have approved of my doing this. Art was the only thing for which she felt seriously. Had it been possible to her, I would have found the book on my pillow the night she was buried; and could she have opened the grave no other hand would have been needed."[15]

Secrecy shrouded the business, but, with Howell at the center, Gabriel knew that "the truth must ooze out in time."[16] It was an infelicitous turn of phrase but accurate, for news of the exhumation soon spread, and the ensuing scandal was only fanned by sightings of Gabriel and Janey out together. At one party he was seen feeding Janey from a dish of strawberries and cream, carefully removing the cream (considered bad for her) from each succulent berry before he spooned it in. Much more of this and the looming storm would inevitably break.

It was William who came up with the solution.

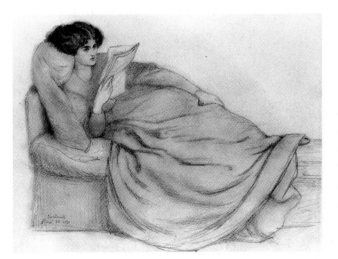

LEFT: ***MRS. WILLIAM MORRIS READING*** *by Dante Gabriel Rossetti. This drawing of Janey was made at Scalands Gate, home of the suffragist and painter Barbara Leigh Smith Bodichon.*

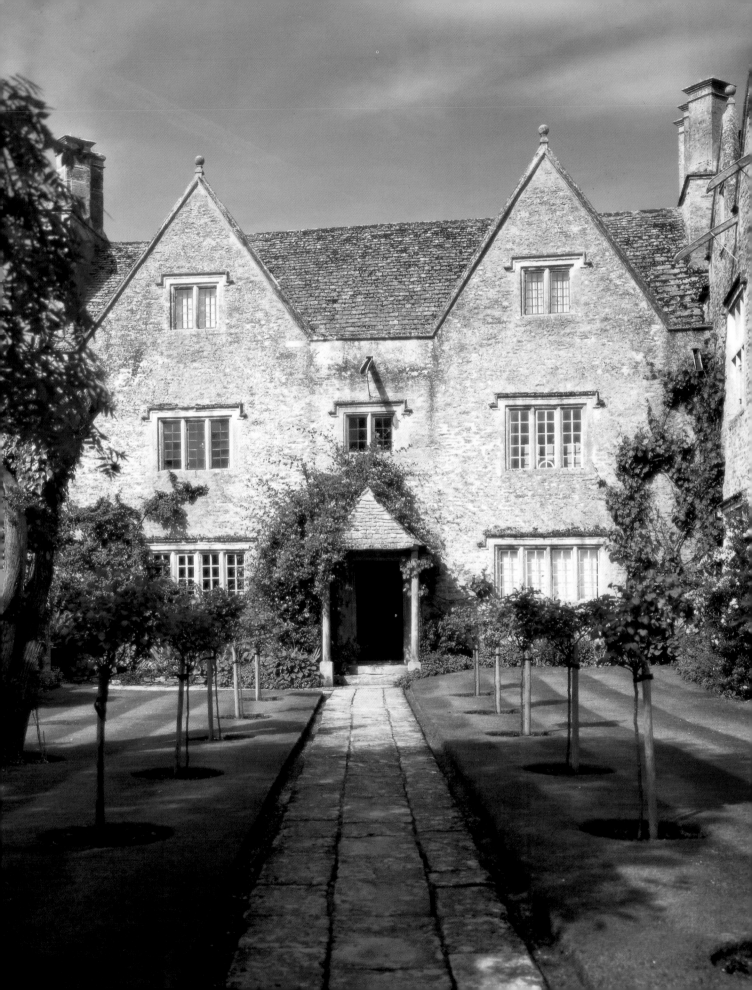

Chapter 10

THE LOVELIEST HAUNT of ANCIENT PEACE

"I have been looking about for a house for the wife and kids and whither do you guess my eye is turned now? Kelmscott, a little village about two miles above Radcot Bridge—a heaven on earth; an old stone Elizabethan house like Water Eaton, and such a garden! close down on the river, a boat house and all things handy. I am going there again on Saturday with Rossetti and my wife: Rossetti because he thinks of sharing it with us if the thing looks likely."

WILLIAM MORRIS TO CHARLEY FAULKNER, 17 MAY 1871

ILLIAM'S RESPONSE TO the deepening relationship between Janey and Gabriel was extraordinarily forbearing. In the most conventional of times, he took the unconventional course of finding a secluded house in the country where his wife could spend the long summer months in the company of his former friend and hero whom she now preferred to him. He found Kelmscott Manor advertised in a house agent's catalogue and went to inspect the ancient stone house twice before signing, with Rossetti, a joint tenancy lease at £75 a year. "We have taken a little place deep down in the country," he wrote to Georgie, "a beautiful and strangely naïf house, Elizabethan in appearance though much later in date, as in that out of the way corner people built Gothic till the beginning or middle of last century. It is on the S.W. extremity of Oxfordshire, within a stone's throw of the baby Thames, in the most beautiful grey little hamlet called Kelmscott."

OPPOSITE AND ABOVE: Kelmscott Manor, Oxfordshire. Frontispiece to News from Nowhere, *William Morris's utopian romance, published in installments in* The Commonweal *between January and October 1890 and inspired by Kelmscott Manor and the surrounding countryside.*

"Apart from the desire to produce beautiful things, the leading passion of my life has been and is hatred of modern civilisation. What shall I say concerning its mastery of, and its waste of, mechanical power, its commonwealth so poor, its enemies of the commonwealth so rich, its stupendous organisation—for the misery of life . . . Its eyeless vulgarity which has destroyed art, the one certain solace of labour?"

(WILLIAM MORRIS, *COLLECTED WORKS*)

Kelmscott Manor was the literal fulfillment of a dream William had had, and, in different circumstances, might have gone some way toward making up for the loss of Red House, but Janey, his queen, had switched allegiance and everything had changed. Soon after signing the lease William sailed away for Iceland, generously urging his wife to be "well and happy."[1] (William was fascinated by the Icelandic legends and literature and had learnt the language so as to be able to research them in depth.)

Janey moved in on 6 July with her daughters Jenny and May and their governess. Ten days later Gabriel arrived with two servants from Cheyne Walk to help the "capable, careful, frugal, and industrious" Philip Comely and his wife, an elderly couple, who rented the adjoining cottage for a shilling a week and looked after the Manor, especially during the winter when it was empty. The house, which dates from the sixteenth and seventeenth centuries, came with sixty-eight acres of "closes" or enclosures and a range of ravishing outbuildings: a barn, sheds, and a dovecote.[2] There was a brewhouse with a sink, coppers, and bread ovens and a three-seater earth closet in the yard beyond, housed in a little stone building with a pyramidal roof.

That first long summer was enchanted. Kelmscott stimulated Gabriel's poetic pulse and he wrote a whole sequence of sonnets that he presented to Janey as a love token. The potent atmosphere of the place provoked the pair into moods "Elizabethan enough" to encourage the reading of Plutarch and Shakespeare. Gabriel, who is always shown in photographs swathed in layers of woolen waistcoats and capes, exchanged them all for a loose blue shirt. He and Janey took long walks through the sleepy countryside, Gabriel admiring the "fat cut hedges"[3] and Janey the thatched farm buildings that seemed "settled down into a purring state of comfort . . . as if, were you to stroke them, they would move."[4] Janey was amazed and delighted to find herself well enough to walk for five or six miles at a time and Gabriel boasted in his letters of her "most triumphant pedestrian faculty; licks you hollow, I can tell you."[5] The house was only a few miles from the source of the Thames in the Cotswold Hills and the "baby Thames" wound down from the low surrounding hills

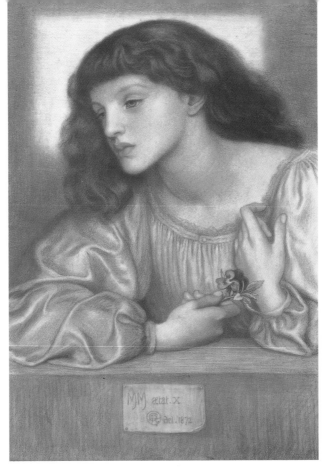

LEFT: *MAY MORRIS* (pastel on
paper) *by Dante Gabriel Rossetti.*
William Michael Rossetti reported
that May Morris's "beauty in
childhood was most marked."

to the level pastures of Kelmscott. Walking beside the river they might encounter the
occasional angler, but mostly they were alone, luxuriating in each other's company.
Next to the house a bustling farm distracted the nine- and ten-year-old May and
Jenny from their lessons with their governess:

"Those glowing August mornings we sat in the pleasant cool of the Panelled Room
trying to learn things about the Roman emperors and outside the wide mullioned
windows the blackbirds were chuckling and feasting among the gooseberries: golden
stacks were growing roof-high in the yard outside and the huge barn was alive with
busy men and women. It was all too interesting: the Roman emperors were not to be
endured for long, and Mother became philosophical over my truancy."[6]

The children could roam freely at Kelmscott, where the outside world seemed far
away. No through traffic passed the remote house. The farm provided most of the
household's needs, while further supplies could be ordered from Lechlade or
Farringdon, three miles off, and brought by cart. After lessons the girls would
scamper across the few small fields to the river, where they were soon busily punting.
Their carefree childhood also extended to "roof-riding," scrambling over the many
gables of the Manor and the farm buildings, which, to William's abiding satisfaction,
were covered with simple stone Cotswold slates, "the most lovely covering which a
roof can have, especially when, as here and in all the traditional old houses of the
country-side, they are 'sized down'; the smaller ones to the top and the bigger
towards the eaves, which gives one the same sort of pleasure in their orderly beauty
as a fish's scales or a bird's feathers."[7]

OPPOSITE: WATER WILLOW by Dante Gabriel Rossetti.

ABOVE: ENTER MORRIS MOORED IN A PUNT, AND JACKS AND TENCHES EXEUNT. Gabriel's caricature of a portly William reading in a punt while grinning fish frolic around him.

Janey set about furnishing and decorating the house. The big parlor had "some pleasing George I paneling" that she repainted white. The original hearth was uncovered beneath some modern masonry, and Janey ordered new tiles from Morris & Co. to surround it. Her letters to Philip Webb are cheerful and full of requests for embroidery designs for cushions and mock-weary pledges never again to "pull another fireplace down as long as I live." The house, she assured him, was "all delightful and home-like to me and I love it."[8]

Upstairs there was a singular room, hung with tapestries dating from the mid-seventeenth century that depicted—often in gory detail—scenes from the Old Testament. William described these as "never great works of art," although he found that their faded colors—the indigo blues, the grays and the warm yellowy browns—made them "look better, I think than they were meant to look."[9] The romance and drama of this room appealed hugely to Gabriel, who bagged it for his studio, taking the adjoining one, with views across the Thames and the clover meadows, as his bedroom.

Janey and Gabriel behaved with some discretion. Janey had her own bedroom: a cool, clean, west-facing room with a four-poster bed and a seventeenth-century chest of drawers, on which she placed the lovely jewel casket that Lizzie and Gabriel had painted for her as a wedding present. Jenny and May always called Gabriel "Mr. Rossetti." The little girls were fascinated by their parents' eccentric friend, who slept late and ate an astonishing number of eggs for breakfast, before disappearing into his studio. They seemed to find nothing untoward in his emergence at dusk to walk with their mother. And besides, toward the end of the first summer their father joined the party at Kelmscott, bringing a little pony with him as a present from Iceland. The girls named it Mouse and harnessed it up to "a little basket-carriage," between the shafts of which it looked "incredibly fat and funny." Mouse soon grew even stouter on the rich grass of Kelmscott. William, outwardly jovial, larked about in the girls' punt and took to fishing enthusiastically for local gudgeon. He loved the willow-bordered river, which provided both a refuge and an inspiration—his long-leafed

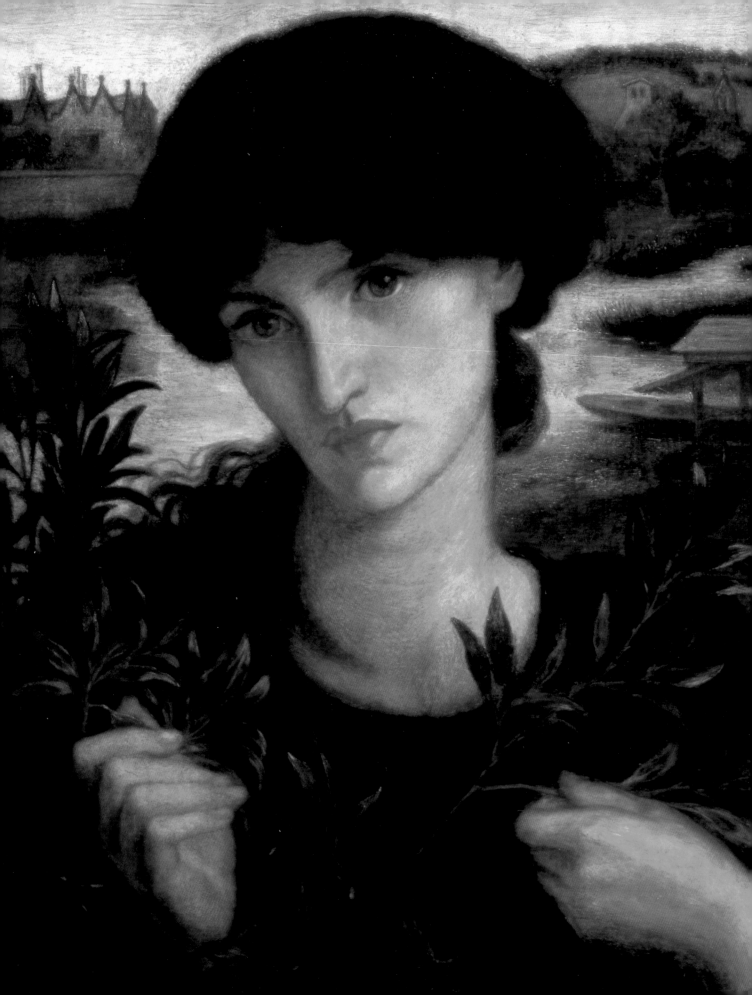

*ABOVE: **INTERIOR OF***
KELMSCOTT MANOR
Watercolor on paper,
attributed to May Morris.

"Willow" became one of his most enduringly popular decorative designs—and delighted in the birdlife, herons, summer snipe, and kingfishers that flitted from under the banks and across the surface of the river as he fished. But it irked William to be at Kelmscott with Gabriel, for, apart from any personal tensions connected with Janey, he soon found that Gabriel had "all sorts of ways so unsympathetic with the sweet simple old place that I feel his presence there as a kind of slur on it."[10] His solution was to plan another trip to Iceland, although he managed to slip down to Kelmscott alone the next spring.

The summers were reserved for Janey and Gabriel. But the second was not to be as idyllic as the first. In June 1872, at the height of his fame and, apparently with all before him, Gabriel suffered a mental breakdown provoked by savage criticism of his poems and morals. For the next few months he teetered on the very edge of sanity, attempting suicide and resorting to chloral. At one point his doctors and his family considered committing him to an asylum, for William Michael felt that he was "past question, not entirely sane,"[11] but Madox Brown, realizing this would put an end to his career, volunteered to accompany him and his doctors to Scotland for a rest cure. Gabriel's friends were divided about the helpfulness or otherwise of contact with Janey, some seeing her as the cause of his decline, and she had to depend on Madox

JANE MORRIS TO PHILIP WEBB, 1871

"I am getting the fireplace set straight in the dining room, the one with the broken mantelshelf, and I think it would look well with tiles. Would you be so kind as to see about these at Queen Square for me? Six dozen would be enough, 5-inch ones . . . two rows on each side and a single row along the top, the rest for the inside of the fireplace which will be an open one. Will they look best of various patterns or all alike? They must be blue. The mantelpiece is stone I find so I am making the masons scrape off the former drab paint. The next thing to be thought of is the grate . . ."

Brown and William Bell Scott for news until, at last, Gabriel himself was in a position to insist, writing to his brother, "all, I now find by experience, depends primarily on my not being deprived of the prospect of the society of the one necessary person."[12]

Throughout it all, William was sympathetic to his wife, generously taking her himself to see Rossetti, and full of concern for Gabriel. To Madox Brown he wrote, "Come by all means and talk to Janey: she will be glad to hear anything you have to say about Gabriel."[13]

It was not until late September, when the summer was almost over, that Gabriel returned to Kelmscott. "Here all is happiness again, and I feel completely myself," he reassured his brother, but Janey was finding him far from his old self. Tortured by hallucinations, he spent his days in a haze of chloral and whisky, finally falling asleep at 3:00 A.M. or 4:00 A.M., or even 5:00 A.M., and waking unrefreshed late in the day.

"That Gabriel *was* mad was but too true, no one knows better than myself," she told Theodore Watts-Dunton a dozen years later. The situation was difficult for all concerned. William, who had once worshiped Gabriel, was saddened to see him in this state but horrified at the idea that he might take up permanent residence at Kelmscott and increasingly unhappy about exposing his daughters to his eccentricities and his unsuitable friends. To one sympathetic female friend he confided: "Another quite selfish business is that Rossetti had set himself down at Kelmscott as if he never meant to go away; and . . . that keeps me away from that harbour of refuge (because it is really a farce our meeting when we can help it)." Gabriel's grumbles and his "unromantic discontent" with the house made William "very angry and disappointed" at his own missed opportunities.[14] But in the end the weather decided things. The house, which was not heated and inclined to be damp, became virtually uninhabitable in the winter, cut off by the river, which flooded the surrounding watermeadows.

By the third summer Gabriel seemed much improved and established himself with Janey at Kelmscott with a retinue of what William—who was now only to be found

ABOVE: *Edward Burne-Jones made this cruel caricature of a lumbering Gabriel carrying cushions to a startled Janey Morris to amuse Mary Zambaco.*

> "Rossetti's tendency in sketching a face was to convert the features of his sitter to his favourite ideal type and, if he finished on these lines, the drawing was extremely charming but you had to make believe a good deal to see the likeness."
>
> (WILLIAM HOLMAN HUNT, *PRE-RAPHAELITISM AND THE PRE-RAPHAELITE BROTHERHOOD*)

at the Manor on rare and brief visits—saw as irritating "hangers on." Gabriel filled the house with friends, models, and family. It was a productive period for his art as well as his poetry. His painting had moved away from his lyrical early scenes to concentrate on single images of soulful women. He coaxed Alexa Wilding, the former dressmaker, to Kelmscott and painted her as *La Ghirlandata*. Janey he posed as *Proserpine*, Ceres's beautiful daughter, tricked into spending half the year with her hated husband in Hades—a choice of subject that spoke volumes for his state of mind at the time.

Alexa's stay at Kelmscott coincided with a visit from Gabriel's mother and his sister Christina. Both Rossetti brothers went to some lengths to reassure their mother of Alexa's suitability as a houseguest. William pointed to her "respectable parentage," while Gabriel wrote:

"Miss Wilding . . . is a *really* good creature, fit company for anyone, and quite ladylike, only not gifted or amusing. Thus she might bore at meals and so on (for one cannot put her in a cupboard) . . . You see, out here one has to live with one's models as they cannot come to sit and then go home. But she is the most retiring and least self asserting of creatures and would not be much in the way, at least not more than was unavoidable."[15]

OPPOSITE: LA GHIRLANDATA by Dante Gabriel Rossetti. Alexa Wilding was the model for this painting. Gabriel's studio assistant Henry Dunn thought "Hers was a lovely face, beautifully moulded in every feature, full of a quiescent soft mystical repose that suited some of his conceptions admirably, but without any variety of expression."

In any event the visit was a success, Christina praising the "lovely homely house" so close to the river "with its endless delights of rushes, lilies and other beauties," and particularly the abundant crop of "strawberries and raspberries and other treats" the garden yielded throughout the summer. And Mrs. Rossetti found Miss Wilding's "good-natured" presence agreeable rather than otherwise. Neither commented on the absence of Janey's husband.

One person who was never invited to Kelmscott—indeed, was expressly forbidden to come—was Gabriel's former mistress, Fanny Cornforth. Unlike "poor, retiring Miss W," the larger-than-life Fanny made her presence felt wherever she went and Kelmscott, then a hamlet of only 117 inhabitants, was too small a place for

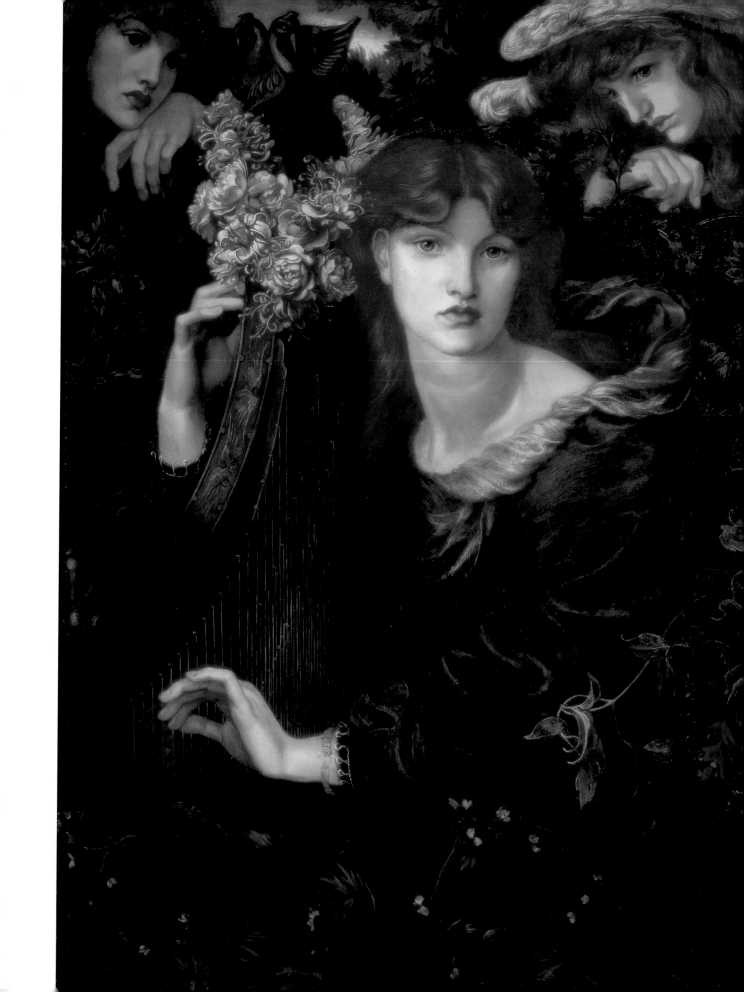

OPPOSITE: Janey's bedroom at Kelmscott Manor. The walls are papered in the Firm's "Willow" pattern with bed-hangings made up to match.

Gabriel to risk further gossip. Besides, the likelihood is that, despite continuing to pay Fanny's household expenses and writing regularly to his "Dear Good Fan," he had told Janey nothing about her existence or her place in his life.

Instead, old friends like Emma and Madox Brown were invited, along with George Hake, who, according to William Michael, kept "everything going, and . . . makes life smoother to all inhabitants of Kelmscott Manor House than they ever found it before."[16] But it soon became obvious that Gabriel's emotional and physical well-being had declined alarmingly since his nervous breakdown. He became increasingly paranoid, thought anglers were taunting him, heard voices, could not sleep without chloral washed down with copious amounts of whisky, claret, and brandy, and was prone to hallucinations. Naturally his friends and family were keen to play down any hint of illness, which might have had a detrimental effect upon the successful sale of his work.

William finally made a stand. He was disentangling himself from Gabriel as a partner, evicting him from his working life if not his domestic one in a controversial reorganization of the Firm, which cost him the friendship of Madox Brown and caused deep divisions.[17] On 16 April 1874, suffering from a cash-flow problem, he wrote tensely to Gabriel, enclosing the rent for that quarter but letting him know that that would be the last:

"As to the future, I will ask you to look upon me as off my share, and not to look upon me as shabby for that, since you have fairly taken to living at Kelmscott, which I suppose neither of us thought the other would do when we first began the joint possession of the house; for the rest I am both too poor and, by compulsion of poverty, too busy to be able to use it much in any case, and I am very glad if you find it useful and pleasant to you."[18]

Without the fiction of the two men's shared tenancy, Janey would not be able to go down to Kelmscott. Events were coming to a head. Gabriel said he would renew the

Dreamer of dreams, born out of my due time,
Why should I strive to set the crooked straight?
Let it suffice me that my murmuring rhyme
Beats with a light wing against the ivory gate,
Telling a tale not too importunate
To those who in the sleepy region stay,
Lulled by the singer of an empty day.

(WILLIAM MORRIS,
THE EARTHLY PARADISE)

lease on his own but then, abruptly in July of that year, he quit Kelmscott—leaving a lovely painted chest languishing in the hall. He would never return. It was William who renewed the lease, using the house as his country home for twenty-five years, until his death.

According to his first biographer, John Mackail, William would come to find at Kelmscott a peace and joy that no other place gave him, and, as his attachment deepened, it became "more and more passionate: for with him the love of things had all the romance and passion that is generally associated with the love of persons only."[19]

HERE IS EVIDENCE TO SUGGEST that William may have been contemplating a partial separation from Janey just before Gabriel's major breakdown, for he began to look about for a London house for his wife and "the littles." His plan was that he should remain at Queen Square, where he would retain a study and a bedroom, giving the rest of the living space over to the workshops, for the decorating side of the Firm had really taken off and business was booming. He found a small house that he thought might suit Janey at Turnham Green, a rambling suburb of orchards and market gardens on the western edge of London, just half an hour's walk from "the Neds." Janey described Horrington House as "a very good sort of house for one person to live in, or perhaps two" and William admitted that it was "a very little house" but pointed out that it had a "a pretty garden" and should "suit Janey and the children."[20] Jenny was now twelve and May ten and their father had not seen them for a month.

Gabriel, meanwhile, was back in Cheyne Walk. He had increased his intake of chloral to 180 grains a day to try to combat his insomnia but succeeded only in

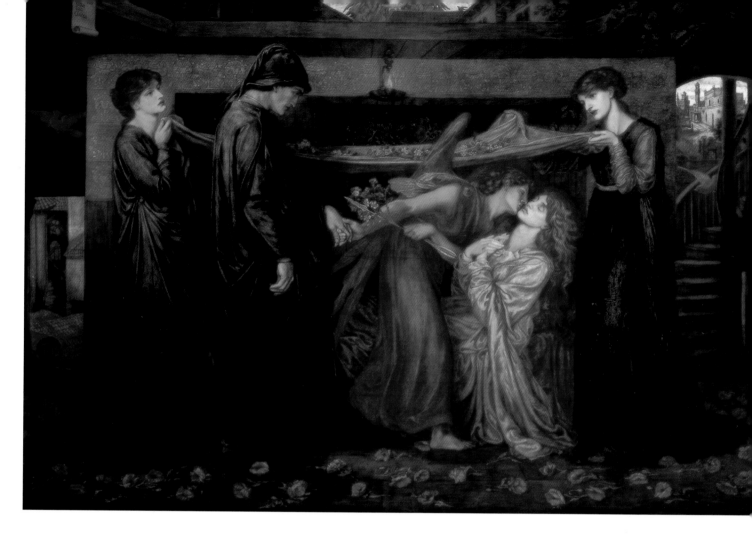

ABOVE: *DANTE'S DREAM*
by *Dante Gabriel Rossetti.*

casting himself into a terrible gloom. Friends and family had rallied at Christmas and there was a fairly constant stream of visitors to see *Dante's Dream*, his most ambitious painting to date, which hung in the new studio addition designed by the trusty Philip Webb and built while Gabriel and Janey were away at Kelmscott. The great Russian novelist Turgenev came and stayed to dinner, sitting up late with Gabriel to discuss the relative merits of Shakespeare, Byron, and Lermentov.

Gabriel set to work on a design for Janey's new stationery that was to have her personal motif of a pansy or heartsease in gold and purple, with half the writing paper headed "Horrington House, Turnham Green, London W" and the other half "Kelmscott Manor House, Lechlade." But it was never printed up, and by February 1873 William had rejoined his family, reporting that he could work in his own "particularly cheerful and pretty" room "with a much better heart than in the dingy room at Queen Square" where, he complained, he had "always felt like a lodger."[21]

He set about making Horrington House feel like home. Workmen erected their benches in Janey's room and soon all was "bare and painty" with "hammering and sawing and running up and down stairs going on." To Aglaia Coronio he confided that "for this long time past I have, as it were, carried my house on my back: but the little Turnham Green house is really a pleasure to me;—may all that be a good

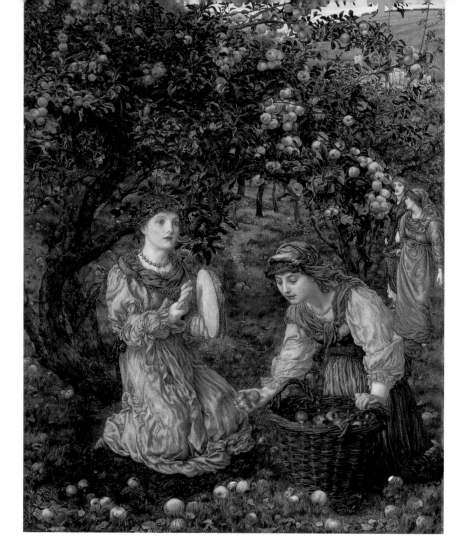

ABOVE: *GATHERING APPLES*
by Thomas Matthews Rooke.
Rooke worked for Burne-Jones
as his studio assistant, while his
wife Leonora was engaged by
Georgie as a governess to their
daughter, Margaret. He was a
man of serene temperament, which
shows through in this painting.

omen!" He felt happier than he had in a long while and urged Aglaia to visit him and Janey when she returned from Greece if "you won't be too much terrified at my housekeeper, who is like a troll-wife in an Icelandic story: with a deep bass voice, big and O *so* ugly!"[22]

William and Janey ended up living at Horrington House for six years. Jenny and May began attending Notting Hill School, where Margaret Burne-Jones was already a pupil. William took the omnibus to Queen Square and often lunched at Charley Faulkner's house a few doors down. If the weather was fine he ambled along, hatless in his French workman's shirt and so discombobulated a new housemaid when she let him in for the first time that "she went down to the kitchen in some perplexity, describing him to the cook as the butcher."[23]

Gabriel, however, was becoming more and more reclusive. Millais and Val Prinsep noted his absence from the Garrick Club. He no longer dined at the Arts Club in Hanover Square or the Arundel Club in the Strand. William Michael, who had taken over the accounts at Tudor House while Gabriel was ill, discovered that his housekeeper, Emma McLounie, and her alcoholic husband, had been systematically stealing from Gabriel, ordering so much wine and spirit that the suspicion was they were selling it as well as drinking it. "The bill shows 2 dozen

DANTE GABRIEL ROSSETTI TO HENRY TREFFRY DUNN

"My dear Dunn, the Elephant writes in a rage, but I have sent her a settler."

(*LIFE WITH ROSSETTI OR NO PEACOCKS ALLOWED*)

Cognac sent on 1 January 1872, and a third dozen on 19 February!!" William exclaimed in a letter.[24]

Fanny was still on the scene. As she grew stouter Gabriel teasingly called her "Ele*Fant*" and wrote joshingly to her requesting that she return an important piece of Nankin china "borrowed" from Tudor House: "Hullo Elephant! Just you find that pot! Do you think I don't know that you've wrapped your trunk round it and dug a hole for it in the garden? Just you find it, for I can't do without it."[25] A lovely drawing of an elephant wielding a spade accompanied the note.

Gabriel's grand love affair with Janey had, it seemed, run its course, although they remained intimate friends. She still sat for him, and they corresponded regularly, sympathizing with each other over their melancholy and their ailments and joking about the problem of finding suitable servants. "On Tuesday I have new servants coming in here," Gabriel wrote from Tudor House, "a housekeeper (middle-aged, wages £20, and 10 years excellent character from her last place) and a little rummy housemaid of 16 whom she recommended and whom I am taking on trial. I suppose they wd [sic] have just to get used to the place for a day or two before we thought of making any appointment." He found the housekeeper "quiet and pleasant enough." The maid seemed "a nice natural little thing," but he worried that she would find the house dull. "It is difficult," he wrote, "to think of such a kid as being only a year younger than your stately self when I first met you."[26]

ABOVE: Gabriel's capricious drawing of Fanny as an elephant digging a hole in which to bury her purloined treasure.

Gabriel, like his wombat, was burrowing down, drawing the house about him like a protective shell. For a short but anxious time in 1878 it looked as if his lease on Tudor House would not be renewed and Gabriel was forced to go house hunting. Fortunately the feared problems at Tudor House did not materialize so he was able to stay on. His reconnoitering was not wasted, however, for when Janey began looking about for somewhere larger than Horrington House, he was well primed to give her his view on the novelist George Macdonald's "commodious" house on the river at Hammersmith Mall. This would soon become Janey's and William's final London home.

Chapter 11

BELONGING to the WORLD

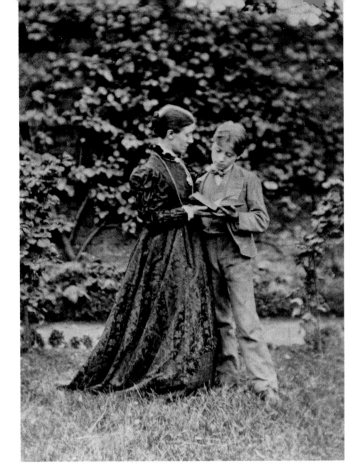

"The words 'the Grange, North End Lane, Fulham,' take me back to the eighteen-nineties and summers of miraculous length and warmth when it was always Sunday and one played for endless hours in a sunny garden."

ANGELA THIRKELL

(EDWARD BURNE-JONES'S GRANDDAUGHTER)

I N THE MIDDLE OF THE Mary Zambaco storm the Burne-Joneses moved house. In those days Fulham—even for those used to living in Kensington—seemed virtually a retreat into the country. But Ned recalled a house he had stumbled upon with William Allingham the year before, a spacious eighteenth-century pile that seemed to offer an artist the right air of studious seclusion. Although he did not know it then, the Grange had once been home to Samuel Richardson, the author of *Pamela* and *Clarissa*. "It is too grand for us," Ned wrote to George Howard in the autumn of 1867, "we have no right to such a place." Nevertheless, a few months later they moved in.

Georgie was later to recall her delight on finding the beautiful garden filled with late-blooming roses and the promise of "a hedge of lavender, whose sweet scent and soft pink and grey colour are inseparably connected in memory with the place and time."[1] There was a fine old mulberry tree on the lawn, "peaches against the walls, and apple-trees enough to justify us in calling part of it an orchard." Beyond the great elms and walnut trees stretched fields and market gardens. Georgie gathered briar roses at the corner of the lane. It was an idyllic spot.

At some point the house, which was surrounded by high brick walls, leafy elms, and lime trees, had been divided into two and Ned and Georgie chose the northernmost half for the light. To help with the rent they invited Wilfred Heeley, an old friend from Ned's Birmingham days, and his wife to take the other half. In

ABOVE: Georgiana Burne-Jones and her son, Phil, in the garden at the Grange. Georgie found her garden a great solace and delighted in the blossoms on the fruit trees and a lovely bed of lilies-of-the-valley some twenty-feet long.

OPPOSITE: ***THE DINING ROOM AT THE GRANGE*** *by Thomas Matthews Rooke. In cold weather this would be one of the warmest rooms in the house, for the fire would be lit before breakfast and kept stoked throughout the day making it a cosy room in which to linger long after dinner.*

ABOVE: *WILLIAM MORRIS ATTENDING HIS WIFE WHO LAYS UPON A COUCH* by *Edward Burne-Jones.*

her *Memorials* Georgie describes how "a veil of green paint and Morris paper" was drawn over the walls (some of which had been decorated with murals). Extra Sussex rush-seated chairs, designed by Madox Brown, were ordered up from the Firm with a supply of the wine William imported from France. He charged Ned twenty-four shillings a case for this but, with Swinburne a frequent visitor, it barely lasted a week, even though Georgie drank nothing but water herself.

Soon after moving in they gave a housewarming party, which Madox Brown described in a letter to George Rae, a Pre-Raphaelite patron: "As to the news I will give you what I have. Jones, having moved to his new house, gave a dance, a very swell affair, the house being newly decorated in the "firm" taste, looked charming; the women looked lovely, the singing unrivalled." Ned and Georgie had dotted orange trees and azaleas throughout the house and "invited all the world" to the biggest party they had ever given. After the dancing, there was a "sumptuous supper."

Madox Brown later learnt that he had been lucky to escape with his life that evening. For soon after the guests had left, the studio ceiling ("about 700 lbs of plaster") came down "just where the thickest of the gathering had been all night." "Had we all been there," William Bell Scott wrote to Alice Boyd, "the new school as Brown said, might have been extinguished, he, Gabriel, Holman Hunt, Morris, Swinburne, little Simeon, Jones and myself might have been squashed at one go."[2]

William, in particular, had had a close escape, for he was to have slept on the sofa on which most of the ceiling fell. Fortunately he had accepted an invitation from Val Prinsep to spend the night in the substantial new house he had commissioned from Philip Webb, who was rapidly becoming the group's favorite architect. This slab-

sided red-brick house, with a Parisian-style double-glazed studio measuring forty by twenty-five feet on the first floor, was built on an acre of newly available land at 1 Holland Park Road on the Holland estate. It was an impressive house for a young bachelor with artistic aspirations, and Val was fortunate in having a father who could make the first payment of £2,000.

This area was fast becoming popular with artists. Next door the finishing touches were being put to an even grander house, designed by George Aitchison for another fashionable Victorian painter, Frederic Leighton. Here a fountain played beneath a golden dome in the Arab tiled hall and a Moorish screen ran the length of the house.

Despite descending ceilings and a distracted husband, Georgie aimed for tranquility at the Grange. Astonishingly, she achieved this, by means of her steady stoicism and a calm pattern of regular events. They never entertained again on as grand a scale as that first party, she recalled in her *Memorials*:

"As far as we could, [we] kept open house in a simple enough way. Though we never had any special time for being at home, Sunday always brought someone to the Grange.[3] The day began with Morris's strenuous company at breakfast and a morning of work with him; friends generally dropped in, or had been invited to lunch; others, together with a fringe of acquaintances, filled the afternoon, and almost always some remained for the evening."[4]

The tradition of Sunday-morning breakfasts with William continued for twenty years right through the difficult period when Ned felt he was losing his old friend to politics. Georgie kept a special outsize coffee cup for William, who had promised his doctor never to exceed one cup, and the friends would linger over their meal of sausages, haddock, tongue, and plovers' eggs until "unsped by sympathy" it was time for William to go off to do his "street-preaching."

Georgie had sent their son, Phil, away to school at nine to shield him from his father's besotted affair with Mary, but Margaret, the darling daughter Ned doted upon, was at home and growing into the very personification of a Burne-Jones stunner. Ned was exceedingly fond of children. He had a childish streak and loved to immerse himself in playing games with them. He drew comic pictures for Phil and

LEFT: William's gargantuan appetite is cruelly denied in this caricature by his good friend Edward Burne-Jones.

OPPOSITE: **GEORGIANA BURNE-JONES—WITH CHILDREN** by Edward Burne-Jones. "A lady more agreeable to know than Lady Burne-Jones would not be easy to find—one more frank, cordial, spirited and clever," wrote William Michael Rossetti.

Margaret of portly ladies or scary scenes of ghosts and monsters, which filled them with delicious terror and delight. His nephew, Rudyard Kipling, whose parents were away in India, loved to stay at the Grange and join in the children's riots that raged around his uncle, calmly drawing cartoons for them. For him the Grange was a magical house, smelling excitingly of paint and turpentine, where his beloved aunt might play the organ or the entrancing figure of William Morris might read his poetry aloud while sitting astride his cousins' rocking horse.

Throughout his life (and long after his affair with Mary was over) Ned looked beyond his marriage for intense female friendship with increasingly younger women—not unlike his old friend and mentor John Ruskin.[5] There is no evidence that these were necessarily sexual relationships; they were more a kind of passionate platonic state, cloaked in the convention of sentimental friendship, which was an accepted Victorian custom, but inevitably they caused Georgie pain. Later Ned admitted to "a dread of lust," a fear of what "might happen to me if I were to lose all fortitude and sanity and strength of mind—let myself rush down the hill without any self-restraint," which suggests that he consciously kept his impulses in check.[6]

Georgie managed these wistful flirtations as ably as she managed the house but what was she really like? Ned loyally called her "my stunner," although it is plain from the surviving photographs that she was far from being a beauty. Small, with mousy hair parted in the center and demurely fastened, she has none of the tumbling

ABOVE: Ned draws himself snoozing uncomfortably in a chair while William, at his most "Topsaical," recites his latest epic poem.

143

extravagance of Janey, nor the arresting, off-key loveliness of Lizzie. Nor, sadly, the perfect beauty of Mary Zambaco.

She may have been a child bride but she proved a tenacious wife who weathered her husband's whimsical wanderings and emerged at the end of her life as an important public figure, titled and occupying a prestigious place on the Board of Trustees of the South London Art Gallery and sitting as a parish councillor.[7] The Grange was her home for more than thirty years.

It became a place of pilgrimage for one impressionable young art student named W. G. Robertson, who gives a vivid impression of his first visit to Fulham. After the vaguest of directions—"Go west along the Cromwell Road until your cab horse drops dead, and then ask"—he continued:

BELOW: The second studio, designed by W. A. S. Benson, where Sunday guests were shown while the shy painter continued working in his studio inside the Grange.

"The front door opened . . . the impression conveyed was that of unusual quiet, a hush almost suggesting the Sleeping Palace of Faerie lore save that there was no drowsiness in the spell; the house seemed to hold its breath lest a sound should disturb the worker.

"The hall was dark and the little dining-room opening out of it even more shadowy with its deep-green leaf-patterned walls; and it is strange to remember that

the Brotherhood of Artists who so loved Beauty did not love light, but lived in a tinted gloom through which clear spots of colour shone jewel-like. At the end of the dining-room stood a dark green cabinet, painted with designs partly raised in gesso and enriched with gold and brilliant hues, wrought by Burne-Jones in the early days when he, with Morris and Rossetti, was devising wondrous furniture and house decoration. Above it hung a small painting, a little figure in magical red . . . beyond the hall was the drawing-room, which struck a different note. Here all was simple austerity, and there was light in plenty from two large windows opening on the garden. The furniture was plain . . . and a pleasant-faced owl looked down from a cabinet; where were a great many books and book cases . . . out through the window I was led, across a lawn to where under a big mulberry-tree sat a tiny lady."[8]

A tiny lady who provided her husband with the perfect conditions in which to work on his large and increasingly successful canvases. The house was filled with echoes of

ABOVE: Life at the Grange revolved around Edward's needs and working pattern. Georgiana Burne-Jones embraced the Ruskinian model of an "enduring, incorruptibly good, infallibly wise" wife who shelved her own ambitions in favor of making the home her "true place and power."

all their former homes. Furniture—the little walnut piano, closets, and cabinets—painted by Ned, Gabriel, and William stood in new positions. One of the embroidered panels from the *Illustrious Women* series that Janey and Georgie had worked for Red House was mounted on velvet to serve as a curtain portière (a rather superior draught excluder and essential in such a large and imperfectly heated house) across the dining room (it is now at Kelmscott Manor). The Grange boasted a butler, William, and a range of parlormaids and kitchenmaids, including one named Annie who stayed with Georgie until her death. Despite such loyalty, Georgie considered that the relationship between servants and employers was "either a bloody feud or a hellish compact."

As the years went on, Ned's relationship with Gabriel grew distant. In 1874 Ned wrote: "This is a letter of bitter reproach—you've finished a big picture and are sending it away to-day, and I do think it's shabby not to tell me and let me see it. Nobody anywhere in the world cares for your pictures as I do, and nobody understands them as well, and I ought to see them."[9]

His own career had taken off and he began to be plagued by swarms of Sunday visitors. Famously shy, Ned responded to these invasions by commissioning the architect W. A. S. Benson (whose wife Venetia was the daughter of the watercolorist Alfred William Hunt and sat for Ned) to build a garden studio, "a long, white, roughcast" skylit shed, to which he directed the hordes who had started to descend ever since 1877 when his affiliation to Sir Coutts Lindsay's newly opened Grosvenor Gallery catapulted him to new heights.

Lindsay, who had spent £150,000 converting three houses in New Bond Street, wanted a gallery to rival the Royal Academy. The Burne-Jones name guaranteed the gallery's artistic credentials. His wife, the society hostess Lady Lindsay, ensured its fashionable success by holding Sunday-afternoon "at homes" in the gallery and hosting dinners at which she mixed artists and aristocracy. "From this time," Georgie wrote "[Ned] belonged to the world in a sense that he had never done before, for his existence became widely known and his name famous." He also became wealthy, securing a commission worth £15,000 from the financier Alexander Henderson, later

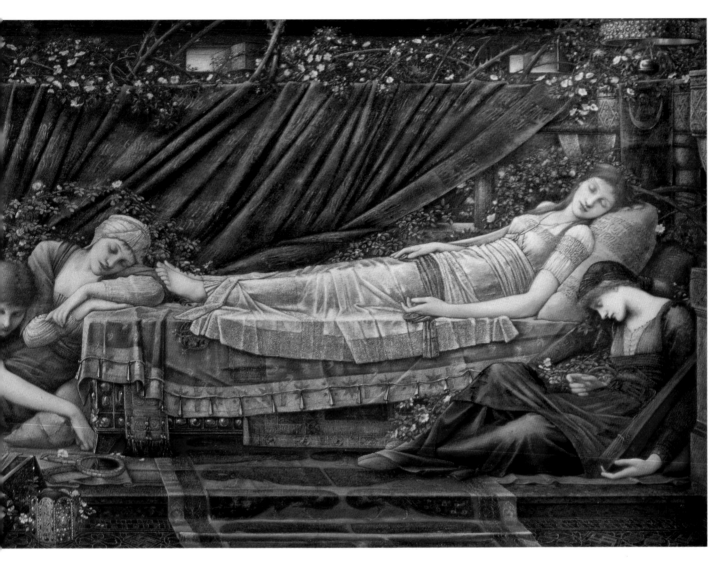

Lord Faringdon, for his *Briar Rose* sequence of paintings, which, like *Cupid and Psyche*, he worked on for a period of several years. By investing the bulk of the money he was able to provide himself and Georgie with a secure income of about £420 a year and, for the first time in his life, a proper bank account. He bought himself a sealskin coat lined with red silk (a sure sign of a Victorian artist's success), and he and Georgie began to take cabs home, rather than walk, after what she called "our dissipations" in decent restaurants in town. The *Cupid and Psyche* sequence was designed as a frieze for the dining room of the house of George and Rosalind Howard at 1 Palace Green and Ned worked on it on and off for ten years, helped by Walter Crane and William Morris, whose wallpaper covered the ceiling. When it was finally finished the *Studio* reported that the room glowed "like a page of an illuminated missal,"[10] but some lamented that, because "there was no call for national epic, the artist had to turn himself into a provider of dining-room pictures for men of money."[11]

*ABOVE: **THE SLEEPING BEAUTY** from **THE BRIAR ROSE SERIES** by Edward Burne-Jones. Edward's fascination with innocence suspended, or frozen, speaks volumes about his own attitude to sexual passion. "Lust," he admitted, "does frighten me, I must say. It looks like such despair."*

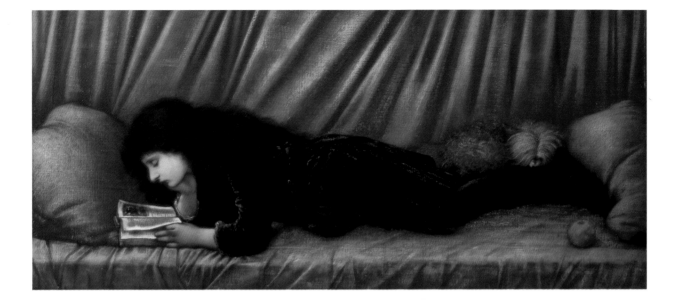

ABOVE: **PORTRAIT OF KATIE LEWIS** by Edward Burne-Jones. The young recipient of a charming stream of letters from Ned, seen here lost in a book.

Ned's new prominence had put him on the "Show Sunday" circuit. This was the custom, scrupulously observed by the Victorian upper-middle classes, of making a tour of artists' studios on Sunday afternoons, and particularly on a specified Sunday in April, known as "Picture Sunday," just before the artists sent their work into the Royal Academy. Carriages would call at Lord Leighton's exotic house in Holland Park and marvel at the Arab Hall, with its sunken black marble pool and gold dome overhead, or Lawrence Alma-Tadema's studio where the ceiling was painted silver and the banister was said to be gold (although "Tad" confessed it was only brass when the letters begging for bits of banister began to arrive). Such wonders were a far cry from the homely clutter of Ned's studio, furnished not with gold and marble but old Persian carpets and rush-bottomed chairs. The *Punch* artist Linley Sambourne and his wife Marion toured the studios of Prinsep, Hunter, Fildes, Leighton, Millais, and Alma-Tadema, as well as several lesser artists, on a single Sunday.[12] Kate Lewis, daughter of the eminent lawyer Sir George Lewis and recipient of a stream of charmingly illustrated letters from Ned, recalled visiting artists' studios, "only a few beyond walking distance," in Kensington in her youth in the mid-1880s:

"We went down Holland Walk, shaded then by great elm trees with rooks cawing noisily from their nest overhead, and through the branches we looked into the beautiful grounds of Holland House. A few yards along the High Street brought us to Sir Frederick [*sic*] Leighton's wonderful house and studio: marble pillars, an indoor pool with water-lilies and a slender fountain, frescoes, mosaics and wonderful hangings. But it didn't seem to be "lived in," or homelike, like those of Luke Fildes and Colin Hunter, nor like the library in which a quite young painter, Graham Robertson, worked."[13]

Ned loathed Show Sunday and would continue to work in his indoor studio, hidden behind the vast canvases and precarious but vital piles of books and folios, which were the bane of Thomas Rooke, his devoted assistant, known always as "Little Rookie." When grandchildren came along they were forbidden entry to this room, causing them to speculate endlessly on the "Sinister people called 'models' who lived there and who

OPPOSITE: A severe Victorian red brick façade masks the splendor and theatrical excess to be found inside Lord Leighton's house in Holland Park. William de Morgan was responsible for the tiles and Walter Crane the frieze in the sumptuous Arab Hall, which, with its sunken marble pool and gold dome, so entranced and impressed visitors and prospective purchasers.

> "One can only stand and listen to the splashing of the fountain falling beneath the golden dome at the far end of the court, and conjure up recollections of the fairest of scenes and grandest of palaces described in the Arabian Nights. We are in Kensington; but as one stands there it would not come as the least surprise if the court were suddenly crowded with the most beautiful of Eastern women reclining on the softest of silken cushions in the niches in the corners; if the wildest and most fascinating dancers of the Arabian Nights were to come tripping in, and to the sound of the sweetest of strains glide across the smooth plaques."
>
> HARRY HOW DESCRIBING LEIGHTON HOUSE, *STRAND MAGAZINE,* 1892

had trays taken up to them at lunch and tea time."[14] But for other Victorian painters it was an important and affirming occasion. Luke Fildes's son remembers his mother instituting "a system by which the parlormaid, stationed on the landing outside the studio door, dropped a coffee bean into a brass bowl for every visitor who came up the Triumphal Staircase" of their home in Melbury Road on Picture Sunday.[15]

In March 1874 *The Architect* ran a piece reminding its readers of the treat in store:

"Studios!—even as we write the word studio, doors fly open to admit for once in the year shoals of eager visitors. Outsiders are always curious about artists and their surroundings; to them the sanctum sanctorum of the painter's house is a mysterious place, draped in tapestry . . . it is the sacred meeting ground of a secret society, whose talk is a masonic puzzle to the uninitiated—a laboratory in which ideas are melted down and boiled up, and turned out on canvas by magic, the paint-pot and brushes being the wizard's apparatus."[16]

The opening day of the Royal Academy Summer Show was a fixed point in the social calendar around which a myriad of other events revolved. Every year, just before the exhibition, Henry Tate, the Liverpool businessman who had made millions out of sugar, entertained artists at his house in Streatham, providing strawberries from his own hothouse. His collection contained a great many late Pre-Raphaelite paintings, and it was at Millais's house in Kensington that Tate discussed with, among others, Lord Leighton, president of the Royal Academy, his plans to donate it to the nation. It was Millais who encouraged Sir Henry Tate to found the Tate Gallery in 1892.

Ned was not there. The pattern of his life followed different lines. Ever since he was a little boy he had seen days in color. Sunday was gold, Monday yellow, Tuesday red, Wednesday blue, Thursday amethyst, Friday sapphire—and "Saturday wet," he said, "ever since I was tiny—but I don't know why." On most days he worked at his painting. He appeared gentle and fragile but he loved a joke and once told an Italian

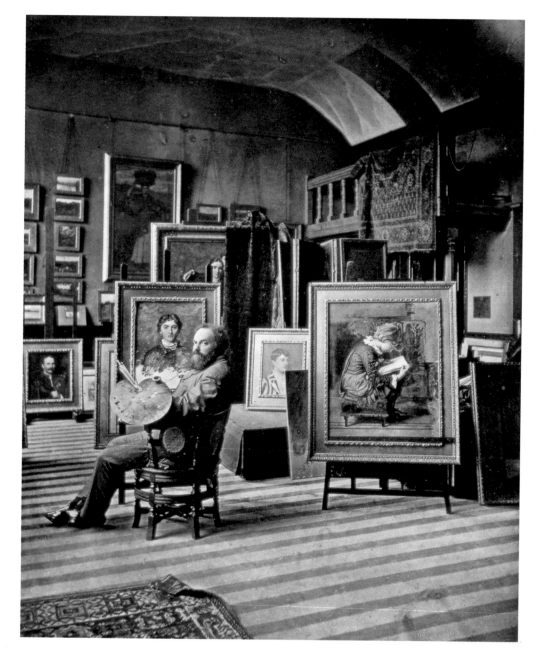

ABOVE: Valentine Prinsep photographed in his studio in Holland Park, looking every inch the successful and prolific Victorian painter, for F. G. Stephens's "Artists at Home" series published in 1884.

model that the swishing she could hear from the walnut orchard in the garden was the sound of Englishmen beating their wives. In fact Georgie was supervising the beating of the carpets. His quiet wit could explode into outrageous bursts of humor, and he laughed in three speeds: normal, hearty and totally silent (most prized by his friends), and convulsed.

The Grange no longer stands. If Georgie and Ned returned to the area today they would find a council estate on the site of their old home. Yet their name lives on in the area, for one of the towerblocks is called Burne-Jones House.

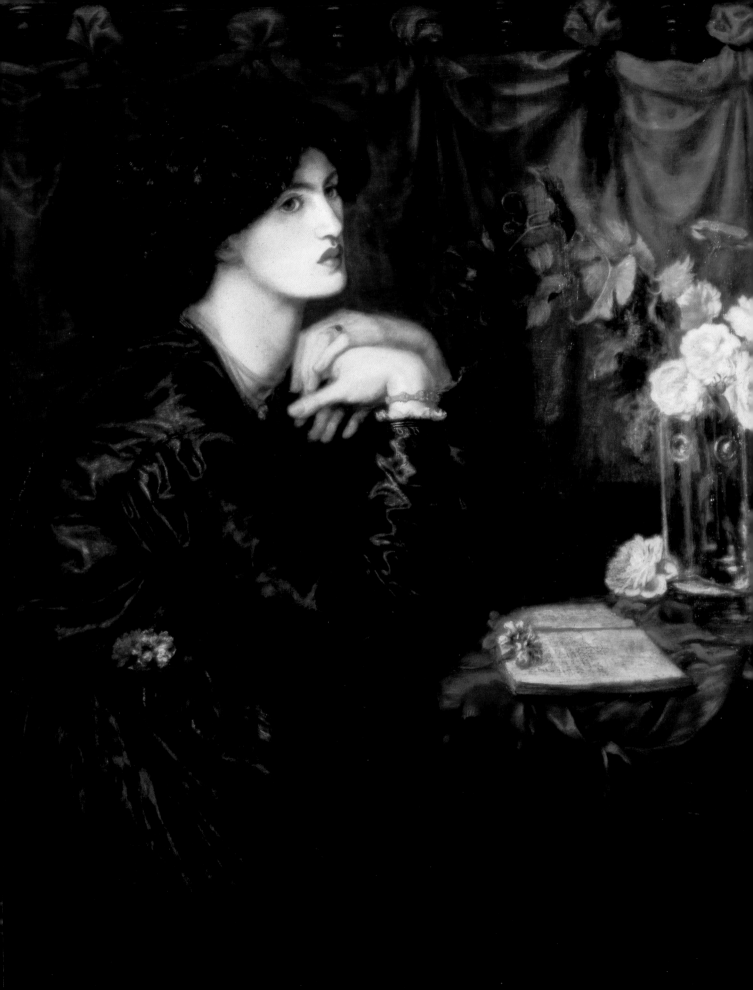

Chapter 12

POLITICAL PASSIONS and the ARK

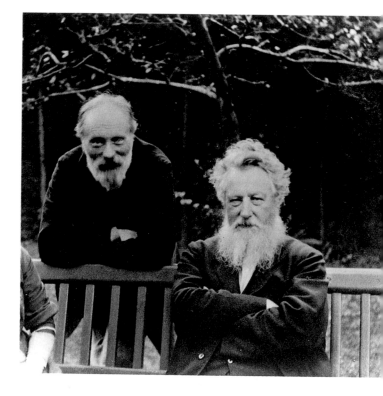

ABOVE: *Edward Burne-Jones and William Morris.*

"My dear Gabriel,
After many delays, we got into the new house only last night, workmen will not have done for another week, and then there will be carpets to fit and various things to finish. Still I thought it would be better to get in as soon as possible, as every week it gets colder and colder.

I am doing nothing myself except feeling tired and lying awake at night.

Your affectionate
Janey"

ILLIAM'S AND JANEY'S NEW London house stood on a wide curve of the river at Hammersmith just in sight of the first suspension bridge ever erected across the Thames (built in 1827 but replaced in their time by the green-and-gold bridge we know today) and stands there still, although it is tourist boats rather than river steamers that are likely to disturb residents of the Mall nowadays. An imposing square house, built of soft yellow brick, it rises tall behind a black wrought-iron gate, beyond a low wall covered with a tumble of honeysuckle and jasmine. The house has four stories, with attics at the top and a basement that Gabriel warned Janey would flood.

Gabriel had viewed The Retreat (as the house was originally called) when house-hunting himself.[1] He sent a fairly detailed description in April 1878, pointing out that although the garden was good the kitchen was "frightful":

OPPOSITE: *MRS. WILLIAM MORRIS IN A BLUE SILK DRESS* by Dante Gabriel Rossetti. "When she came into the room in her strangely beautiful garments, looking at least eight feet high, the effect was as if she had walked out of an Egyptian tomb at Luxor," wrote George Bernard Shaw of Janey.

"... perfectly dark and very incommodious—the kitchen stairs being a sort of ladder with no light at all, in which smashes would I should think assail the ear whenever a meal was going on. You would hardly get good servants to stay there (it is all stone moreover) unless some alterations were made, which would be difficult. Besides these objections, the place is very damp: masses of dead leaves forming a complete swamp in the garden when I was there: I fear really it is *not* the place to suit the health of any of you—though I am sorry to say so, knowing the difficulty of such a search."[2]

William decided to see for himself and took Philip Webb, the architect of Red House, with him. That the house had huge potential was immediately obvious to him, and he wrote at once to Janey, dismissing the idea of damp and reporting that it "could easily be done up at a cost of money" and "made very beautiful with a touch of my art."[3] He had earmarked "a very nice room looking into the garden" for Janey and "a nice room for each of our maidens." Furthermore, there were a couple of "larking rooms" for the girls above the adjoining coach house and a superb drawing room thirty-seven feet long, running the width of the house on the first floor with five tall windows commanding wide views of the river and "which could be made one of the prettiest in London." He was aware that the house was a long way from the center of town and proffered as an alternative another house he had viewed, on the corner of a terrace overlooking Holland Park, though he thought it so "scrimpy and dull" that he would rather be "back among the bugs of Bloomsbury." No, decidedly, the Hammersmith house was the one for them. It had a rambling and "most beautiful" garden,[4] "a queer little den of a bathroom with gas & water laid on," and a "dismallish handsome room" with a lofty ceiling that "I believe by dint of cheerful papering, book-cases and the like it might be made a very good dining-room."[5] Janey, with Gabriel's words of caution ringing in her ears, was unconvinced but William was not prepared to compromise with "the ordinary modern-Cromwell-Rd-sort-of-house" in which he warned he would be "so hipped that I should be no good to anybody."

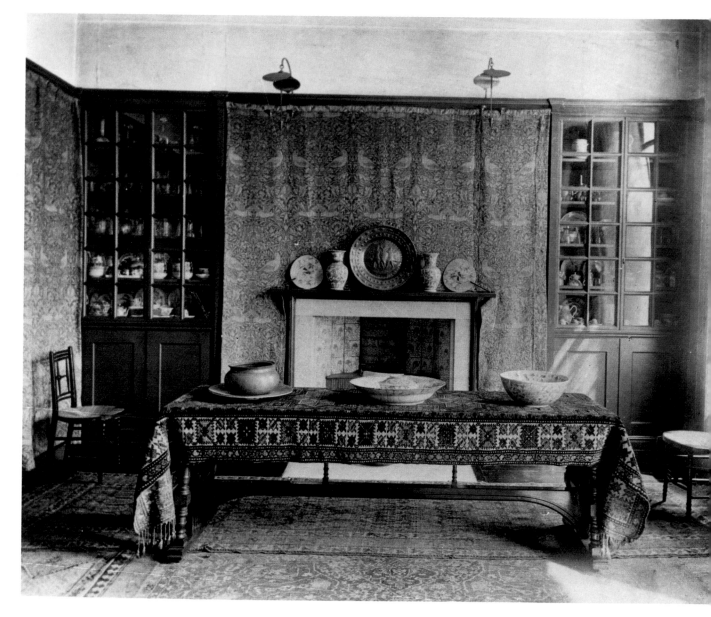

For a while they toyed with the idea of exploring Bloomsbury again, although William worried that "you and the childer [*sic*] would be much off from the Neds."[6] Finally, with the promise of a pony and trap (which never materialized) and a third maid (who did) William, forty-four by now, persuaded Janey, whose thirty-seventh birthday had just passed, that The Retreat ("fy on the name!") would be a house in which "we shall all grow younger" in the company of friends who would be lured by the garden and the river.

The fact that the house needed a great deal of repair is reflected in William's offer to pay a rent of £85 per year—rather below the going rate of £140 for a good house with a garden outside London and considerably below the £300 he warned Janey

ABOVE: The first-floor drawing room at Kelmscott House. The walls are covered in William Morris's "bird" hangings. "All rooms ought to look as if they were lived in, and to have, so to say, a friendly welcome ready for the incomer," William wrote in Making the Best of It.

"I do not think he ever felt in his heart that the house he named Kelmscott House was our real home; it was a convenient and seemly shelter from the weather, a place to keep books and pretty things in, but at best a temporary abode . . . No house in London could ever be invested with the passionate delight he had in our dear riverside home, the home of his dreams, with its poet's garden."

(MAY MORRIS INTRODUCING THE *COLLECTED WORKS OF WILLIAM MORRIS*)

OPPOSITE: The dining room at Kelmscott, papered in Pimpernel, with the vast Persian carpet that so impressed George Bernard Shaw suspended from the ceiling. It was on hand looms set up in the stables of Kelmscott House that the first hand-knotted Hammersmith rugs, marked with a distinctive hammer and blue zigzag to symbolize the river setting, were made for the Oxford Street shop. The completion of a big carpet was always an occasion, and the family would troop across the garden to admire it as it came off the beams.

they could expect to pay in the middle of town. William set to work at once. He engaged the Firm's contractors and decorators, transforming the "dismallish" dining room with his own "Pimpernel" patterned wallpaper into a lovely blue and green room, high ceilinged, and lightened by a white painted fitted dresser along the far wall to house his collection of blue-and-white china. Gabriel's portrait of Janey, known as *Mrs. William Morris in a Blue Silk Dress* was hung above the Adam mantelpiece in this room.[7] It also boasted a Persian carpet "so lovely that it would have been a sin to walk on it," according to George Bernard Shaw, who noted that it was "consequently not on the floor but on the wall and half way across the ceiling." It was Shaw, too, who remarked on the daring absence of tablecloths.

William installed the vast settle from Red House in the drawing room, along with a cabinet painted with scenes from the life of St. George, and the wardrobe adorned with scenes from Chaucer's *The Prioress's Tale* that had been a joint wedding present from Ned and Philip Webb. "We girls," May enthused, "as loyal worshippers in the home circle, thought it not 'one of the prettiest rooms in London,' but just *the* most beautiful."[8] William's rooms were downstairs: his study ("severely undecorated," according to his first biographer, with "a square table of unpolished oak scrubbed into snowy whiteness" but with neither carpet nor curtains) to the right of the central door; his bedroom, in which he had built a tapestry-loom so that he might teach himself the art of weaving, to the left.

The whole house expressed the "artistic taste of extraordinary integrity" that Shaw and other visitors had come to associate with William's mature style. The redecoration set William back around £1,000—at a time when his annual income was on the increase from £1,200 in 1878 to £1,800 ten years later—but meant he had an excellent house right on the river, which made it a popular venue on the annual Oxford v. Cambridge Boat Race day. The sociable William adored these occasions yet Janey rather dreaded them: "There is a dreadful thing called a 'Boat Race' in our part of London, which I am only too glad to avoid," she wrote to the poet Wilfrid Blunt.

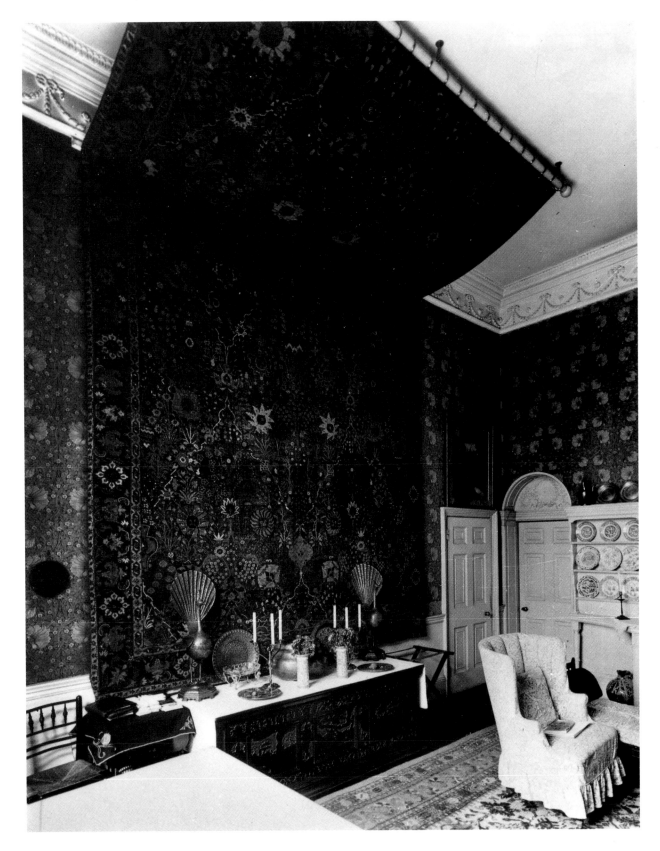

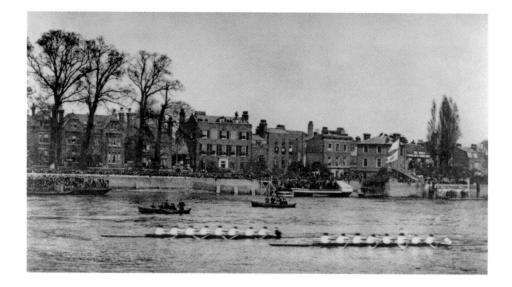

ABOVE: *The Oxford and Cambridge Boat Race passing Kelmscott House in 1892. The workmen from Merton Abbey were among William's guests that year.*

In 1879 William invited more than ninety guests to watch the Boat Race from the house. Afterward they were given lunch and played games in the garden, then toured Devonshire House in Chiswick, which was specially opened for them. Three years later he assured two prominent members of the Temperance movement that they would "be very welcome and shall not be COMPELLED to drink anything save water." If only all his guests could have been relied upon for such sobriety. The venue soon became a fixture and "all sorts of disagreeable people" simply turned up on the day. "A good many of them would go on the roof," William complained, "and sit outside of it: Bah. It makes me giddy to think of it—and O how black their hands were afterwards."

William's keen social conscience was pricked by the poverty he saw around him at Hammersmith. The district bordered a riverside slum and "ragged mites" would tumble about on their steps, destroying his concentration as he tried to work on his political writings in his ground-floor study. "As I sit at my work at home," he told an audience at the School of Science and Art:

"I hear the yells and shrieks and all the degradation cast on the glorious tongue of Shakespeare and Milton. As I see the brutal reckless faces and figures go past me, it rouses the recklessness and brutality in me also, and fierce wrath takes possession of me, till I remember, as I hope I mostly do, that it was my good luck only of being born respectable and rich, that has put me on this side of the window among delightful books and lovely works of art, and not on the other side, in the empty street, the drink-steeped liquor-shops, the foul and degraded lodgings."[9]

William, who argued passionately and publicly for equality and made Kelmscott House the center of his political activities, saw no conflict in his employment of servants at both Kelmscotts. Indeed, he and Janey prided themselves on their fair treatment of all in their employ. Janey paid her domestic staff well and presented one of the housemaids with a silk dress on her marriage in 1883. Census records show that

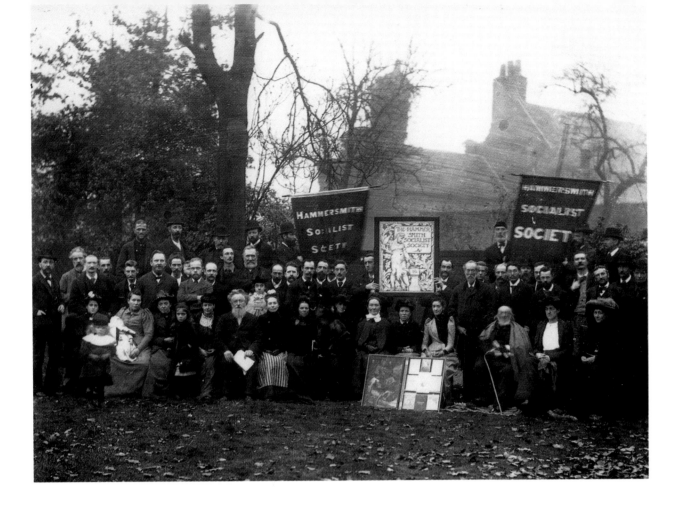

there were three servants living at Kelmscott House in 1880: a thirty-eight-year-old cook called Annie and a housemaid, Elsa, and parlormaid, Elizabeth, both in their twenties. Unlike Gabriel, Janey was good at finding and holding on to excellent cooks, but Floss Gummer, a kitchenmaid from a later period at Kelmscott House, remembered that the hours were long and that William was prone to occasional volcanic bursts of temper. Their elder daughter Jenny had been diagnosed with epilepsy and her fits were often frightening for the servants and taxing for her parents.

As William's extraordinary political zeal mounted, he converted the long adjoining coach house—which he had originally fitted out as a carpet workshop—to a lecture room for the Hammersmith Socialists. Here William Morris, the privileged son of prosperous parents, exhorted new members of his Socialist League to "agitate, educate and organize." He urged the "working-men of Hammersmith" to come to his headquarters in Hammersmith "so that you may combine for real freedom, for a life fit for human beings."[10]

The dates of William's sojourn at Kelmscott House, as he renamed The Retreat, are carved into a simple stone to the right of the door. On the left a black stone commemorates the stay of William's predecessor, George Macdonald, a poet and novelist, who lived in the house with his wife and eleven children for ten years before William and Janey.

The scene at Upper Mall is still beautiful. The houses are old and stately, elegant buildings flanked today by neatly groomed urban parks, part of the riverside walk

ABOVE: The Hammersmith Socialist Society. William Morris joined the newly formed Social Democratic Federation in 1883 and threw his considerable energies into his new political life. He addressed meetings, wrote pamphlets, and launched the Socialist newspaper Justice. *His activities centered upon the Hammersmith branch of the league, which in 1890 he renamed the Hammersmith Socialist Society.*

ABOVE: William Morris in his study at Kelmscott House. May recalled how her father used to work against the background noise of local children playing on the scrubbed steps of his front door until he could endure it no longer and then he would "go out and beg them to give him a little peace and quiet and play elsewhere for a while."

opened up by the council. Sadly, the "fine old trees" along the towpath have long since disappeared, victims of Dutch elm disease. There are several venerable pubs such as The Rutland and, nearest to William's and Janey's house, The Dove. Next door a house wreathed in ivy boasts a blue plaque commemorating Thomas James Cobden-Sanderson, who founded the Doves Bindery and Doves Press in the house and later lived and died there. It was Janey who encouraged her near-neighbor to try his hand at bookbinding, commissioning him to bind a volume of Gabriel's poetry and two volumes of Dante for her.

At low tide the colorful houseboats, all lashed together, lean at crazy angles and grimy London gulls and waders pick about in the oozy green mud of the riverbed. But both Gabriel's and William's large and lovely riverside houses have been marred by modern roads and the tyranny of traffic. At Chelsea a churning river of cars stands between Cheyne Walk and the Thames. At Hammersmith the tranquility is disturbed by the incessant thunder and roar of the Great West Road, six lanes of motorway, with four more on the overpass, which rises right behind William's house. The peace is illusory.

KELMSCOTT HOUSE AND KELMSCOTT MANOR were linked by the Thames, and William, according to his first biographer, "liked to think that the water which ran under his windows at Hammersmith had passed the meadows and grey gables of Kelmscott." He had long cherished a plan to travel the 130 miles from one house to the other by boat.[11] The first of two voyages began on a sunny summer afternoon on 10 August 1880. It was quite a party. "Little things please little minds," he wrote gleefully to Georgie, "therefore my mind must be little, so pleased am I this morning." And it *was* a glorious morning. The sky "one sheet of pale warm blue" and the "earth sucking up the sun rejoicingly." He and Jenny had already been out to view the "odd but delightful" craft he had hired from an Oxford boat firm. He called it, appropriately enough, the *Ark*. "Imagine," he enjoined Georgie, "a biggish company boat with a small omnibus on board, fitted up luxuriously inside with two shelves and a glass rack, and a sort of boot behind this." To his younger daughter May, and her school friend Elizabeth Macleod, it seemed like "a sort of insane gondola." William was like a small boy, relishing the prospect of sleeping "with the stream rushing two inches past one's ear" and "the romance of the bank" all around them during the day. The party, which included three bachelor friends (William de Morgan,[12] Crom Price, and Richard Grosvenor) set out after lunch and rowed as far as Sunbury, some six miles above Hampton Court, before stopping for the night. William and Crom slept aboard while the others stayed at the Magpie Inn, which had provided them with a late supper of poached eggs, ham, and pickled salmon.[13] Next day they were off again. The weather continued blissful and William, who had appointed himself cook and chronicler, kept a day-to-day journal under the title "The Voyage of the Ark." This humorous log (written nine years before Jerome K. Jerome's *Three Men in a Boat*) gives a vivid picture of the colorful crew, guzzling gingerbeer and soda water, and taking lunch "luxuriously" on the bank beneath enormous willows, or tea on the grass of Runnymede.

They ambled along through Windsor and Eton, towed by a man with a pony, hit a regatta at Maidenhead that held them up, skirted a weir at Marlow, and were stuck in the mud for twenty minutes at Wargrave. "All the males of the party gave conflicting orders in loud tones (mostly emphatic)," William wrote. Nights were spent in picturesque villages where the party "scattered all over" availing themselves of whatever accommodation the small inns afforded, while William and Crom generally maintained their preference for the *Ark*. Janey, William reported, was "quite at home" on the *Ark*, reclining against a bank of pillows like a medieval queen with her embroidery frame. Only the wasps were a bother.

At Oxford Janey disembarked and went ahead by rail to get everything ready at Kelmscott Manor. The river was too narrow now for the *Ark* so they left it in Salter's Boatyard and "muddled ourselves home somehow" in two rowing boats, marveling at the haymakers on the flat flood-washed spits of ground and islets all about Tadpole, who were gathering their hay on punts. It was night by the time they reached Radcot, their little lantern met by the answering lights of "the ancient house" that Janey had "lighted brilliantly, and sweet it looked, you may be sure." Presently, he wrote, his favorite house "had me in its arms again."[14]

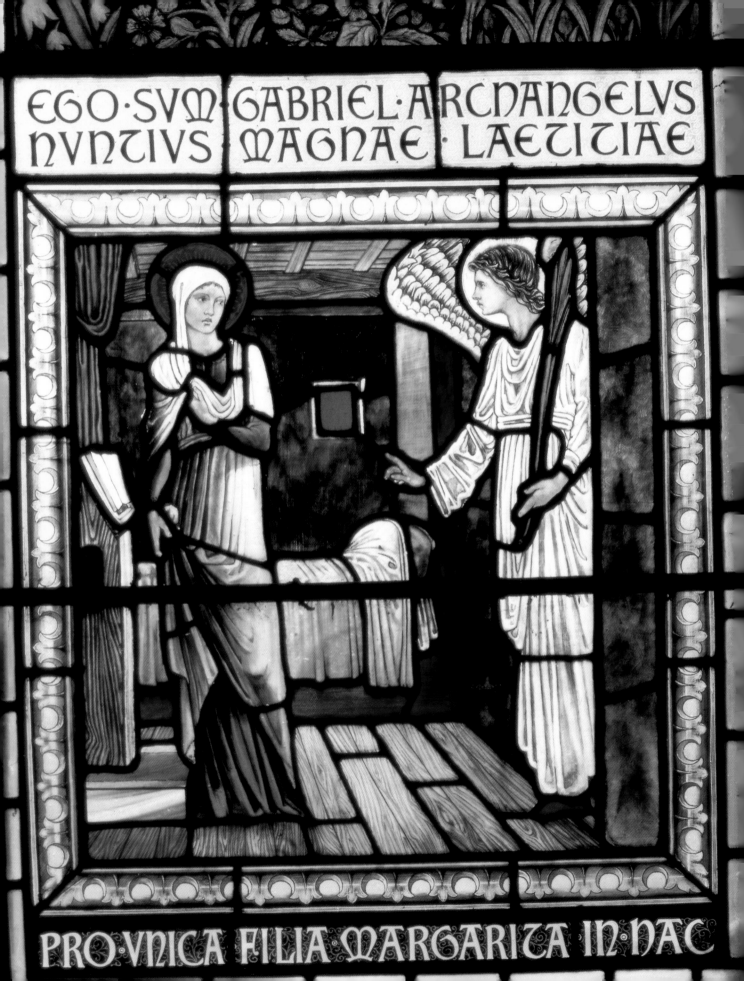

EGO·SVM GABRIEL·ARCHANGELVS
NVNTIVS MAGNAE·LAETITIAE

PRO·VNICA·FILIA·MARGARITA·IN·HAC

Chapter 13

A HOUSE *by* the SEA

"We are at a little village near . . . Brighton—
Georgie and Margot and I—a peaceful little place
in the Down country; and here some half dozen
times a year do I come to rest me for three or four
days . . ."

EDWARD BURNE-JONES

 EN YEARS INTO THEIR TIME at the Grange, Georgie began to
look about "for a little house of our own by the sea." It was
typical that Ned, the physical opposite of his ebullient friend
William Morris, should leave the arrangements to his capable
wife, who "commands and forbids with increasing energy." He
liked the idea of Brighton, but not of travel, so it was alone that
Georgie journeyed down to the Sussex coast one "perfect autumn day." Finding
nothing to suit them in Brighton, she turned her back on the town and walked
eastward over the Downs to Rottingdean.

"No new houses then straggled out to meet one," she wrote in her *Memorials*, "the
little place lay peacefully within its gray garden walls, the sails of the windmill turned
slowly in the sun, and the miller's black timber cottage was still there. The road I
followed led me straight to the door of a house that stood empty on the village green
. . . we bought it at once."[1]

Prospect House, a small whitewashed property on the edge of cornfields with
views across the Downs, became an important second home to the Burne-Joneses.
Georgie, who used to joke that Hampstead Heath was Ned's "northern limit of
travel," could always persuade him to make the fifty-nine-mile rail journey to Sussex
because he had "a home at each end of the road."[2] It was delightfully bucolic. Milk
came from the farm in pails (just as it had in Fulham when they first moved there),
and the house stood opposite a solid little Saxon church, in which, in 1888, Ned's

*ABOVE: EDWARD BURNE-
JONES ON A BOAT AT WALTON
by Thomas Bastien-Lepage.*

*OPPOSITE: THE
ANNUNCIATION (stained glass)
by Edward Burne-Jones.
The church was explicitly targeted
by the Firm in a persuasive
prospectus and proved an
important source of commissions.*

163

.ABOVE: NORTH END HOUSE, ROTTINGDEAN by Thomas Matthews Rooke. Georgie described Rooke, who was a familiar and welcome visitor at North End House (formerly Prospect House), as one of the family's "most intimate and unexacting friends."

and Georgie's daughter Margaret was married to John Mackail in a picturesque ceremony that included "four damsels in white" scattering rose petals from big baskets. Ned, who admitted to a "a short torment of jealousy," had the parson omit all references to procreation in the marriage service, allowing him to say only that "marriage was ordained for mutual help and comfort." [3]

Still, he was delighted when his grandchildren visited. One of them, Angela, always a "noticing" little girl, went on to make her name (as Angela Thirkell) as the writer of amusing and sometimes slightly fantastic novels with an English-village setting. In *Three Houses* she writes observantly about Ned and Georgie:

"As I look back on the furniture of my grandparents' two houses I marvel chiefly at the entire lack of comfort which the Pre-Raphaelite Brotherhood succeeded in creating for itself. It was not, I think, so much that they actively despised comfort, as that the word conveyed absolutely nothing to them whatever. I can truthfully say that at neither . . . house was there a single chair that invited to repose." [4]

Georgie would have been mortified had she read this, for she envisaged Prospect House as a perfect retreat for Ned and their friends. Once again W. A. S. Benson was employed to "ingeniously" fit and furnish "the little house so that we had ample space, and beds were easily found in the village for visitors. The largest room became both studio and bedroom for Ned, and he loved the view of it." [5] Angela, whom Ned

spoilt shockingly, allowing her to butter her bread on both sides, was often to be discovered there. One day, when she failed to materialize, Ned went looking for his little granddaughter and found her banished to the corner of the nursery for some small misdemeanor. "The very next day," Angela later wrote, "he took his paint box into my corner and painted a cat, a kitten playing with its mother's tail, and a flight of birds, so that I might never be unhappy or without company in my corner again."[6]

When his favorite nephew, Rudyard Kipling ("beloved Ruddy"), took a house in the village, Ned toyed with the idea of a permanent move to the country. London, he now found "so ugly . . . all about us the streets have grown so hateful—noisy, rowdy, blackguardly—it is often well-nigh unendurable."[7] But his work was "unportable" and he would miss his friends and his Sunday-morning breakfasts at the Grange with William, even though he found that "we are silent about much now and used to be silent about nothing."[8]

Fulham was undoubtedly changing. The District Railway had opened, spawning new housing of the kind Kensington had experienced. The little lane behind the Grange became a street, and a row of houses showed above the Grange's wall where before had only been the friendly branches of a walnut tree. The long studio across the end of the garden that Ned had asked Benson to build served as a screen, as well as a place to house finished work and somewhere to divert the hordes of admiring public.

At the age of fifty Ned complained that "the blaze is going out of me."[9] Gabriel had died the year before in a large rambling bungalow near the windswept cliff face at Birchington-on-Sea on the north Kent coast, where he had gone to convalesce after a stroke had incapacitated him. The raw, newly built house was owned by the architect J. P. Seddon, an old friend, who insisted Gabriel consider it home for as long as he needed it. He did not need it long. Weakened by an almost constant use of chloral and subdued by morphia, he died on Easter Sunday 1882 and, having a horror of Highgate Cemetery, was buried in the churchyard of All Saints' at Birchington. He was fifty-three years old. He had made a will on his deathbed, leaving half his property to his mother and half to his brother William Michael, and

ABOVE: Edward doted on his grandchildren, Denis and Angela Mackail. Angela remembered how each year he would paint scenes—a picture of the church, or the downs, or fat babies with a cat, or a pond with ducks—in edible watercolors on a white iced cake to mark the anniversary of his marriage to Georgie.

"The worst of it is I've no longer Rossetti at my back—he has left me more to do than I've the strength for, the carrying on of his work all by myself."

(*THE MEMORIALS OF EDWARD BURNE-JONES*)

"three of the largest and best chalk drawings" of Janey together with the profile head "now hanging over the mantelpiece in the studio" to "my friend Mrs. William Morris of Kelmscott House Hammersmith." Ned, who had set out for the funeral but collapsed on the way, was also remembered in the will as "my friend," to whom Gabriel left a few personal effects—his spectacles and two or three paintbrushes as a memento.

Gabriel's affairs were in disarray. Sums advanced for paintings not yet finished had to be returned and a bill for £2,250 resulted in a contents sale at Tudor House. Everything from valuable antiques to dented kitchen utensils went under the auctioneer's hammer, raising nearly £3,000. The separate sale of paintings and drawings realized a little less. Five years after his death J. P. Seddon designed a memorial, which Ford Madox Brown ornamented and William Holman Hunt officially unveiled in front of Gabriel's house at Chelsea Embankment. But by then Gabriel's work was out of fashion and, like much Victorian painting, it languished in the doldrums until the 1950s when the Pre-Raphaelite revival began to gather strength. In 1987 *Prosperine* sold at auction for £1.4 million.

Gabriel's death came as a huge blow for Ned. Gabriel had been his first glorious teacher, a loyal supporter, and the poet who understood his love for Mary Zambaco. He found he missed his old mentor "at every turn, and more and more, and that the loss of him cannot be made up."[10] He felt he had fallen out of fashion and told his studio assistant Thomas Rooke it was "a pity I was not born in the middle ages," adding that "people then would have known how to use me—now they don't know what on earth to do with me."[11]

Yet his reputation was hardly languishing. John Ruskin wrote to ask for a list of his major paintings for a lecture he was to give at Oxford. He wanted, he explained, to "reckon you up, and it's like counting clouds."[12]

In 1885 he was elected an Associate of the Royal Academy, despite never having exhibited there—indeed, having "pointedly abstained from exhibiting." Lord Leighton, the president of the Royal Academy, called it "a pure tribute to your

genius." But it caused Ned concern and he talked the matter over with William, who saw no dilemma. He had not sought the "honour," and he had no need to accept. But Ned was gradually cajoled into it, despite his better judgement and the loyalty he felt towards the Grosvenor Gallery. Leighton claimed that he was prepared to share him, but soon pressure was put on Ned to attend formal dinners and show himself part of the establishment.[13]

Within a decade he *was* the establishment. In 1894 William Gladstone, the prime minister, wrote to ask him to "accept the honour of a Baronetcy, in recognition of the high position which you have obtained by your achievement in your noble art."[14] Ned implored his friends to keep the news from Topsy who, with his socialist ideals, was bound to be provoked into an outburst. William did not hide his disgust.

But William could not be angry with Ned for long. Their work together was "the solid foundation" of his life and now they had a new project. They had embarked on a mammoth collaboration on an illustrated Chaucer for William's new Kelmscott Press, 425 copies of which were finally printed. The Kelmscott Chaucer has been described as one of the greatest English books ever produced. It is certainly one of the most beautiful. Printed on vellum, bound in white pigskin with silver clasps, it

ABOVE: **THE KELMSCOTT CHAUCER** *was a huge undertaking and became a labor of love for Edward Burne-Jones, who provided the illustrations.*

EDWARD BURNE-JONES TO MRS. FRANCES HORNER, 1889

"This is quite a delightful time here—the place is all changed since you saw it, for the magician's hand (I allude to Mr. Benson) has been upon it . . . there is . . . a study, a haunted room, and a wide hall and new dining room with hangings round it and a still room for Georgie to make scents and jam, and a studio for me, and a sublime bedroom for Phil—all since you saw the little place."

(*THE MEMORIALS OF EDWARD BURNE-JONES*)

unpainted masterpieces.

ABOVE: **UNWANTED MASTERPIECES** *a self-portrait by Edward Burne-Jones.*

took four years to produce and contained eighty-seven illustrations by Ned as well as William's beautifully decorated initials and intricately patterned borders. The Kelmscott Chaucer encapsulates the inescapable conflict in William's work and life: A committed socialist, he had created a book that, exclusive and exquisite, was a book for the rich, just as his interior designs decorated the homes of the rich.

Partly thanks to Ned's gentle nature, discord was rare between them. Theirs was an enduring friendship built on mutual respect and genuine fondness. For Ned "Morris belongs to the big past, when we were all young and strong and ready to beat the world to bits and trample its trumpery life out." He loved to tease Topsy, especially about food. In a letter to his son Phil he describes hiding the chicken and wine meant for a picnic so that when William opened the basket he found it empty. "Mr. Morris looked like a disappointed little boy," he wrote gleefully. The next day he and Charley Faulkner were at it again. "We pretended that no dinner had been ordered, through forgetfulness, and that being Whit-Monday nothing could be got, and he prepared to eat bread and cheese, when lo! again, a delightful and varied dinner was served, and we were so merry."[15]

A vivid impression of Ned's mischievous *esprit de jeu* is given by Thomas Rooke ("Little Rookie"), his studio assistant, who captured the gentle humor of the artist and revealed the most domestic corners of his life in his book *Burne-Jones Talking*. This exchange on 28 February 1896 at dinner is a good example.

"Mistress: 'There's boiled mutton, but don't give your Master carrots. (*To him.*) Relations are strained between you and carrots, aren't they, Ned dear?' E B-J: 'Carrots and I are not on speaking terms. When I see a carrot in the street I walk on the other side. Potatoes and I are on speaking terms merely, there's no friendship between us.'"[16]

Food was important at Prospect House (which, following William's lead, Ned soon renamed North End House, to echo his London home). Angela Thirkell

remembered the creamy and delicate lobsters that came fresh from the fishwoman's cart just an hour after the lobster pots had been raised and "prawns of gigantic size" along with shrimps, which they caught themselves, and winkles, although "these were consider low and Nanny did not encourage them . . ."[17] They ate in the dining room draped on three sides with Janey's embroidered hangings, favored hiding places for Angela and her brother Denis.

Earnings from the Firm for glass and tapestry designs had enabled Ned to buy the small property next door to Prospect House for £950. Benson was again called in to supervise the work of connecting the two houses and adding a modest studio. The house was now large enough to accommodate gatherings of the whole family and Angela recalled the magic of Christmas morning at Rottingdean when she and her brother would draw back the delicate muslin curtains around their grandmother's old oak four-poster bed and snuggle up with her to examine the contents of their stockings. The treasures included "tangerines, chocolates, a tiny Prayer Book with print that no human eye could read, and Sir Joshua Reynolds' angels stamped in silver on the cover, a little fan, a necklace and reindeer gloves with fur lining."[18] Georgie's bedroom was over the drawing room and had a big window facing east. It was very much her own province.

Ned "seized" on the brick-floor kitchen for his own special purposes, chasing out kitchen-range and sink and putting in a quantity of old oak furniture. Georgie complained that he wanted to make the room as much like a "pot-house parlour" as

ABOVE: North End House, Rottingdean. In 1889 Edward bought the house next door and once again employed Benson to reorganize and adapt the extended space making a comfortably sized country home.

BELOW: Edward draws himself and William carousing at table while young Phil stands at the head.

possible, "where men can drink and smoke and be vulgar." He installed old oak dressers painted black and lined with gaily colored jugs and German platters. Georgie, relenting, made red curtains that complemented the red brick floor and were set off by the whitewashed walls. Ned put up a painted bas-relief of a mermaid sporting in the waves that led to the room becoming known as "The Merry Mermaid." "The most delightful room it is," Ned said, "and I have wanted such a one all my life." "Here," Georgie recalled "he wrote letters, smoked, played dominoes, and made merry with his men-friends; the door into the garden stood open, the fire crackled on the hearth, and through the little panes of the west window he looked over and beyond the green garden to a line of the downs behind which the sun set."[19]

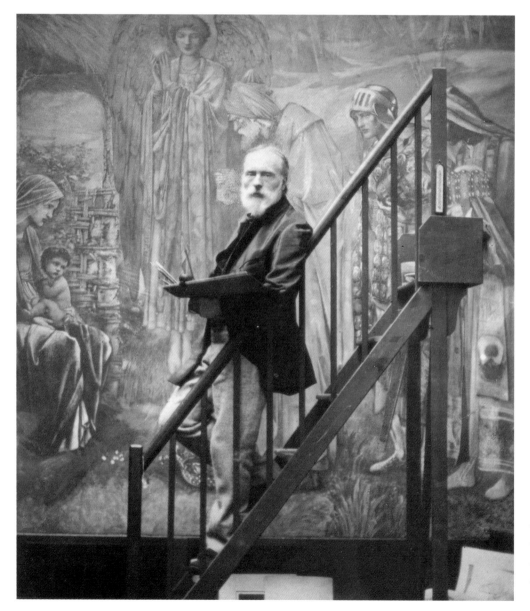

LEFT: A photograph by Barbara Leighton of Sir Edward Burne-Jones painting THE STAR OF BETHLEHEM in his studio, 1890.

In 1897 Ned complained of feeling "dull and flat these days . . . the melancholy I so dread, that had left me for a little, has been pouring back on me, and it is hard to deal with."[20] He was worried about whether or not the lease would be renewed on the Grange, which he and Georgie never owned outright, despite living there for thirty years. He hated change and, at the age of sixty-five felt, he "could not make a new start anywhere else. I couldn't bear having to go." The lease was renewed, but on the morning of 17 June 1898, after complaining of his heart "banging about," he died of angina pectoris.

His servant Annie, as instructed, wore no mourning as she placed a wreath of lilies-of-the-valley in the hearse. Ned's ashes were interred in a corner formed by the outside wall of the little church at Rottingdean, near the seven stained-glass windows he and William had designed, opposite his own house in a spot he had chosen himself so that Georgie would able to look out of the house and say "How d'you do?" from her window.

Six days later—as the result of an individually signed petition, sponsored by the Prince of Wales—the first memorial service to honor an artist at Westminster Abbey was held. The plethora of eminent people who attended should have put paid to Ned's belief that he had fallen out of fashion.

The obituaries were glowing. "We all know how," wrote the *Art Journal*, "from the dreariest and most prosaic surroundings, out of the most unpropitious circumstances, his passion for beauty and poetry fought its way upwards in to the light."

ABOVE: ***THE VILLAGE CHURCH, ROTTINGDEAN*** *by Philip Burne-Jones. Edward's son had a genuine gift for landscapes, though he was better known for his portraiture.*

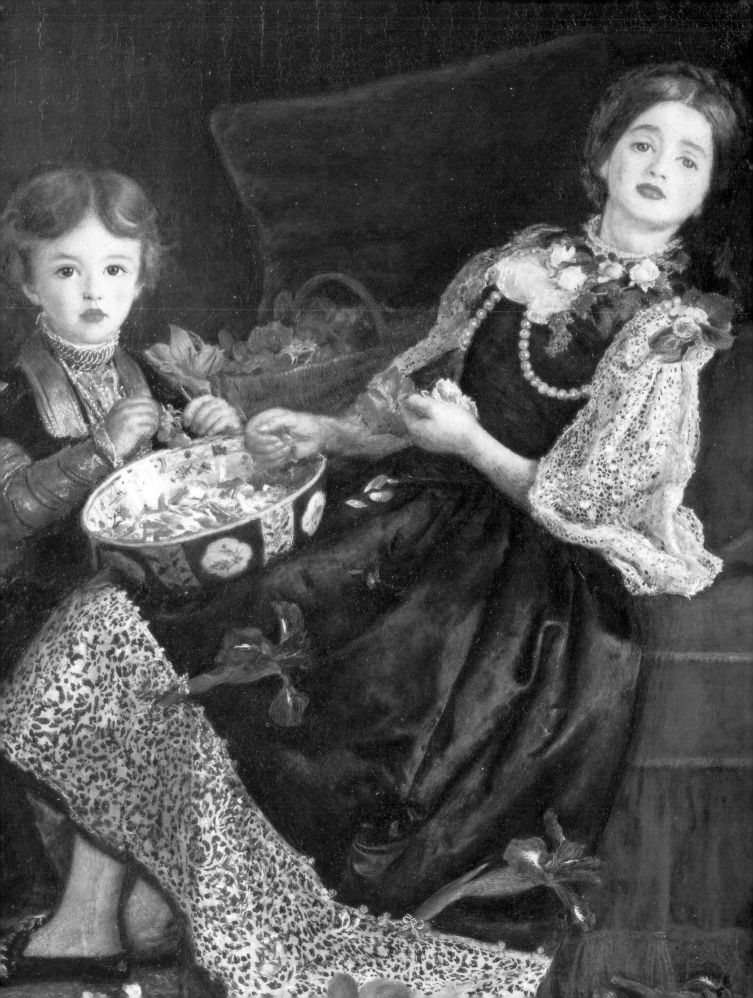

Chapter 14

THE SILVER CEILINGS of SUCCESS

"My new home shall be a Palace, such as the Italian painters commonly used."

JOHN EVERETT MILLAIS TO WILLIAM HOLMAN HUNT, 1877

ABOVE: *John Everett Millais looking every inch the baronet photographed at home in Kensington in 1884.*

I N HER REVIEW of the 1875 Royal Academy Exhibition the novelist Margaret Oliphant asked what had become of "the poet, the glorious young revolutionary, the rebellious yet beloved hope and favourite of the Academy, the daring and splendid youth who once took us by storm?" and concluded: "Mr. Millais has resigned himself to mammon, or what is the same thing, to portrait painting."[1]

Twenty years earlier Millais had longed for people to buy his pictures while he was "working for fame" rather than later "when I shall be married and working for a wife and children." Now he had a wife and no less than eight children. After 1860 he had more or less abandoned Pre-Raphaelite principles in favor of more lucrative society portraits and sentimental scenes, claiming he could no longer afford to spend a day painting an area "no larger than a five shilling piece." The bold young rebel who had scornfully nicknamed the eighteenth-century founder of the Royal Academy "Sir Sloshua Reynolds" and startled the art establishment out of complacency with his innovative style had now embraced the establishment and relished the rewards his position brought. His inexorable social rise had led him west from Gower Street, via Regent's Park, to the burgeoning prosperity of Kensington where the courtly overtones of an address near the Palace flattered his society sitters, prepared to pay up to £1,000 for their portrait. He had been one of the first to reserve a house in the terrace built by Sir Charles Freake that was going up on the west side of Cromwell

OPPOSITE: *POT POURRI by John Everett Millais. "For my part," Millais stated, "I paint what there is a demand for . . . Why, I've just sold a picture done in two weeks which will pay the expenses of all my family, my shooting and fishing too, for our whole time in Scotland."*

173

Place, but in 1877, now earning as much as £30,000 in a single year, he set his sights higher. He commissioned a massive neo-renaissance mansion, with Roman, Doric, and Ionic columns, from Philip Hardwick, the architect of grand Victorian station hotels, to stand at 2 Palace Gate, a stone's throw from the Royal Albert Hall.

It was, from the start, a showy house, intended to rival the Arab hall of Lord Leighton's house and the gold banisters and silver ceilings of Alma-Tadema's sixty-six room monument to classical excess. The ugliest of the Pre-Raphaelites' homes, the slab-sided red-brick and Portland stone pile is now Zambia House, and visitors are invited to ring the bell for visas and passports. In Millais's day the great and the good (including Richard Wagner and the Prince of Wales) came to marvel at the vast and splendid white marble hall that led up to a splashing fountain, complete with black marble seal, on the first-floor landing. No expense was spared. The view from the tall windows of his banqueting hall (now impeded by an even uglier block of red-brick flats) looked right up the Broad Walk of Kensington Gardens. Millais himself designed the wrought-iron scrollwork, the paneling and carvings. The showpiece studio, reached by three flights of marble stairs overlaid with a Persian carpet, was lit by electricity and bedecked on three walls with maroon-bordered Beauvais tapestries. North light flooded in through a vast plate-glass window, fitted with the latest in steel-roller shutters rather than blinds. The model's dais stood in the center of the forty-foot room, the easel to the left, next to a table laid out with the artist's painting materials. One unusual feature of the studio was a long slit in the floor, covered by a trapdoor, just behind the easel, which communicated with the storeroom below and permitted the large canvases to be taken away easily.

Here he painted Gladstone, Disraeli, Tennyson, and Henry Irving. The eighty-two-year-old Thomas Carlyle is said to have asked, rather sniffily, as he ascended the grand staircase for his sitting, "Has paint done all this, Mr Millais?" "It has," Millais cheerfully replied. "Then there are more fools in the world than I thought there were," was Carlyle's dour riposte.

Fools or not, they appreciated and generously rewarded Millais's efforts to please. Now a fully fledged Royal Academician, he worked hard and played hard,

spending long summer months at his large Perthshire estate, shooting pheasant, ducks, woodchucks, and hares and fishing for salmon in the Tay. Millais loved music and in his London home would fold back the partition between the studio and the drawing room beyond to allow his daughter's piano playing to float through as he worked. To unwind he might fish in the Serpentine (he had special royal permission) in nearby Hyde Park or play billiards at the Garrick Club in Covent Garden. Its charter declared it a club "in which actors and men of education and refinement might meet on equal terms." The novelists Dickens, Thackeray, and Trollope were all members.

In 1885 he became the first English artist to accept a baronetcy. His old friend William Holman Hunt was on hand to congratulate him. Hunt, who had spent much of his time away in the Middle East, had recently bought a large rambling Regency house with a generous garden and orchards in Fulham. Draycott Lodge, once the home of Horace Walpole, had large, intercommunicating rooms into which Hunt packed his vast collection of antique furniture, ornate chests, and ivory cabinets, Persian carpets, Jacobean embroidered hangings, and other *objets d'art* that he

ABOVE: The dining room of William Holman Hunt's Draycott Lodge at 114 New King's Road, which he filled, as he did the other rooms in the rambling house, with treasures collected on his travels. He settled here in 1883 after years of temporary lodgings and traveling to and from the Middle East. He also owned a country cottage at Sonning.

OPPOSITE: **WILLIAM HOLMAN HUNT**. *This self-portrait, which hangs in the Uffizi Gallery, reveals William Holman Hunt's great love of elaborate costume.*

ABOVE: A glimpse of the rich interior of Draycott Lodge, a house that gave William Holman Hunt and his second wife, Edith, much pleasure. The house no longer stands, though for a while a primary school named after the painter stood on the site.

and his second wife, Edith, had amassed over the years. The confusion of styles and periods—Georgian furniture mixed with Regency and Morris's rush-seated dining chairs, Italian Old Masters (a Titian portrait of his daughter Lavinia and a treasured Bellini), and framed photographs hung against a background of Morris wallpaper, alongside lustre plates and majolica—was typical of the cluttered late Victorian period.

The writer Alice Meynell, visiting the Hunts in 1893, described Draycott Lodge as "walled in from the multitudinous streets, and concentrating all the remaining sweetness of the region in its wild fields and delicate lawn."[2] She was shown into the large studio, hung round with relics of Hunt's travels and detailed the oriental rugs, Damascus lamps, della Robbia paintings of the Madonna and Child, the Bellini, and "innumerable gleanings from Eastern travel."

Sadly, Edith and William were forced to move in 1902 when Draycott Lodge was compulsorily acquired for the building of a school. Their final home was a new stucco and brick gaslit house in 18 Melbury Road, in the center of a well-to-do artistic community that included Marcus Stone at No. 8, Luke Fildes at No. 11, and

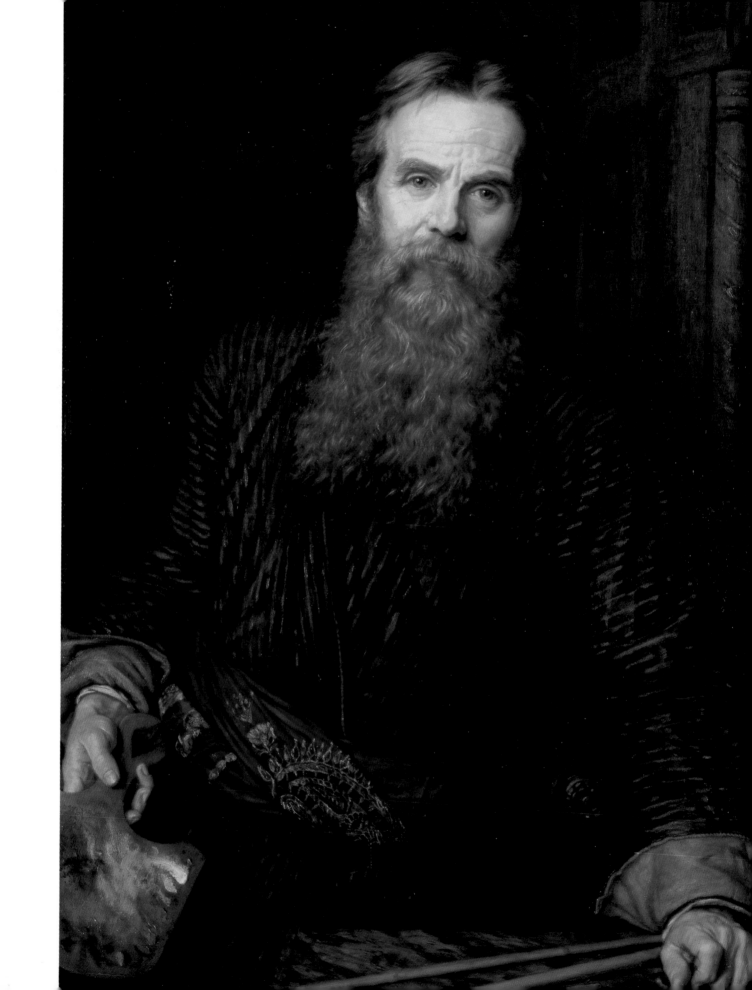

Colin Hunter at No. 14. Val Prinsep was around the corner in 1 Holland Park Road. Each of these men made a comfortable living from his painting, achieving both critical and financial success, and benefiting from a new breed of patron, Northern merchants and magnates such as Henry Tate, with his sugar fortune, and Frederick Leyland, the Liverpool shipping millionaire (whose daughter Florence married Val Prinsep in 1884). The bohemian notion of an artist starving to death in a garret was out of tune with the times. Hunt, whose estate was worth £16,169 1s 4d on his death, believed that artists should be not only well paid but well dressed and live in comfort surrounded by beautiful things.

Millais lived up to that ideal, his work becoming commercially successful as he catered more and more to mainstream tastes. In 1886 his fame increased as a result of the publicity that resulted from his painting of his five-year-old grandson, Willie, blowing bubbles. The original purchaser, Arthur Tooth, a Bond Street art dealer, had sold it on to the *Illustrated London News*, which reproduced it on a full page of its Christmas number and then, shockingly, granted the Pears soap company the rights to use the image in advertisements across not only Britain but Europe as well. Millais, who was not party to the transaction, was accused of commercialism and for a while a controversy raged. However, it did not do lasting damage and in 1894, Leighton, seriously ill with heart disease, wrote urging him to step into his shoes as president of the Royal Academy.

*BELOW: **RECLINING WOMAN WITH A PARROT** by Valentine Prinsep. Prinsep's paintings found a ready market, although his marriage to Florence Leyland, the daughter of a Liverpool shipping millionaire and art patron, had removed the need to paint for a living. After his father-in-law's death, he commissioned Philip Webb to more than double the size of his house at 1 Holland Park Road.*

"My dear old friend, there is *only one man* whom *everybody* without exception, will acclaim in the chair of president on May 4th—a great artist, loved by all—*yourself.*"[3]

Millais did succeed Leighton as president but he was not to hold the position for long. A bad bout of influenza in the early 1890s had left him almost unable to speak and his throat troubled him increasingly. In the summer of 1896 an emergency tracheotomy performed by his doctors by candlelight at his home failed to save his life, and on 12 August he died of throat cancer. He was buried on 21 August at St. Paul's Cathedral. His great palette, brushes, and maulstick were tied with crepe and placed on top of the beautiful old pall that covered the coffin. William Holman Hunt was one of the pallbearers.

Only a few weeks before, Queen Victoria had agreed, at last, to receive Effie at Court. Both Millais and Hunt had railed against the unfairness of their wives' social invisibility. Any scandal touching Victorian women cast a long shadow and the strict social etiquette of the time had imposed severe restrictions on Effie, so that she had often had to stay at home while Millais took their daughters out into society or chaperoned them at débutante balls. The situation for Edith Hunt was different. Her marriage to Hunt, her dead sister's husband, was not even recognized in England and Hunt campaigned tirelessly during the final years of his life to effect a change to the "injustice of the law" that made it illegal. The Deceased Wife's Sister's Act was at last passed in 1907; three years later Hunt died in 18 Melbury Road. Edith was with him at the end. King Edward VII sent a message of sympathy and a state funeral took place at noon on 12 September, once again at St. Paul's Cathedral. The Pre-Raphaelite ranks were thinning, but William Michael Rossetti and Arthur Hughes were among the pallbearers. Hunt's ashes were laid to rest in the crypt beside those of his great friend Millais.

ABOVE: ***THE HOME QUARTET: MRS. VERNON LUSHINGTON AND HER CHILDREN*** *by Arthur Hughes. Vernon Lushington was an important public figure—Secretary to the Admiralty and a judge—by the time he commissioned this charming picture from Arthur Hughes, but as a young man he had been instrumental in introducing Edward Burne-Jones to Dante Gabriel Rossetti and later lived in Kensington Square.*

Chapter 15

THE DREAM EXTINGUISHED

"My work is the embodiment of dreams in one form or another."

WILLIAM MORRIS TO CORMELL PRICE, 1856

E RETURN FINALLY—as William wished he could more often—to Kelmscott Manor. "A house that I love; with a reasonable love I think: for though my words may give you no idea of any special charm about it, yet I assure you that the charm is there; so much has the old house grown up out of the soil and the lives of those that live on it."[1] There he fell into the natural rhythms of life and drew inspiration for his designs from "the long-purples & willow herb" and the diverse birdlife along the riverbanks where he fished for his breakfast perch.

Unfortunately William's busy political schedule frequently forced him to be away from his beloved Kelmscott—and there was a further complication. Janey, now in her forties, had embarked on another affair, this time with Wilfrid Scawen Blunt, a poet and maverick explorer turned politician, whose interest in her seems to have stemmed from his fascination with Dante Gabriel Rossetti. Yet Blunt's passion for identifying with dead poets (he appears to have modeled his own profligate career on that of Byron, grandfather to his wife, Lady Anne), was not matched by his passion for Janey, with whom he was never really in love, although he caused her long-suffering husband further pain on his visits to Kelmscott. "I wish," William wrote to his great friend and fishing companion F. S. Ellis, "you had been here instead of the new comer, whose shortcomings I am not used to like I am to yours and mine."[2] Given the corridor creeping that was going on, this was a remarkably restrained complaint.

*ABOVE: **WILLIAM MORRIS** by Cosmo Rowe. This portrait was painted a year before William Morris's early death at the age of sixty-two.*

*OPPOSITE: **KELMSCOTT MANOR** by May Morris. Evelyn Waugh called Kelmscott "architecturally very perfect, but not a particularly large house."*

*ABOVE: **MRS. WILLIAM MORRIS** photographed by Sir Emery Walker. "When I first saw her," recalled W. G. Robertson, "the dusky wonder of her hair was threaded with grey, but the face seemed to change hardly at all . . . She was a Lady in a Bower, a Blessed Damozel . . . perhaps at her wonderful best in her own house, standing in one of the tall windows . . . there she seemed to melt from one picture into another, all by Rossetti and all incredibly beautiful."*

Blunt was more boastful in his account. "Kelmscott," he wrote "was a romantic but most uncomfortable house with all the rooms opening into each other and difficult to be alone in." Janey spent her evenings in the "tapestried chamber" that Gabriel had once used as his studio and that, Blunt complained, was "a cul-de-sac approachable only by passing through Morris's own bedroom where he lay at night in a great Elizabethan four-poster." He confided further:

"Mrs. Morris slept alone at the end of a short passage at the head of the staircase to the right. All was uncarpeted with floors that creaked . . . In the daytime with the sun streaming through the windows the old house was full of happy life, but in the darkness of the night it was a ghostly place full of strange noises where every movement was heard plainly from room to room. To me such midnight perils have always been attractive. Rossetti seemed a constant presence there, for it was there that he and Janey had had their time of love some 14 years before—and I came to identify myself with him as his admirer and successor."[3]

His triangular fantasies are distasteful and May, older now and more aware, found Blunt "an Egotist and vain."

William's response was to immerse himself in his work. There was enough of it. As the founder of the Society for the Protection of Ancient Buildings and the leader of the Socialist League he toured the country, agitating on behalf of buildings and advocating a worker's revolution, stressing the importance of education, organization, and equality. In addition there was the Kelmscott Press and the Firm's business to attend to, plus his own writing (poetry and political pamphlets) and his designs for wallpapers, textiles, and carpets. His famous energy and capacity for hard work caused the writer Max Beerbohm to remark, rather sourly in his old age, "Of course he was a wonderful all-round man, but the act of walking round him always tired me."

It was beginning to tire William out, too. He had suffered recurring attacks of gout since his twenties. Now diabetes was diagnosed. There were complications and William's health began to decline dramatically. "The ground beneath one is shifting," his old friend Ned wrote, "and I travel among quicksands." William made what would prove a last trip to Norway but returned weakened and, on 3 October 1896, he died at home in Hammersmith. He was sixty-two years old. His doctor, Sir William Broadbent, famously declared the cause of death to be "simply being William Morris and having done more work than most ten men."

Not for William the pomp and grandeur of a funeral at St. Paul's Cathedral or Westminster Abbey. His own was simple, yet dramatic, and it took place in the little twelfth-century village church he so cherished at Kelmscott, all decorated for the Harvest Festival with pumpkins, apples, and autumn leaves. His body was placed in an unpolished oak coffin and conveyed to Paddington station in a glass-sided hearse drawn by two horses. The train was met at Lechlade by a gaily painted harvest-cart, decorated with vine leaves. "The burial was as sweet and touching as those others were

ABOVE: The funeral cart, festooned with vines, alder, and bulrushes, which met the London train at Lechlade and carried William Morris's coffin to Kelmscott churchyard. Four countrymen in moleskin bore the body to the haycart, which was driven "by a man who looked coeval with the Anglo-Saxon Chronicle."

foolish," Ned wrote to his friend Mrs. Helen Gaskell. "The little wagon with its floor of moss and willow branches broke one's heart it was so beautiful—and of course there were no kings there—the king was being buried and there were no others left."

The day, which had begun blustery and gray in London, worsened and rain fell on the mourners as William's body was laid to rest in a corner of the churchyard beneath a starkly beautiful gravestone designed by his faithful friend Philip Webb.

Kelmscott Manor remained in the family. Janey purchased the house for £4,000 just before she died and May lived on there, devoting a great deal of her time to securing her father's reputation through her writing and continuing his work. She fielded enquiries from writers, including a young Evelyn Waugh, who was researching a biography of Dante Gabriel Rossetti and invited himself to tea. (Waugh's keen interest in the Pre-Raphaelite Brotherhood was fueled by his connection to William Holman Hunt through Hunt's marriage to both Fanny and Edith Waugh.) He was surprised by the simplicity of the house and seemed disappointed that it had no grand entrance, no long drive. "It is approached," he wrote, "through a little door in the stone wall, which opens into a narrow strip of paved path between clipped yews—one of them a very fine dragon, designed by Morris himself. Another little door leads into the house. There must have been a good deal of bumping of heads." He found the rooms "low and small, darkened with paint and patterned hangings" but he liked the garden, which he described as "tiny and ornamental, set out in little paths where two cannot walk abreast, bordered by low box hedges, and walled with mellow Cotswold stone and great ramparts of yew." It was the very antithesis of Gabriel's "gloomy wilderness in Cheyne Walk." May did not warm to Waugh and she hated his book when it came out, commenting that he was one of those "not altogether equipped for the task" of writing a biography and "lacking all insight into his subject."[4]

She had more of a rapport with the poet John Betjeman, who used to drive out in a pony cart to take tea with her and her companion Miss Lobb. He loved the garden with its gray stone wall, box borders, cut yews and roses, and was captivated by the charm of Kelmscott. "I think that why anybody likes it so much," he said, "is because it is small and something they feel they could live in and love themselves."[5]

On May's death in 1938 Kelmscott Manor was left in trust to Oxford University before passing, in 1962, to the Society of Antiquaries who lovingly restored the house and opened it to the public.

BELOW: Philip Webb designed this simple gravestone in the Cotswold tradition. Webb felt the loss of his old friend acutely. "My coat feels thin," he wrote. "One would think I had lost a buttress."

RIGHT: William's four-poster bed at Kelmscott Manor, romantically furnished with fine printed hangings and draped in a counterpane embroidered with simple flowers and foliage.

Morris's verses composed especially "For the Bed at Kelmscott" and embroidered by his daughter May onto the two curtains which hung around the huge seventeenth-century carved-oak four-poster he slept in at Kelmscott Manor:

The Wind's on the wold and the night is a-cold
And Thames runs chill twixt mead and hill
But kind and dear is the old house here
And my heart is warm midst winter's harm.
Rest then and rest and think of the best
Twixt summer and spring when all birds sing
In the town of the tree and ye lie in me

And scarce dare move lest earth and its love
Should fade away ere the full of the day.
I am old and have seen many things that have been
Both grief and peace and wane and increase.
No tale I tell of ill or well
But this I say: night treadeth on day
And for worst and best right good is rest.

FOOTNOTES

See Select Bibliography for publication details not listed below.

CHAPTER 1

[1] The statue was *The Fight of Hector and Achilles*.
[2] W.M. Rossetti, *Some Reminiscences*, p. 70.
[3] ibid. pp. 66–7.
[4] W.M. Rossetti, *The PRB Journal*, p. 85, 7 December 1850.
[5] W. Holman Hunt, *Pre-Raphaelitism and the Pre-Raphaelite Brotherhood*, vol. i, p. 198.
[6] B. and J. Dobbs, *Dante Gabriel Rossetti, An Alien Victorian*, ch. 5.
[7] G.H. Fleming, *Rossetti and the Pre-Raphaelite Brotherhood* (Hart-Davis, 1967), p. 174.
[8] O. Doughty and J.R. Wahl (eds), *Letters of Dante Gabriel Rossetti*, vol. i, p. 115.

CHAPTER 2

[1] Other commentators have suggested that Effie may have been menstruating on her wedding night. Ruskin himself told her later that he had been "disgusted with [her] person that first evening." Dr. Charles Locock and Dr. Robert Lee, who examined her at the time of the annulment, reported: "We found that usual signs of virginity are perfect and that she is naturally and properly formed and there are no impediments on her part to a proper consummation of the marriage." Letter dated 30 May 1854, quoted in M. Lutyens, *Millais and the Ruskins*, p. 219.
[2] The Casa Wetzlar, the Ruskins' apartment, is now the Gritti Palace Hotel.
[3] Effie Ruskin to Rawdon Brown, 22 July 1852.
[4] Effie Ruskin to her mother, 26 July 1852.
[5] Effie Ruskin to her mother, 20 March 1853.
[6] M. Lutyens, *Millais and the Ruskins*, pp. 37–8.
[7] T. Hilton, *John Ruskin, The Early Years*, p. 186.
[8] Millais to Mrs. Collins, mother of Charles, 10 July 1853.
[9] M. Lutyens, *Millais and the Ruskins*, p. 50.
[10] Millais to Charles Collins, August 1853.
[11] J.G. Millais, *Life and Letters of Sir John Everett Millais*, vol. i, letter dated 6 September 1853, p. 206.
[12] M. Lutyens, *Millais and the Ruskins*, pp. 120–21. The letter to Mrs. Gray is undated, but the envelope bears the date 19 December 1853.
[13] ibid. pp. 186–7. Effie to Mrs Ruskin, 25 April 1854.
[14] J. Howard Whitehouse, *Vindication of Ruskin*, p. 12.
[15] M. Lutyens, *Millais and the Ruskins*, p. 230.
[16] O. Doughty and J.R. Wahl (eds), *Letters of Dante Gabriel Rossetti*, vol. i, p. 200.
[17] M. Lutyens, *Millais and the Ruskins*, pp. 234–6. Written Friday night, July 21/22 1854.
[18] Millais to Mrs. Collins, 29 July 1855.
[19] M. Lutyens, *Millais and the Ruskins*, p. 259.
[20] ibid. p. 264.

CHAPTER 3

[1] Lizzie changed the spelling of her surname some time after meeting Gabriel, and possibly at his suggestion, for he deemed a single "l" to be somehow less common and hence liable to promote her elevation in the world.

[2] O. Doughty and J.R. Wahl (eds), *Letters of Dante Gabriel Rossetti*, vol. i, p. 122.
[3] The house was eventually pulled down to make way for the Embankment.
[4] "Extracts from the diaries of George Price Boyce 1851–1875" in the *Old Water-Colour Society's Club XlXth Annual*, vol. 1941, p. 17.
[5] Ford Madox Brown in V. Surtees (ed.), *The Diary of Ford Madox Brown*, p. 101, 7 October 1854.
[6] Dante Gabriel Rossetti to William Allingham in O. Doughty and J.R. Wahl (eds), *Letters of Dante Gabriel Rossetti*, vol. i, p. 245.
[7] W.M. Rossetti, *Ruskin, Rossetti, Pre-Raphaelitism*, (George Allen, 1899), pp. 47–8.
[8] Ford Madox Brown in V. Surtees (ed.), *The Diary of Ford Madox Brown*, 6 October 1854.
[9] Barbara Leigh Smith Bodichon to Bessie Parkes, c. 1854.
[10] John Ruskin to Dante Gabriel Rossetti, 24 April 1855.
[11] Ford Madox Brown in V. Surtees (ed.), *The Diary of Ford Madox Brown*, p. 126, 10 March 1855.

CHAPTER 4

[1] W. Morris, *A Dream of John Ball* (Reeves & Turner, 1888).
[2] G. Burne-Jones, *Memorials of Edward Burne-Jones*, vol. i, p. 127.
[3] ibid. p. 147.
[4] William Morris to Edward Burne-Jones, 17 May 1856.
[5] G. Burne-Jones, *Memorials of Edward Burne-Jones*, vol. i, p. 136.
[6] M. Lago (ed.), *Burne-Jones Talking*, p. 142.
[7] ibid. p. 142.
[8] J.W. Mackail, *The Life of William Morris*, vol i., pp. 107–8.
[9] G. Burne-Jones, *Memorials of Edward Burne-Jones*, vol. i, p. 147.
[10] A blue plaque erected in 1922 commemorates the stay there of Dante Gabriel Rossetti (1828–82), William Morris (1834–96), and Edward Burne-Jones (1833–98).
[11] G. Burne-Jones, *Memorials of Edward Burne-Jones*, vol. i, pp. 169–70.
[12] ibid. pp. 169–70.
[13] ibid. p. 176.
[14] ibid. p. 179.

CHAPTER 5

[1] Rev. W. Tuckwell, *Reminiscences of Oxford* (Cassell, 1901).
[2] William Morris to James Richard Thursfield, 1869.
[3] Cormell Price to his father, December 1857.
[4] Algernon Charles Swinburne to Edwin Hatch, 17 February 1858, *Swinburne Letters*, ed. C.Y. Lang (Yale University Press, 1959), vol. i, p. 18.
[5] Gabriel's prevarications are charted in Ford Madox Brown's diary. This entry for 16 March 1857 is typical: "Miss Siddall has been here for 3 days & is I fear dying. She seems not to hate Gabriel in toto. Gabriel had settled to marry at the time I put it down in this book & she says told her he was only waiting for the money of a picture to do so, when, lo the money being paid, Gabriel brought it & told her he was going to pay with it & do with it, but never a word more about marriage. After that she determined to have no more to do with him . . . however Again the next morning he called & said the only thing that prevented his buying the licence was want of tin, upon which I said if it was this that prevented it I would lend him some. He agreed to this & a few days after borrowed £10 but spent it all somehow & last night came for one more." V. Surtees (ed.), *The Diary of Ford Madox Brown*, pp. 195–6.
[6] Gabriel was always "poaching" Annie when she had been booked

to model for Boyce, who would arrive to find a note from Gabriel sending "1,000 apologies" and begging "Pray pardon."
[7] M. Lago (ed.), *Burne-Jones Talking*, p. 49.

CHAPTER 6

[1] G. Burne-Jones, *Memorials of Edward Burne-Jones*, vol. i, p. 159.
[2] Anon. Possibly a member of the Pattle or Prinsep families; extract from an article *c.*1900 in the possession of the Watts Gallery.
[3] Valentine Prinsep, "A Chapter from a Painter's Reminiscence," *Magazine of Art*, 1904.
[4] G. Burne-Jones, *Memorials of Edward Burne-Jones*, vol. i, p. 183.
[5] Effie Millais to Rawdon Brown, 27 October 1856.
[6] J. Guest, *Lady Charlotte Schreiber* (John Murray, 1952), p. 202.
[7] M.S. Watts, *George Frederic Watts: The Annals of an Artist's Life* (Macmillan, 1912), pp. 156–7.
[8] It now boasts a blue plaque commemorating Ford Madox Brown's sojourn there.
[9] Ford Madox Brown in V. Surtees (ed.), *The Diary of Ford Madox Brown*, p. 155, 22 October 1855. No doubt Emma was looking forward to the extra space after the cramped conditions of their former cottage at 1 Grove Villas, Church End, Finchley (the house has long gone but its site is recognizable). According to William Michael Rossetti the cottage consisted of a parlor, a kitchen, and a bedroom, a tight fit for five Browns and one servant. Brown may have extended this, as his diary is peppered with terse comments about mornings lost to workmen in the house. He also installed a shower bath, a portable contraption that released water from an overhead cistern after a period of pumping.
[10] G. Burne-Jones, *Memorials of Edward Burne-Jones*, vol. i, p. 204.
[11] O. Doughty and J.R. Wahl (eds), *Letters of Dante Gabriel Rossetti*, vol. i, p. 368.
[12] Dante Gabriel Rossetti to William Allingham.
[13] G. Burne-Jones, *Memorials of Edward Burne-Jones*, vol. i, pp. 207–8.
[14] O. Doughty and J.R. Wahl (eds), *Letters of Dante Gabriel Rossetti*, vol. i, p. 384.

CHAPTER 7

[1] G. Burne-Jones, *Memorials of Edward Burne-Jones*, vol. i, p. 212.
[2] Dante Gabriel Rossetti to Charles Eliot Norton, 9 January 1862, O. Doughty and J.R. Wahl (eds), *Letters of Dante Gabriel Rossetti*, vol. ii, p. 436.
[3] G. Burne-Jones, *Memorials of Edward Burne-Jones*, vol. i, p. 154
[4] *The Defence of Guenevere* was published, at Morris's own expense, in March 1858 by Bell & Daldy. The book carried a dedication "To My friend, Dante Gabriel Rossetti, Painter, I dedicate these Poems."
[5] *Illustrated Exhibitor*, 1862, p. 53.
[6] *The Building News*, 8 August 1862, p. 99.
[7] Ruskin and Rosetti were appointed godfathers, by proxy. Both had every generous intention, but neither remembered to send the customary gift, until old Mrs. Ruskin heard of it and indignantly sent off a silver knife, spoon, and fork.
[8] G. Burne-Jones, *Memorials of Edward Burne-Jones*, vol. i, p. 222.
[9] H. Rossetti Angeli, *Dante Gabriel Rossetti: His Friends and Enemies*, p. 195
[10] ibid. p. 197.
[11] G. Burne-Jones, *Memorials of Edward Burne-Jones*, vol. i, p. 279.
[12] ibid. p. 277.
[13] ibid p. 282.

CHAPTER 8

[1] G. Burne-Jones, *Memorials of Edward Burne-Jones*, vol. i, pp. 286–7.
[2] ibid. p. 287.
[3] ibid. p. 298.
[4] ibid. p. 288.
[5] A.W. Baldwin *The Macdonald Sisters* (Peter Davies, 1960) p. 97.
[6] G. Burne-Jones, *Memorials of Edward Burne-Jones*, vol. i, p. 286.
[7] Henry Treffry Dunn, *Recollections of Dante Gabriel Rossetti & His Circle*, p. 42.
[8] G. Burne-Jones, *Memorials of Edward Burne-Jones*, vol. i, p. 288.
[9] ibid. p. 299.
[10] ibid. p. 299.
[11] ibid. p. 299.
[12] Henry Treffry Dunn, *Recollections of Dante Gabriel Rossetti & His Circle*, p. 29.
[13] William Bell Scott to Alice Boyd, 26 November 1868.
[14] William Bell Scott to Alice Boyd, 23 November 1871.
[15] G. Burne-Jones, *Memorials of Edward Burne-Jones*, vol. i. The final page of the first volume contains a cryptic reference to the storm of passion that was lashing their lives at this time. "Two things," Georgie wrote, "had tremendous power of him—beauty and misfortune—and far would he go to serve either; indeed his impulse to comfort those in trouble was so strong that while the trouble lasted the sufferer took precedence of every one else." As Mary did over her
[16] G. Burne-Jones, *Memorials of Edward Burne-Jones*, vol. i, p. 303.
[17] Undated letter to Mrs Cassavetti senior.
[18] O. Doughty and J.R. Wahl (eds), *Letters of Dante Gabriel Rossetti*, vol. ii, p. 685.

CHAPTER 9

[1] 24 Cheyne Row (now owned by the National Trust) home of Thomas and Jane Carlyle from 1834–81 during which time their annual rent of £35 never altered.
[2] H. Rossetti Angeli, *Dante Gabriel Rossetti: His Friends and Enemies*.
[3] Ruskin dismissed him in 1870.
[4] H. Caine, *Recollections of Rossetti*, p. 64.
[5] W.M. Rossetti, *Some Reminiscences*, vol. i, p. 288.
[6] ibid. p. 288
[7] E. Gosse, *The Life of Algernon Charles Swinburne*, p. 106.
[8] Dante Gabriel Rossetti to Mrs Alexander Gilchrist in O. Doughty and J.R. Wahl (eds), *Letters of Dante Gabriel Rossetti*, vol. ii, p. 482, dated Tuesday 1863 [sic].
[9] Dante Gabriel Rossetti to Ford Madox Brown, ibid. p. 545, 28 February 1868.
[10] G. Pedrick, *Life with Rossetti or No Peacocks Allowed*, p. 4.
[11] ibid. p. 4
[12] William Morris to unidentified correspondent, 3 February 1868, in M. Morris, *Introductions to the Collected Works of William Morris*, vol. i, p. 76.
[13] Letter to Miss Losh, 21 September 1869 in O. Doughty and J.R. Wahl (eds), *Letters of Dante Gabriel Rossetti*, vol. ii, p. 745.
[14] Cremorne Gardens, with its fireworks and raffish reputation, was voted by common consent a nuisance in a respectable and genteel neighborhood and was closed in 1875.
[15] O. Doughty and J.R. Wahl (eds), *Letters of Dante Gabriel Rossetti*, vol. ii, p. 761.
[16] ibid. p. 752. Dante Gabriel Rossetti to his brother William, 13 October 1869.

CHAPTER 10

1 William to Janey Morris, 6 July 1871 in N. Kelvin, *The Collected Letters of William Morris*, vol. i, 1848–80, no. 141.

2 J.W. Mackail, *Life of William Morris*, vol. i, p. 235.

3 Dante Gabriel Rossetti to William Bell Scott, 17 July 1871.

4 Dante Gabriel Rossetti reporting Janey's comment in a letter to his mother dated 17 July 1871.

5 Dante Gabriel Rossetti to William Bell Scott, 17 July 1871.

6 M. Morris, *Introductions to the Collected Works of William Morris*, vol. i, p. 233.

7 J.W. Mackail, *Life of William Morris*, vol. i, p. 229.

8 Janey Morris to Philip Webb, summer 1871, in J. Brandon Jones, *William Morris and Kelmscott*, p. 92.

9 J.W. Mackail, *Life of William Morris*, vol. i, p. 230.

10 William Morris to Aglaia Coronio, 25 November 1872.

11 W.M. Rossetti, *Dante Gabriel Rossetti: His Family Letters with a Memoir*, 1895, vol. ii, p. 308.

12 Dante Gabriel Rossetti to William Michael Rossetti, 17 September 1875.

13 William Morris to Ford Madox Brown, June 1872.

14 William Morris to Aglaia Coronio, 25 November, 1872 in P. Henderson (ed.), *The Letters of William Morris to His Family and Friends*, pp. 50–51.

15 Dante Gabriel Rossetti to his mother, May 1873.

16 William Michael Rossetti to Dr. Hake in R. Peattie (ed.), *The Selected Letters of William Michael Rossetti* (Pennsylvania State University Press, 1990), p. 233.

17 William Morris to Charles Fairfax Murray, 27 May 1875: "I have got my partnership business settled at last, and am sole lord and master now."

18 William Morris to Dante Gabriel Rossetti, 16 April 1874.

19 J.W. Mackail, *Life of William Morris*, vol. i, p. 225.

20 William Morris to Aglaia Coronio, 23 January 1873.

21 J.W. Mackail, *Life of William Morris*, vol. i, p. 289.

22 William Morris to Aglaia Coronio, 11 February 1873.

23 J.W. Mackail, *Life of William Morris*, vol. i, p. 217

24 R. Peattie (ed.), *The Selected Letters of William Michael Rossetti* (Pennsylvania State University Press, 1990), p. 219.

25 O. Doughty and J.R. Wahl (eds), *Letters of Dante Gabriel Rossetti*, vol. iii, p. 1299

26 Dante Gabriel Rossetti to Janey Morris, 20 July 1879.

CHAPTER 11

1 G. Burne-Jones, *Memorials of Edward Burne-Jones*, vol. i, p. 307.

2 W.E. Fredeman, "The Letters of Pictor Ignotus: William Bell Scott's Correspondence with Alice Boyd 1859–1884," *Bulletin of the John Rylands Library*, Manchester, vol. 58, p. 103.

3 An established "at home" day was part of the Victorian convention. Mrs. Alma-Tadema was at home on Mondays, Mrs. Rider Haggard on Wednesday, Mrs. du Maurier on Thursday, and Mrs. Marcus Stone on Sunday. Guests—mostly women—would be offered tea, cakes, and small talk and not expected to stay too long. Georgie's informality is refreshing in so formal an age.

4 G. Burne-Jones, *Memorials of Edward Burne-Jones*, vol. ii, p. 88.

5 With the daughter of a patron Frances Graham, for example, a Pre-Raphaelite stunner whose marriage to John Horner barely impinged on Burne-Jones's devotion to her.

6 M. Lago (ed.), *Burne-Jones Talking*, pp. 187–8.

7 Georgie campaigned for the gallery, which included a free lending library, to be open on a Sunday, "the only day when working people were free to visit museums."

8 W. Graham Robertson, *Time Was*, p. 73.

9 G. Burne-Jones, *Memorials of Edward Burne-Jones*, vol. ii, p. 51.

10 *The Studio*, 15 October 1898.

11 W.L. Lethaby, *Philip Webb and His Work*, p. 33.

12 Fanny Fildes gave good dinner parties and Marion Sambourne kept a record of the menu for one of these in her diary for 19 December 1879: "Crécy soup, fillet soles, white sauce. Sweetbreads stewed. Fillets of beef in brown gravy. Lax, watercress. Mince pies." Suggestions for dinner party menus were set out in Mrs. Beeton and *Family Fare or the Young Housewife's Daily Assistant*, which Marion Sambourne found invaluable. According to this, a dinner party for eight, of six or seven courses, would cost from £1.19.0 to £2.11.6. A family dinner would consist of only four courses, and servants were expected to make do with one course and leftovers.

13 K. Terry Gielgud, *An Autobiography* (London, 1953), p. 75.

14 A. Thirkell, *Three Houses*, p. 19.

15 L.V. Fildes, *Luke Fildes* (Michael Joseph, 1968) p. 86.

16 *The Architect*, 28 March 1874.

CHAPTER 12

1 William soon changed the name, which, he joked, put him in mind of an asylum. "People would think something was amiss with me," he wrote to May, "and that your poor mama was trying to reclaim me."

2 Dante Gabriel Rossetti to Janey Morris, 1 April 1878, from 16 Cheyne Walk.

3 William to Janey Morris, 18 March 1878, in P. Henderson, *The Letters of William Morris to his Family and Friends*, pp. 113–14.

4 Later William would complain that the soil was "composed chiefly of old shoes and soot," in G. Burne-Jones, *Memorials of Edward Burne-Jones*, vol. ii, p. 86.

5 William to Janey Morris, 18 March 1878, in P. Henderson, *The Letters of William Morris to his Family and Friends*, pp. 113–14.

6 William to Janey Morris, 26 March 1878, in P. Henderson, *The Letters of William Morris to his Family and Friends*, p. 117.

7 The prominence of Janey's wedding ring in this portrait is somewhat undermined by Gabriel's boast along the top of the painting: "Jane Morris AD 1868 D.G. Rossetti pinxit. Famous for her poet husband and surpassingly famous for her beauty, now may she be famous for my painting." Although not actually scandalous, it did undercut the submissive wife image and, ten years on, may have mocked rather than consoled William.

8 M. Morris, *Introduction to the Collected Works of William Morris*, vol. i, p. 362.

9 Address to the School of Science and Art, 13 October 1881, in J.W. Mackail, *Life of William Morris*, vol. ii, p. 21.

10 Quoted from his *Manifesto of the Social Democratic Federation*.

11 J.W. Mackail, *Life of William Morris*, vol. i, p. 372.

12 "According to my recollection," William de Morgan said of these voyages, "we none of us stopped laughing all the way," in J.W. Mackail, *Life of William Morris*, vol. ii, p. 16.

13 "The commonplace inn was a blow to the romance of the river, as you may imagine." William Morris in J.W. Mackail, *Life of William Morris*, vol. ii, p. 10.

14 J.W. Mackail, *Life of William Morris*, vol. ii, p. 14.

CHAPTER 13

[1] G. Burne-Jones, *Memorials of Edward Burne-Jones*, vol. ii, p. 50.
[2] ibid. p. 123.
[3] ibid. p. 182.
[4] A. Thirkell, *Three Houses*, p. 64.
[5] G. Burne-Jones, *Memorials of Edward Burne-Jones*, vol. ii, p. 123.
[6] A. Thirkell, *Three Houses*, p. 61.
[7] G. Burne-Jones, *Memorials of Edward Burne-Jones*, vol. ii, p. 199.
[8] ibid. p. 200.
[9] ibid. p. 133.
[10] ibid. p. 200.
[11] M. Lago (ed.), *Burne-Jones Talking*, 29 May 1897, p. 146.
[12] G. Burne-Jones, *Memorials of Edward Burne-Jones*, vol. ii, p. 130.
[13] "I am particularly made by nature not to like Academies. I went to one when I was a little boy and didn't like it then," he wrote in 1893 in a resignation letter.
[14] G. Burne-Jones, *Memorials of Edward Burne-Jones*, vol. ii, p. 240.
[15] ibid. p. 59
[16] M. Lago (ed.), *Burne-Jones Talking*, p. 95.
[17] A. Thirkell, *Three Houses*, p. 96.
[18] G. Burne-Jones, *Memorials of Edward Burne-Jones*, vol. ii, p. 118.
[19] ibid. p. 196.
[20] ibid. p. 316

CHAPTER 14

[1] Review of the 1875 Royal Academy Exhibition in *Blackwood's Magazine*.
[2] Christmas number of the *Art Journal* for 1893.
[3] J.G. Millais, *The Life and Letters of Sir John Everett Millais*, vol. ii, p. 315.

CHAPTER 15

[1] L. Parry (ed.), *William Morris, Art and Kelmscott*, p. 120.
[2] William Morris to F.S. Ellis, 8 October 1888 in P. Henderson (ed.) *The Letters of William Morris to His Family and Friends*, p. 301.
[3] W. Scawen Blunt, *My Diaries*, vol. i, p. 29.
[4] M. Morris, *Introduction to the Collected Works of William Morris*, vol. i, p. 75.
[5] BBC Radio broadcast made by John Betjeman, 4 May 1952.

ACKNOWLEDGEMENTS

Many people have helped me in the preparation and writing of this book. I acknowledge with thanks the facilities afforded me by the British Library, the University of London libraries, the Victoria & Albert Museum, the Tate Gallery, the Courtauld Institute, and Birmingham Museum and Art Gallery. I would like to take this opportunity to specially thank Alan Ball and the Trustees of the London Library for their grant and acknowledge the unfailingly courteous help and assistance of the many librarians in reference sections of London borough libraries who have rallied to my aid. I would also like to thank Dr. Rob Allan and Richard Thicke of the Friends of Red House; Jan Marsh; Libby Willis; David Fordham for designing the book so beautifully; Mary Jane Gibson for her knowledgeable help and assistance as my picture researcher; and finally Jessica Spencer, my editor at Pavilion, for her good nature and patience throughout. A book of this kind owes much to the scholarship that first awoke my interest in the period. My debt to these authors is, I hope, made apparent in the bibliography to be found on p. 190.

PICTURE ACKNOWLEDGEMENTS
AM = Ashmolean Museum
BMAG = Birmingham Museums & Art Gallery
DAM = Delaware Art Museum
MCAG = Manchester City Art Gallery
NMGM = National Museums & Galleries on Merseyside
PC = Private Collection
VAL = Visual Arts Library

Front Cover: Samuel & Mary R. Bancroft Memorial, DAM, Wilmington/VAL/Bridgeman Art Library
Back Cover: Stapleton Collection/Bridgeman Art Library

AM: 26, 121. **BMAG**: 41, 163, 168. **Bridgeman Art Library**: 1 PC; 2 DAM/VAL; 14 MCAG; 17t AM; 18 The Makins Collection; 21 Forbes Magazine Collection, NY; 23 BMAG; 29 The Makins Collection; 30 DAM/VAL; 33 BMAG; 36 DAM; 37, 39 BMAG; 42 Fitzwilliam Museum; 49 PC; 50 MCAG; 60 BMAG; 61 DAM; 63 Fine Art Society; 64 Lady Lever Art Gallery, NMGM (detail); 67 Trustees of the Watts Gallery, Compton; 68 BMAG; 69 Phillips, The International Fine Arts Auctioneers; 71 Fitzwilliam Museum; 74 Stapleton Collection; 78 Anthony Crane Collection; 80 Christie's Images; 82 Fitzwilliam Museum; 87 BMAG; 88 National Gallery of Victoria, Melbourne; 90 Spencer Museum of Art, University of Kansas, KA; 92 Victoria & Albert Museum; 100 Maas Gallery; 103 Lady Lever Art Gallery, NMGM; 104 PC; 106 Christie's Images; 111 Samuel and Mary R. Bancroft Memorial, DAM/VAL; 114, 115 BMAG; 117 Fogg Art Museum, Harvard University Museums, Bequest of Grenville L. Winthrop; 120 Phillips; 122, 125 Christie's Images; 127 DAM; 128 Stapleton Collection; 131 Guildhall Art Gallery, Corporation of London; 135 Walker Art Gallery, Liverpool, NMGM; 147 Faringdon Collection, Buscot; 148, 149 PC/Mallett Gallery; 151, 162 St Margaret's Church, Rottingdean/Martyn O'Kelly Photography; 167, 170 Stapleton Collection; 172 PC; 178 Whitford & Hughes; 179 Fine Art Society. **British Museum**: 96, 126. **C.W. Band, Physics Photo Unit, University of Oxford**: 57. **Christie's Images**: 32, 34, 46. **Courtauld Institute of Art, Witt Library**: 19t, 31,119. **Fitzwilliam Museum, University of Cambridge**: 38. **Hammersmith & Fulham Archives and Local History Centre**: 91, 139, 153, 154, 155, 157, 158, 159, 160, 165, 175, 176, 185. **Hulton Getty**: 40, 84, 93. **Jeremy Cockayne**: 132. **Maas Gallery**: 48. **Martin Charles**: 77. **Museum of Fine Arts Boston © 2001**: 62. **National Monuments Record © Crown Copyright**: 54, 79, 94, 144, 145. **National Portrait Gallery**: 3, 15, 17b, 65, 73, 75, 89, 108, 112, 173, 182, 184. **National Trust Photographic Library**: 16, 25, 99, 138, 181; Derrick E. Witty 138; John Hammond 110. **Peter Nahum at the Leicester Galleries**: 171. **Private Collections**: 44, 47, 51, 98, 123, 142, 169. **Royal Borough of Kensington & Chelsea Libraries & Arts Service**: 66, 107, 174. **Scala**: Galleria degli Uffizi 77. **Society of Antiquaries of London**: 52. **Sothebys Photographic Library**: 19b, 129, 140, 143, 164. **Tate Gallery**: 27, 43, 46, 53, 56, 58, 72, 97. **Topham Picturepoint**: 25. **Tullie House, Carlisle**: 55. **William Morris Gallery, Walthamstow**: 83, 183. **Victoria & Albert Museum Picture Library**: 95.

SELECT BIBLIOGRAPHY

Allingham, H. (ed.), *William Allingham: A Diary*, Macmillan, 1907

Angeli, Helen Rossetti, *Dante Gabriel Rossetti, His Friends and Enemies*, Hamish Hamilton, 1949

Barnes, Rachel, *The Pre-Raphaelites and their World*, Tate Gallery Publishing, 1998

Blunt, Wilfred Scawen, *My Diaries*, Martin Secker, 1919

Bradley, Ian, *William Morris and his World*, Scribners Sons, 1978

Brandon Jones, John, *William Morris and Kelmscott*, London Design Council, 1981

Bryson, John (with Janet Camp Troxell), *Dante Gabriel Rossetti and Jane Morris, Their Correspondence*, Clarendon Press, 1976

Burne-Jones, Georgiana, *Memorials of Edward Burne Jones*, vols. i–ii, Macmillan, 1904

Caine, Hall, *Recollections of Rossetti*, Cassell & Co., 1928

Casteras, Susan P., *Images of Victorian Womanhood in English Art*, Associated University Presses, 1987

Cecil, David, *Visionary and Dreamer, Two Poetic Painters, Samuel Palmer and Edward Burne-Jones*, Constable & Co., 1969

Dakers, Caroline, *The Holland Park Circle, Artists and Victorian Society*, Yale University Press, 1999

Dobbs, Brian and Judy, *Dante Gabriel Rossetti, An Alien Victorian*, Macdonald & Janes, 1977

Doughty, Oswald and J.R. Wahl (eds), *Letters of Dante Gabriel Rossetti*, 4 vols., Clarendon Press, 1965–6

Dunn, Henry Treffry, *Recollections of Dante Gabriel Rossetti & his Circle or Cheyne Walk Life*, Dalrymple Press, 1984

Fitzgerald, Penelope, *Edward Burne-Jones, a Biography*, Michael Joseph, 1975

Fleming, G.H., *John Everett Millais, A Biography*, Constable,1998

Fleming, G.H. *That Ne-er Shall Meet Again: Rossetti, Hunt, Millais*, Michael Joseph, 1971

Gissing, A.C., *William Holman Hunt, A Biography*, Duckworth & Co., 1936

Gosse, Edmund, *The Life of Algernon Charles Swinburne*, London, 1917

Harris, Jennifer, *William Morris and the Middle Ages*, Manchester University Press, 1984

Harrison, Martin, *Pre-Raphaelite Paintings and Graphics*, Academy Editions, 1971

Harrison, Martin and Bill Waters, *Burne-Jones*, Barrie & Jenkins, 1973

Henderson, Philip,*The Letters of William Morris to his Family and Friends*, Longmans Green & Co., 1950

Hilton, Timothy, *John Ruskin, The Early Years*, Yale University Press, 1985

Hilton, Timothy, *The Pre-Raphaelites*, Thames & Hudson, 1970

Hunt, Diana Holman, *My Grandfather, His Wives and Loves*, Hamish Hamilton, 1969

Hunt, Violet, *The Wife of Rossetti, Her Life and Death*, John Lane, The Bodley Head, 1932

Hunt, William Holman, *Pre-Raphaelitism and the Pre-Raphaelite Brotherhood* vols. i–ii, Macmillan, 1905

Ironside, R. & John Gere, *Pre-Raphaelite Painters*, Phaidon Press, 1948

Kelvin, Norman, *The Collected Letters of William Morris: vol. i, 1848–1880*, Princeton University Press, 1984

Lago, Mary (ed.), *Burne-Jones Talking* , John Murray, 1982

Lethaby, W.R., *Philip Webb and his Work*, Oxford University Press, 1935

Lubbock, P. (ed), *Letters of Henry James*, London, 1920

Lutyens, Mary, *Millais and the Ruskins*, John Murray, 1967

Lutyens, Mary and Malcolm Warner, *Rainy Days at Brig O'Turk: The Highland Sketchbooks of John Everett Millais, 1853*, Dalrymple Press, 1984

Maas, Jeremy, *Holman Hunt & The Light of the World*, Scolar Press, 1984

MacCarthy, Fiona, *William Morris, A Life for Our Time*, Faber & Faber, 1994

Mackail, J.W., *The Life of William Morris*, vols. i–ii, Longmans, Green & Co., 1899

Macleod, Dianne Sachko, *Art and the Victorian Middle Class*, Cambridge University Press, 1996

Marsh, Jan, *Dante Gabriel Rossetti, Poet and Painter*, Weidenfeld & Nicolson, 1999

Marsh, Jan, *Jane and May Morris, A Biographical Story 1839–1938*, Pandora, 1986

Marsh, Jan, *The Legend of Elizabeth Siddal*, Quartet Books, 1989

Marsh, Jan, *Pre-Raphaelite Sisterhood*, Quartet Books, 1985

Marsh, Jan, *Pre-Raphaelite Women, Images of Femininity in Pre-Raphaelite Art*, Weidenfeld & Nicolson, 1987

Marsh, Jan and Pamela Gerrish Nunn, *Women Artists and the Pre-Raphaelite Movement*, Virago, 1989

Millais, John Guille, *The Life and Letters of Sir John Everett Millais*, 2 vols., Methuen & Co., 1899

Morris, May, *Introductions to the Collected Works of William Morris*, reprinted in 2 vols., Oriole Editions, 1973

Orr, Clarissa Campbell (ed.), *Women in the Victorian Art World*, Manchester University Press, 1995

Parris, Leslie (ed.), *Pre-Raphaelite Papers*, The Tate Gallery, 1984

Parry, Linda, *Art at Kelmscott*, The Boydell Press, The Society of Antiquaries of London, 1996

Pedrick, Gale, *Life with Rossetti or No Peacocks Allowed*, Macdonald, 1964

Pevsner, Nikolaus, *Pioneers of the Modern Movement from William Morris to Walter Gropius*, Faber & Faber, 1936

Reynolds, Graham, *Victorian Painting*, The Herbert Press, 1987

Robertson, W. Graham, *Time Was*, Hamish Hamilton, 1931

Rose, Phyllis, *Parallel Lives, Five Victorian Marriages*, Chatto & Windus, 1984

Rossetti, William Michael, *The P.R.B. Journal*, edited from the original manuscript and with an introduction and notes by William E. Fredeman, Oxford University Press, 1975

Rossetti, William Michael, *Pre-Raphaelite Diaries and Letters*, Hurst and Blackett Ltd, 1900

Rossetti, W.M. *Some Reminiscences*, Brown Langham & Co Ltd, 1906

Ruskin, John, *The Works of John Ruskin*, ed. by E.T. Cook and Alexander Wedderburn, George Allen, London, 1903–12

Spalding, Frances, *Magnificent Dreams – Burne-Jones and the Late Victorians*, Phaidon Press, 1978

Stansky, Peter, *Redesigning the World, William Morris, the 1880s and the Arts and Crafts*, Princeton University Press, 1985

Stansky, Peter, *William Morris*, Oxford University Press, 1983

Stirling, A.M.W., *A Painter of Dreams, the life of Roddam Spencer Stanhope*, John Lane, 1916

Surtees, Virginia (ed.), *The Diary of Ford Madox Brown*, Yale University Press, 1981

Surtees, Virginia, *Sublime and Instructive*, Michael Joseph, 1972

Thirkell, Angela, *Three Houses*, Oxford University Press, 1932

Trevelyan, Raleigh, *A Pre-Raphaelite Circle*, Chatto & Windus, 1978

Walkey, Giles, *Artists' Houses in London 1764–1914*, Scolar Press, 1994

Whitehouse, J. Howard, *Vindication of Ruskin*, Allen & Unwin, 1950

Wildman, Stephen, *Visions of Love and Life, Pre-Raphaelite Art from the Birmingham Collection*, Art Services International, 1995

Wood, Christopher, *The Pre-Raphaelites*, Weidenfeld & Nicolson, 1981

Wood, Christopher, *Victorian Panorama, Paintings of Victorian Life*, Faber & Faber, 1976

INDEX

For the Salish Sea—
daily companion, teacher.
For Loki and Tao,
feline inspirations.
And for Lily, born in water,
beautiful soul.
—*Brenda Peterson*

To the rightful few—
casting healing lights
upon an ailing world
long darkened
by our lost
sensibility and vision.
—*Ed Young*

Catastrophe by the Sea

by BRENDA PETERSON
art by ED YOUNG

WEST MARGIN PRESS

A cat called Catastrophe
prowls over driftwood,

splashes through tide pools,
disturbs hermit crabs and sculpin fish,
whose scaly gills flutter in fear.

His whole world now is
the beach at low tide.

An oystercatcher
whistles a warning.

Catastrophe wandered too far from home.
Now he is lost and misses his family.
"Who will play with me here?"
he wonders.

Not the octopus who jets and squirts

an inky cloud at the intruder.

She squeezes under a rocky ledge,

her three hearts drumming.

When Catastrophe paws
at a sea anemone,
the green sea flower
shoots salty spray
smack into his face.

Catastrophe leaps back
and cleans his fur with
a furious lick.

"I thought you were dead!"

"I'm just as alive as you!"
the anemone spouts.

Catastrophe touches the
anemone's rubbery tentacles,
but they sting him.

"Ouch!" he growls.

The cat prepares to pounce,
but the anemone protests,
"Why are you all by yourself?
I have lots of friends in our cozy colony."

In the cold, shallow seawater,
hundred-year-old anemones wave
their tentacles.

"If we get lonely, we make
twins of ourselves," they sing.

The cat decides not to attack.
These are the first friendly creatures
he's found on the beach.

"Just call me Catastrophe," he purrs.

"And you can call me Naimonee," she says,
with a smile like a rosy blossom.

A kind welcome feels good
to the cat who is no longer alone.

"I'm Buddy,"
a barnacle pipes in.
He clicks open his shell
and other barnacles
around him rattle and clap
like castanets.

Sea slugs flap their spiky wings.

Crabs dance a sideways
cha-cha-cha.

Sand dollars samba
in the shallow waves.

Catastrophe greets the tide pool band
with a twirl of his own.
"You should take your show on the road.
You could be rock stars!"

"We're already rock stars," Buddy says.
"We are stuck to these rocks
with the world's strongest glue!"

"You mean you never leave
this beach?" Catastrophe asks.

"As a little larva, I traveled the deep ocean.
Some of my cousins attached to a gray whale
and still sail the sea.

But I caught the scent of other barnacles
and found them here on our beach.
I molded this shell around my body
to keep me snug and safe."

Buddy's barnacle band sings,

"Happy homebodies are we,
in and out of the sea."

Out of nowhere, a big wave

splashes over the tide pool.

An undertow sucks Catastrophe inside.

He spins and somersaults.

Catastrophe is swept off the rocks.
He swallows so much seawater,
he almost drowns.

Surf rushes in and fills the tide pools.

Sea creatures feed hungrily.
Wide-open shells,
fuzzy little legs,
and tentacle fingers
snatch plankton and small fish
from the surging water.

At last, the wave hurls
the cat back onto the sunny beach.
Sputtering, Catastrophe smooths his wet fur.

The cat looks around
but can't find his tide pool friends.
"Buddy? Naimonee?" Catastrophe yowls.

No answer.

He shivers, then crawls under driftwood,
and curls up on the cold sand to sleep.

Now that the tide is in,
it's much lonelier
on the beach.

The next morning, Catastrophe wakes up to the clicking castanets of the barnacle band.

Shrimp pop like percussion.

Then the sweet, familiar voice of Naimonee calling,

"Cat-as-tro-phe!"

The cat runs toward the voices
of his friends in the tide pool.

Catastrophe pets Naimonee,
but very gently.
He purrs at Buddy,
"I'm so happy I found you again."

Suddenly the cat hears
a loud thumping.

BAM! BAM! BAM!!

Sneakers
on the sand!

Racing each other,
two children crunch
the barnacles.
Their feet squish
sea anemones.

"Run, Catastrophe!" Buddy shouts
before he shuts up his shell.

The cat scoots across the warm beach.

He slips on slimy algae.

Skitters on sea lettuce.

When the boy grabs him,
Catastrophe closes his eyes.
He knows what comes next.

The cat recognizes bullies
on the beach.
He used to be one.

"You're on all those LOST CAT posters!"
the girl says.

The boy grins.
"Your people really
miss you."
Catastrophe relaxes and lets
the children hold him closer
and pet his salt-crusted fur.

"C'mon," the girl says. "Tide's coming in.
And cats don't belong on the beach.
Let's take you home."

Catastrophe meows at the children,
"Watch out for my friends
in their tide pool!"

The children seem to understand.
They tiptoe carefully
around Buddy and his barnacles.

They stop to watch
 Naimonee's garden blooming.

As Catastrophe is carried home,
he hears Buddy's barnacle band sing
goodbye to him:

"Happy homebodies are we,
in and out of the sea."

AUTHOR'S NOTE

Living on the Salish Sea, I watched my mischievous cat Ivan Louis III sometimes escape our house to prowl the backyard beach. One day, I saw Ivan leap up in surprise when he poked a colony of sea anemones who then squirted him. They were full of water to survive low tide. It was as if my cat suddenly understood these tide pool creatures were as alive as he was. Children also explore the beach at low tide, delighted by the endlessly entertaining tide pools. Often the kids are guided by a beach naturalist who explains that this complex tidal ecosystem is precious to all life. That we are all deeply connected to the tiniest, most overlooked, and even seemingly ugliest of sea creatures.

The National Park Service calls tide pools "windows on the sea." Catastrophe's friendship with sensible Buddy the Barnacle and the lovely sea anemone, Naimonee, along with their tide pool pals teaches him about their survival skills—the "secret powers" of tide pool creatures. Clinging to rocky ledges, vulnerable tide pool creatures brave powerful tides twice a day. Sometimes, even with their protective shells, the sun burns and dries out their exposed bodies. These tide pool animals have much to teach us about endurance, belonging together, and cherishing our home beach. Like Catastrophe and the kids, animals and humans can become truly good neighbors.

ACKNOWLEDGMENTS

This new book has benefited from an inspiring editorial "dream team," with master artist Ed Young, my long-time astute editor Marlene Blessing, brilliant designer Alison Kan Grevstad, and our scientific partners at the Seattle Aquarium Marsha Savery and Jim Wharton.

We are also grateful to my literary agent, sublime Sara Jane Freymann; Hailey Dowling, my indispensable editorial assistant; for the nurturing support of West Margin Press publishing director Jennifer Newens, excellent marketing strategies from Angela Zbornik, and the subtle line editing of Michelle McCann.

CAN EMPATHY INSPIRE CONSERVATION AND BRING US CLOSER TO NATURE?

The world is a strange and wonderful place to explore. Life beneath the waves may be the strangest of all. Ocean creatures look very different and lead diverse lives. This biodiversity strengthens the system—but can make it hard for us to feel connected to these alien beings. Empathy asks us to swim a mile in their fins. This helps us see and feel what we have in common with even the most unusual of ocean creatures. Feeling connected to ocean animals includes them in our circle of concern, so we care and conserve them.

What began with an idea from the team at the Seattle Aquarium to develop a tool that would help build empathy in Aquarium guests led to a fruitful collaboration and this beautiful book. Storytelling is one of the most powerful empathy-building tools; it invites us to step into the tale and experience the story alongside our characters. We hope you enjoy exploring the tide pools with Catastrophe and feel just a little closer to this captivating aquatic world.

—The Seattle Aquarium

Library of Congress Cataloging-in-Publication Data is on file

ISBN: 9781513262345 (hardbound) | 9781513262352 (e-book)

Proudly distributed by Ingram Publisher Services

Printed in China
23 22 21 20 19 1 2 3 4 5

Published by West Margin Press®

WEST MARGIN PRESS
WestMarginPress.com

WEST MARGIN PRESS
Publishing Director: Jennifer Newens
Marketing Manager: Angela Zbornik
Editor: Olivia Ngai
Design & Production: Rachel Lopez Metzger